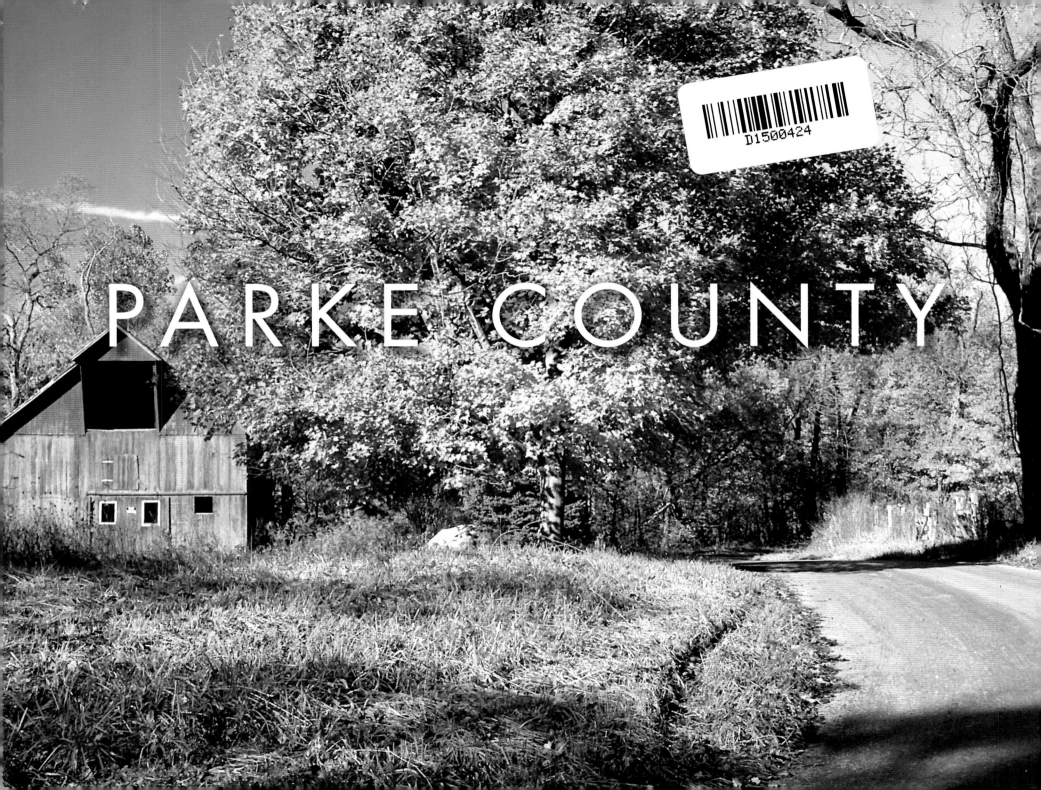

PARKE COUNTY

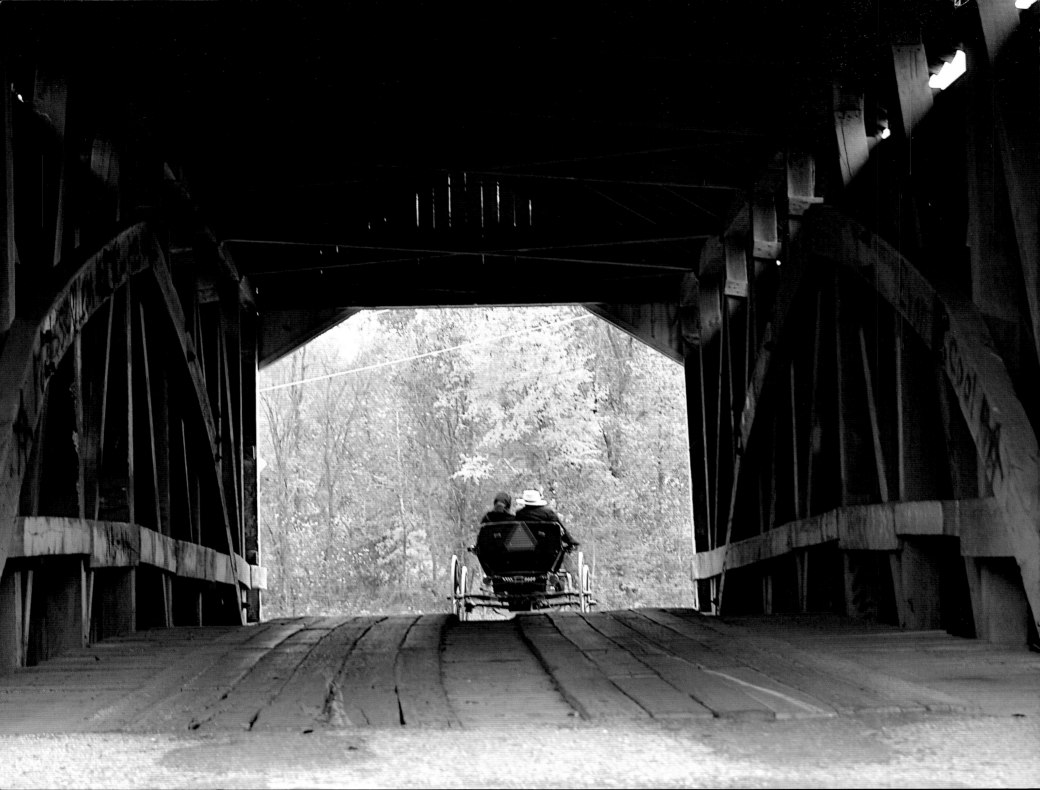

PARKE COUNTY
INDIANA'S COVERED BRIDGE CAPITAL

MARSHA WILLIAMSON MOHR

Foreword by MIKE LUNSFORD

Afterword by JON KAY

an imprint of

Indiana University Press • Bloomington and Indianapolis

This book is a publication of

QUARRY BOOKS

an imprint of

INDIANA UNIVERSITY PRESS
Office of Scholarly Publishing, Herman B Wells Library 350
1320 East 10th Street, Bloomington, Indiana 47405 USA

iupress.indiana.edu

♾The paper used in this publication meets the minimum requirements of the American National Standard for Information Sciences—Permanence of Paper for Printed Library Materials, ANSI Z39.48–1992.

Manufactured in China

Library of Congress Cataloging-in-Publication Data

Mohr, Marsha Williamson.
 Parke County : Indiana's covered bridge capital / Marsha Williamson Mohr; foreword by Mike Lunsford ; afterword by Jon Kay.
 pages cm
 ISBN 978-0-253-01615-7 (pb)
 1. Parke County (Ind.)—Description and travel. I. Title.
 F532.P2M64 2015
 977.2'465—dc23
 2014041114

1 2 3 4 5 20 19 18 17 16 15

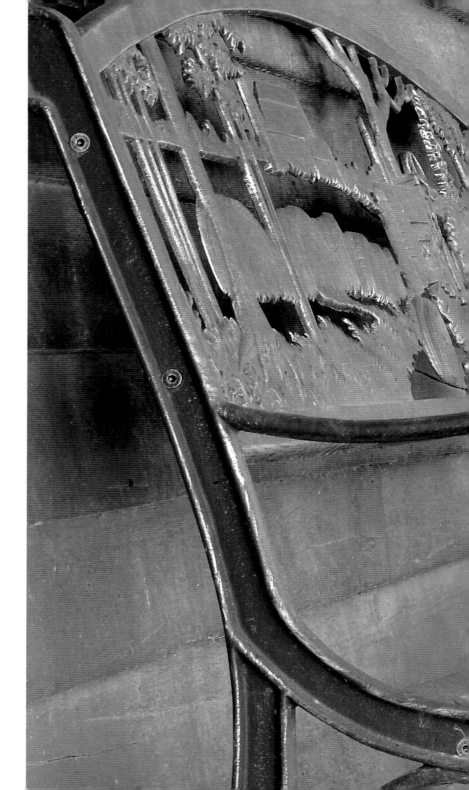

I want to dedicate this book to the people of Parke County,

with special thanks to the little lady with a walker in the corner café in Marshall who invited us to her house; to the Dovers, who fixed us lunch from their evening home meal while we were biking through Mansfield during the "off season"; and to the man and woman who operate the Bridgeton Mill and make the best cobbler in the state!

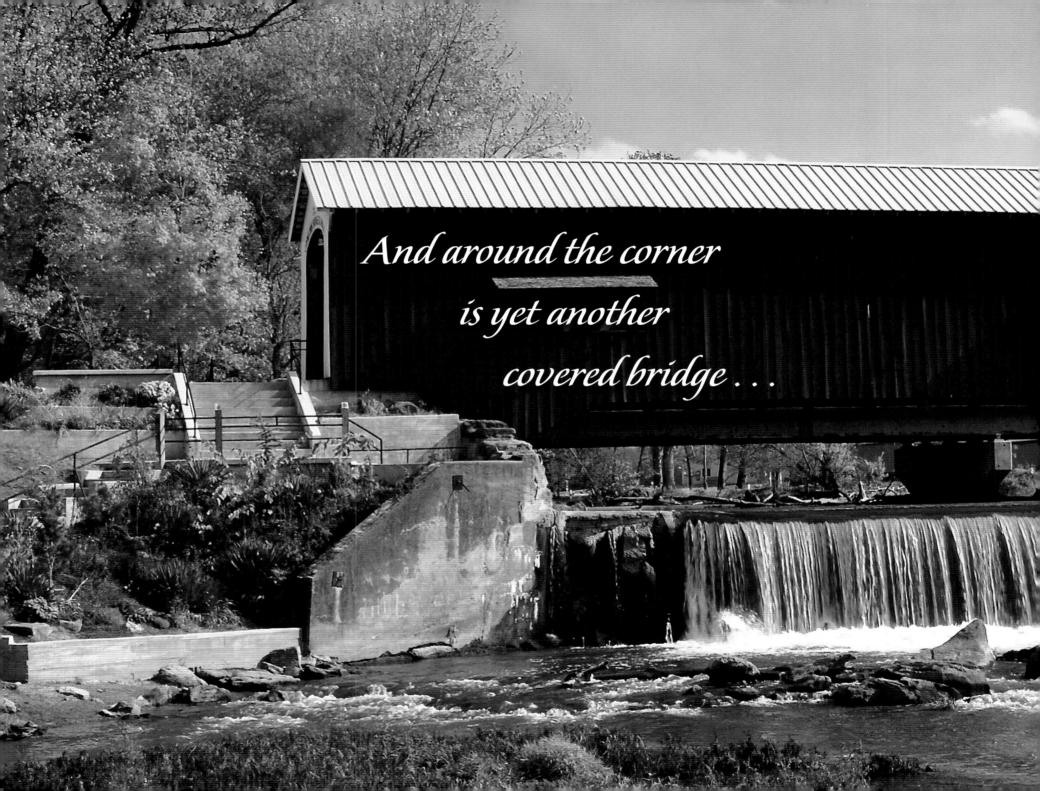

And around the corner
is yet another
covered bridge . . .

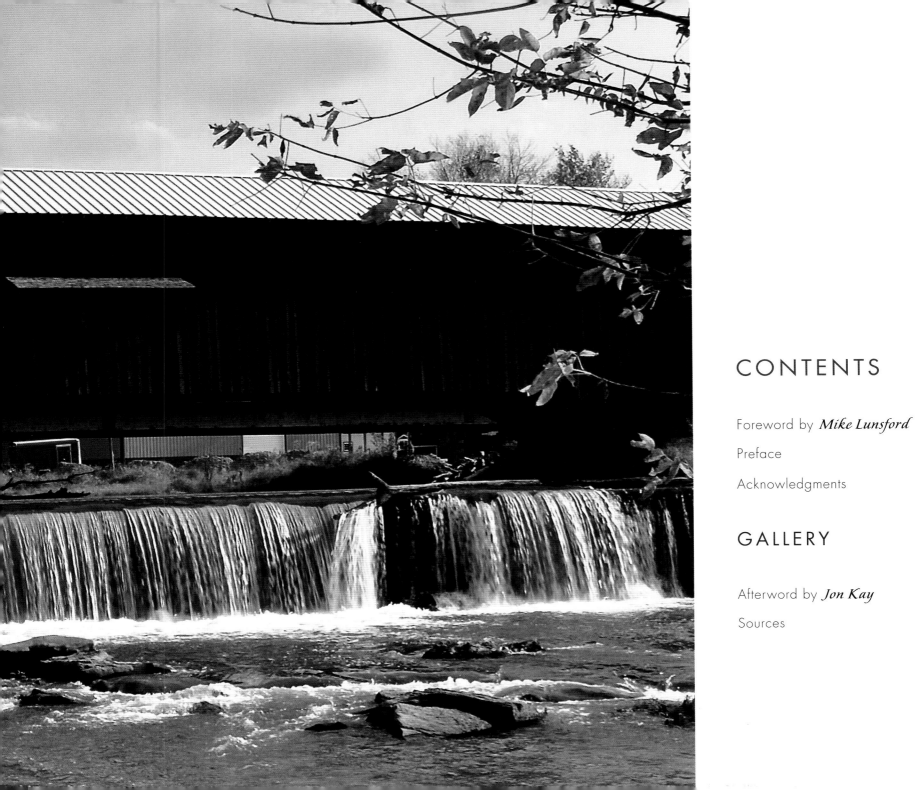

CONTENTS

GALLERY

FOREWORD

Mike Lunsford

A SETTING SUN IS PAINTING THE NAKED ARMS OF THE sycamore trees near my window with a sense of warm light, now slowly fading in the chill of Arctic air come calling too soon. It is a blue November day, calm and quiet and lazy, a typical afternoon on the ridge in southern Parke County that I call home.

It is commonly said, but sometimes hard to believe, that we "wouldn't live anywhere else." But despite my love for Vermont's green mountains and Maine's craggy coasts and the scent of pine in Tennessee, I think it is more true for me than for most. I happily admit to being a contented fish in a small pond, although instead of green water and cattails, my banks hold fertile soil, good timber, winding one-lane roads, and fair-minded people.

As beautiful as Parke County is, it is also underappreciated, and I would stand guilty as charged if ever accused of that offense. I'd venture to guess that many people who live here as my neighbors and friends will see right away what I discovered the first time I wandered through Marsha Mohr's photographs of our home ground, many of which you are about to see for yourself. It is difficult to be prophets in our own land, so we sometimes need wayfarers like her to point out what even L. Frank Baum's Dorothy had to learn for herself: that "there is no place like home." The barns and streams and rocks, the autumn leaves and covered bridges that Marsha captures and cherishes are our own, yet we drive past and over and through them every day as we head to work and church and school, and never really know them, treasure them, perhaps even take notice of them. Like the "prodigal son" of the Scriptures, we have a lack of appreciation lurking in our sensibilities, for like most folks, we have the urge to travel to other places and see other things. Marsha's pictures, like the richness of the father's house in that often-told parable, are examples of why those who leave Parke County for other places always seem to return, even if only in memories.

I first met Marsha at an Indianapolis author's fair, and as I thumbed through one of her books on Indiana's covered bridges, I found a picture of the Harry Evans Bridge, a small poplar-sided, tin-roofed span built in 1908 and named for the man who owned the woods nearby. The bridge crosses knee-deep Rock Run, which, just a few hundred yards to the west, empties itself into the wider and deeper Big Raccoon. I can walk to that spot in about twenty minutes from where I now sit, and I told her that day, "I waded there when I was a boy. I skipped rocks and hunted for Indian beads there too."

"I just love Parke County," Marsha told me. "It's one of my favorite places in the whole world. I'd like to do a book about it someday."

Well, that day has come, and it's my hope that those of you who meander wide-eyed through the following pages will gain a sense of appreciation, not only for Marsha's artistic eye, but for a county, virtually all rural, that is larger than most of the other ninety-one in Indiana—about 450 square miles—yet is so sparsely populated that more people live in all but about a dozen of them. Our biggest town and our county seat, Rockville, has just 2,600 inhabitants and sits right in the middle of the whole thing.

Marsha tells me that she fell under Parke County's spell as a child, just as her father drove up to the Mansfield Mill during the Covered Bridge Festival on a rainy fall day. "I think it was right then when my heart soared, and I was in love with your county," she says. She comes from rural stock, and that appears to be one reason for her affinity for this place. Her father worked in agriculture at Purdue University, and her grandparents and brother farmed in Wayne County. She got her start as a photographer snapping shots of aging barns, but no matter where she travels and what she sees, she has never quite gotten over the pull of hickory-pegged beams and rickety hay mounts and rusting wire.

We are corn-fed people here, working people. We live in the west-central part of the state, bound together by the Wabash River to our west and the sandy soil of the Illinoisan till plain to our south. A line, shown only on a map, separates us and Clay County to the east, while the last of the far-reaching Wisconsinan glaciers—which on a previous trip eons ago scoured out Lake Michigan—left us our hills and boulders and washes and streams, many on display at Turkey Run and Shades State Parks in our north. We are sixty miles from the state capital, just five miles from Illinois in our farthest-reaching northwestern corner, and the ground on which we live and farm was surveyed and carved and fenced out of Vigo County, which lies just across the road on which my home place can still be found, just three miles away.

We truly were a "land of the Indians" here until we got our official start as a county in 1821, but that was not before William Henry Harrison had marched an army up what is still called the Lafayette Road (County Road 600W, now) a decade earlier on his way to fight the Prophet at the Battle of Tippecanoe. The spot where he and his men camped, just north of Raccoon Creek, became known as Armiesburg, and it served, for a little while, as our county seat. There is a historical marker there now commemorating the famed "Ten O'Clock Line," but little else.

Our first county seat was Roseville, named after entrepreneur Chauncey Rose, whose name was also bestowed on Rosedale, the county's third-largest town, which holds steady at a population of about 725. My home is sandwiched neatly between that pair of villages, but the coal mines and sand pits, the rail lines and grist mills that once flourished here are only memories. The echoes of the steam engine whistles and clacking coal cars that once sounded on the tracks just below my house have been replaced by the howls of coyotes and the lonely tunes of my back porch wind chimes. Our age of steam and iron and coal, of the rail lines that ran through burgs like Jessup and Catlin, Sand Creek Station and Judson, disappeared years ago.

Pay close attention to the land as you take in Marsha's photos; we have it in rich abundance here. Even a fading *Historical Atlas of Parke County*, printed in 1874 and bought for a song at auction, tells me, "The geological position of Parke County is somewhat peculiar." We have good soil here—our richest resource—yet had more than enough clay in our creek banks to have supported a strong tile and paving brick industry some eighty years ago in places like Mecca and Montezuma. Many of our oldest buildings still sit on foundations of native-cut sandstone and limestone too, and I am told that at one time, seventeen coal mines sat within just a few miles of my house. The land on which I live was, ages ago, part of a five-mile-wide island that sat above a floodplain that eventually spilled into the channel that became the Wabash River. By the middle of the nineteenth century, an arm of the Wabash & Erie Canal ran parallel to that river, but with the advent of railroad travel and state highways, it eventually became a thing of the state's nearly bankrupted past. Visitors, if they know where to look, can still find sets of locks from the canal.

For a place that has so few people—we claim only about thirty-nine per square mile—Parke County has produced numerous famous sons and daughters, the best-known, I suppose, being Hall of Fame pitcher Mordecai "Three-Finger" Brown. "Miner" Brown got his middle name, "Centennial," from his birth year of 1876, and his most famous nickname after a hungry corn thresher separated his thumb and forefinger from his right hand. Born in unincorporated Nyesville, he pitched for a while for a mine team in Roseville—by then called Coxville—and then headed to Clay County, the Three-I League, and eventually the glory days of the Chicago Cubs.

We have had other luminaries as well, both the educated and the eccentric. Among the former was William Henry Harrison Beadle, who became a Civil War general, a surveyor and geographer, and eventually a South Dakota college president. Grover Jones was born in Rosedale, but eventually became a well-known Hollywood screenwriter and director. Joe Cannon, born in a house that, somehow, remarkably stays upright near Annapolis, became an Illinois legislator and one of the all-time most powerful Speakers of the House of Representatives. Juliet Strauss, whose staunch defense of the landscape helped keep the beauty of Turkey Run intact, became nationally known for her column, "The Ideas of a Plain Country Woman." She defended small-town and rural life,

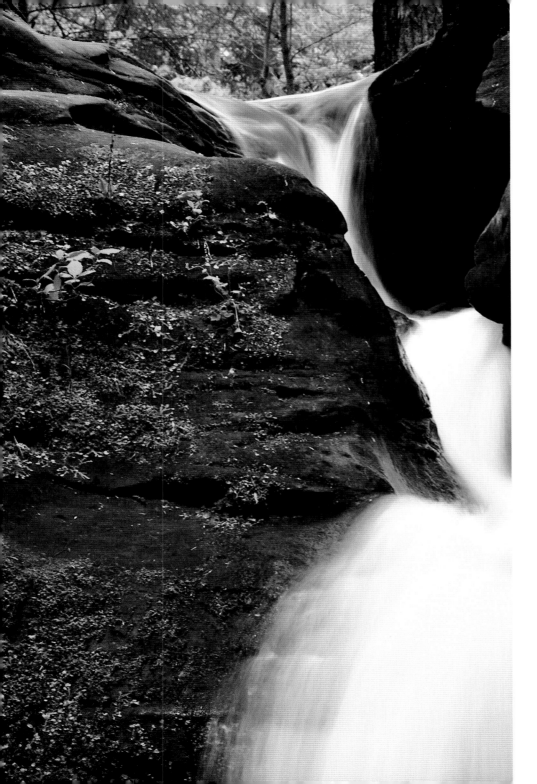

once writing, "Country people really are the only people who live in this world, if by this world is meant trees, and hills, and fields."

Dr. Wallace Wheat, an idiosyncratic herbalist who was trained at a Cincinnati medical school, hailed from Parke County too. It was said that on busy days, patients waited in a line of cars a quarter-mile long to see him. "Doc" became well known for his cancer treatments and $1.10 examination fees, but attained legend by burying his money in and around his Roseville home, setting off a treasure hunt of sorts in the years after his death.

Edward "Tex" Terry also came from here. A mostly B-movie actor who worked with John Wayne and married a Hollywood agent, Tex eventually came home to drive his cattle-horn-bedecked Cadillac in local parades, put on bullwhip shows for children, and open a tavern, best known in its day for its penny-filled bar and walls adorned with Tex's old movie posters. He's buried beneath a surprisingly large granite monument less than a mile from my house.

So, what is here now to love besides our trees and a festival that celebrates our thirty-one covered bridges—the most in the country—and the lingering ghosts of our history? First of all, that festival welcomes around a million and a half visitors to the county every October, and many of them return year after year. They tell us that they love the country charm of sleepy small towns, of beans-and-cornbread suppers, and the rugged trails of a state park built with the hands of Civilian Conservation Corps labor during the Great Depression. They love the fields of rattling corn and copper-tinted soybeans, just being harvested at festival time; they love the moving waters of a thousand rambling streams and spillways, the cool green slabs of stone in the "Devil's Den," and the beauty of the "Narrows," all in the making for the last three hundred million years.

We are a place where the vestiges of Quakers and their stops on the Underground Railroad remain, and where the Amish, with their buggies and sawmills and kerosene-lamp-lit ways, have come to stay and prosper. We are a place that may have lost its canals, and virtually all of its railroads, yet we remain vibrantly crisscrossed by two United States highways and six more of the state variety. We seem to have a pleasant

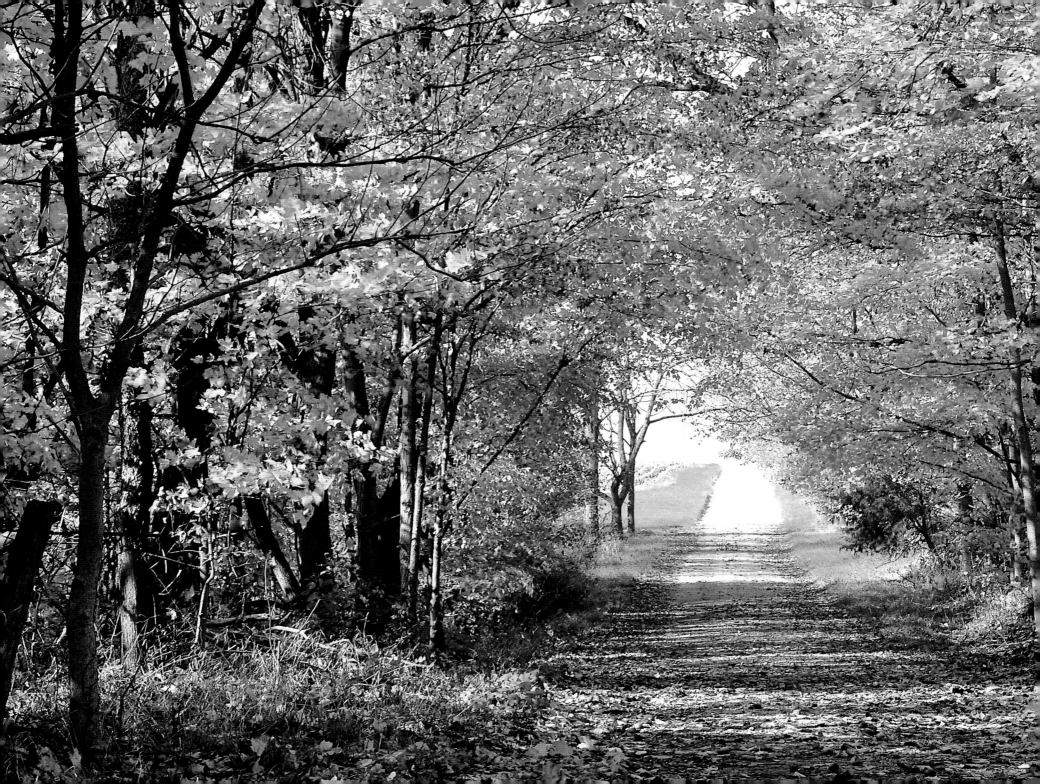

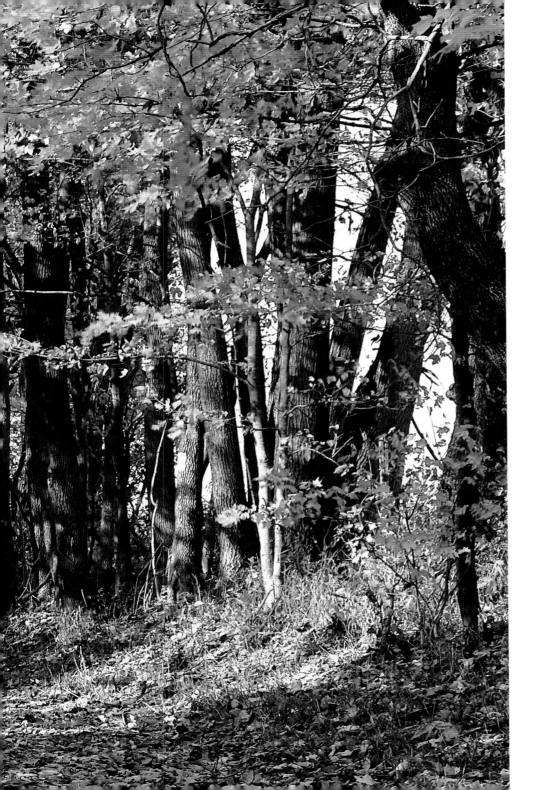

incongruity here: a place for maple fairs and threshing days, double Burr Arch antique bridges that serve us every day, and family-owned farms handed down generation after generation. It is as genuine as dirt-covered blue jeans, wonderfully isolated from strip malls and stalled traffic. It is a fine place to visit and a better place to live.

Marsha understands that. "I think the Bridgeton Mill and bridge setting, with the sound of the water falling, is one of the prettiest sights in the world," she says. "I have photographed at least twenty-five different subjects in all four seasons in Parke County: cabins, one-lane roads, barns, seven of the covered bridges, the mills, the hollows. . . . It is a peaceful place."

I am, on occasion, stopped on my walks by poor lost souls who have braved our county's roads with neither GPS nor a sense of direction. "Where are we?" I am asked. I usually just ask in return, "Well, where do you want to go?" Almost always the destination is either a covered bridge or an easy route out of this country maze to a highway toward home.

There is, of course, much more to tell. Of the ferries that at one time dotted the Wabash River, particularly above the point where a covered bridge took horses and buggies "at a walk" across its wide water. Of the short-lived "sanatorium" near that same spot at the turn of the century; it offered steam baths and mineral water to those willing to ride the steamboats up the river. Of the opera houses, of the black soil of Henry's Prairie and the steam shovels that turned the Big Raccoon around. Of Don Lash, who ran a world record time in the two-mile and won twelve national titles, of the sand dug out of a southern Parke County hillside that was used to make the first Coca-Cola bottles, of the eleven small county schools that gave their teams nicknames such as the Immortals, the Hotshots, and the Aces. Of the hometown bank robbed by John Dillinger in 1933.

But now I think it is time I let you go; there are things to see in the pages that follow. Hoosier journalist William Miller Herschell popularized the saying, "Ain't God good to Indiana?" Marsha Mohr proves that to be true with her camera. I suspect, however, that she believes the Creator spent just a little extra time with Parke County.

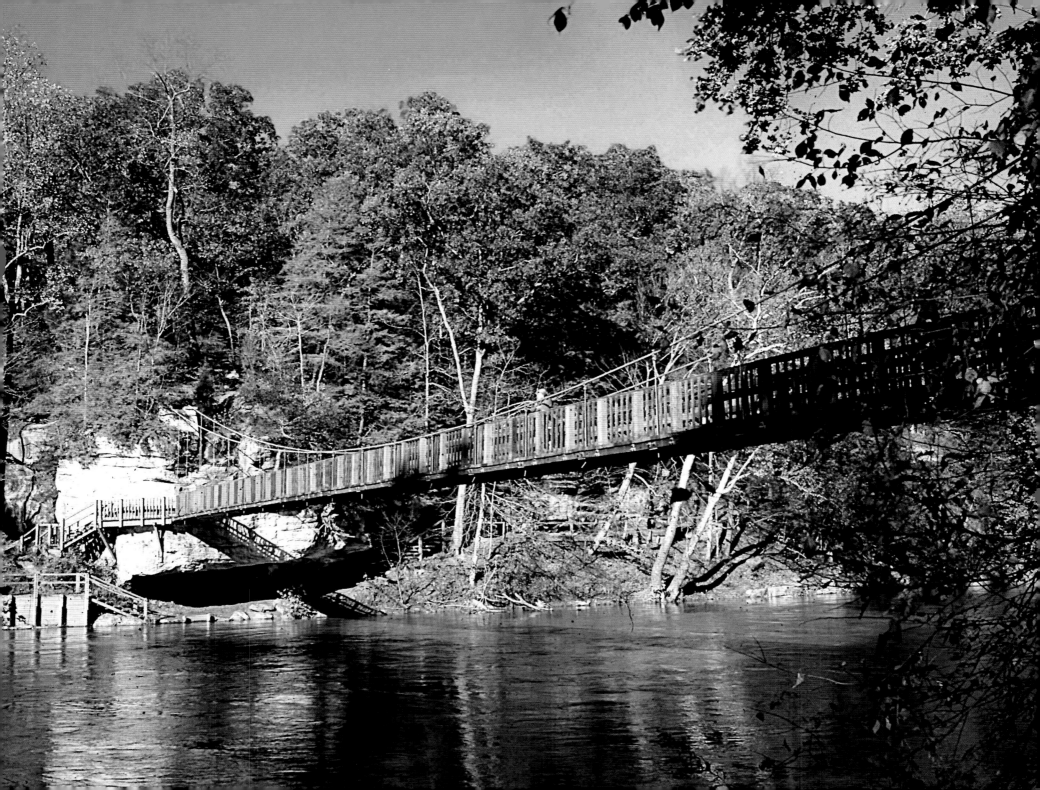

PREFACE

How does one explain Parke County? The open meadows. The distant sights of covered bridges and farmers harvesting their crops. One-lane gravel roads leading to a photo around every corner. The view through a covered bridge window looking out toward Mansfield Mill, where a father and his two sons in bib overalls are fishing. As I leave, heading east out of Bridgeton, I turn around and look across the fields and remember what remarkable sights the mills and bridges were. I question if there is any scenery finer, even in New England.

I have had the good fortune to travel all over the United States, Canada, and the Caribbean and I was taught at a very young age to appreciate nature. I was also taught another value that is rarer these days: an appreciation for rural life. Living in Indiana does precipitate such a passion, and it didn't hurt that my father was involved in agriculture and my grandparents farmed in Wayne County. But I think my passion for rural beauty goes well beyond the normal admiration and, despite my travels all over our amazing country, that passion always brings me back to this one particular favorite location. Parke County gives me energy that is very hard to describe—power I don't feel in other places.

I am fortunate that the county is only a short one-hour drive from my home. My trips there started many years ago on a cool, rainy autumn day during the Covered Bridge Festival when Dad pulled up and parked next to the Mansfield Mill. Right then I was captivated by the excitement of the rushing water next to the mill and the sight of the covered bridge. It was a sight, though I didn't know it at the time, that I would see over and over in my lifetime.

As a young adult I wandered around the county's back roads and got lost many times. The wooden road-number signs were sometimes correct, sometimes not; sometimes turned the wrong direction; and some-times gone. I never knew exactly when or where I might come across a covered bridge. I recall the excitement of seeing one from the corner of my eye and slamming on my brakes, forgetting that I was on a steep gravel hill and had a manual transmission. Now, I feel confident I have traveled nearly every road and I no longer get lost. I have grown to love the county and wonder if its residents share the same affection.

I appreciate that development has been discouraged in Parke County. The Amish who have moved there have only enhanced the pastoral character of the area. Some roads still run through streams where there probably should be a bridge. Although the county is famous for being the "Covered Bridge Capitol of the World," there is an abundance of natural beauty there as well, including two parks that draw in many visitors each year: Shades State Park and Turkey Run State Park, one of the first areas set aside as a state park in Indiana. We have been on every trail in each park many times and the hollows are marvelous to view. Waterfalls cascade down into those hollows and ponds reflect each season.

My husband and I love to bicycle the back roads, and I remember a day that we left from Rockville for a 35-mile trip with two friends, not having checked the weather report. Thunder started rumbling off in the distance, and it was approaching fast. We sped up as I exclaimed that we should get to the McAllister Covered Bridge for cover. As we patiently waited out the storm, I kept staring and staring at what I saw as a perfect landscape. The doorway of the bridge framed a one lane road with a tree posing gracefully at the side.

It would be hard to imagine any place more peaceful, except for one week a year during the Covered Bridge Festival. You can't count on parking at the Mansfield Mill during that time anymore! For many of the residents of Parke County this festival is their bread and butter, and for

many guests it is an attraction in itself. I asked a friend if she saw the covered bridge in Mansfield when she went to the festival and her reply was, "What covered bridge?" But even amidst all the crowds and excitement, the natural beauty and covered bridges provide a perfect backdrop for one of the most visited festivals in the country.

I have been blessed to have had two God's Country articles on Parke County in *Country* magazine. Through the photographs in this book, my goal is to share that passionate "God's Country" feeling I get every time I visit.

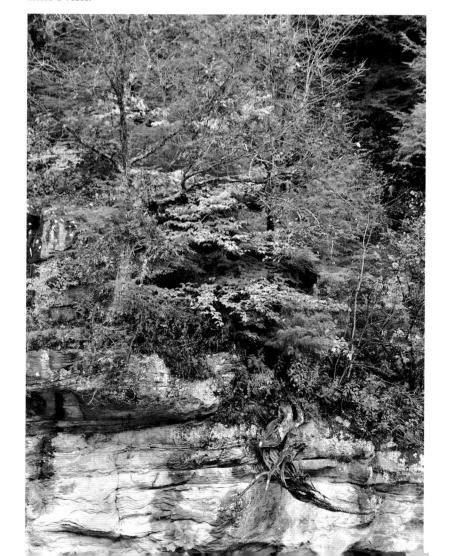

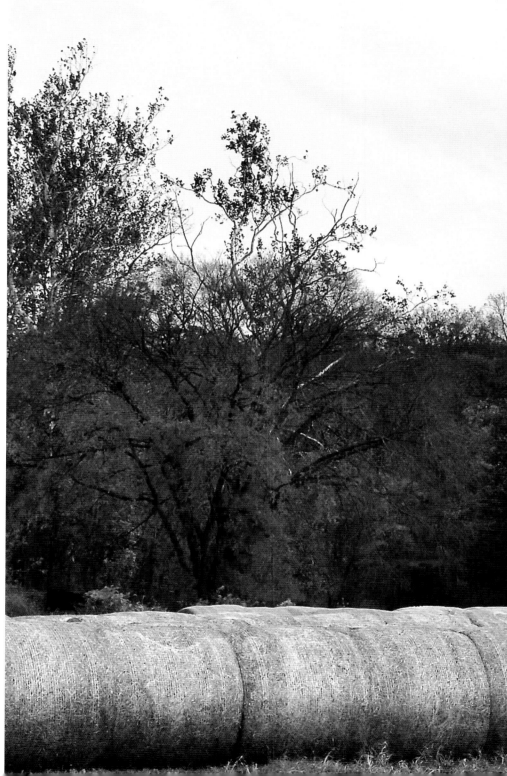

ACKNOWLEDGMENTS

I WOULD LIKE TO FIRST ACKNOWLEDGE THE HELP AND support of my husband, Larry. While I've traveled to take pictures, he has done the grocery shopping, cleaning, cooking, and laundry. No matter how many times I would go to Parke County or in what season, I would come home and have a variety of good photographs. Larry used to ask me where I was headed and when I answered "Parke County," he would say, "AGAIN?" Now, in his retirement, he goes with me and shares my passion.

I also want to recognize my parents. Dad was the one who took me to Mansfield for the first time during the Covered Bridge Festival and got me hooked. Thank you also to Mom, who took many trips with me to Parke County. Bless her heart for understanding my avoidance of the busy areas during the festival and taking every gravel back road imaginable.

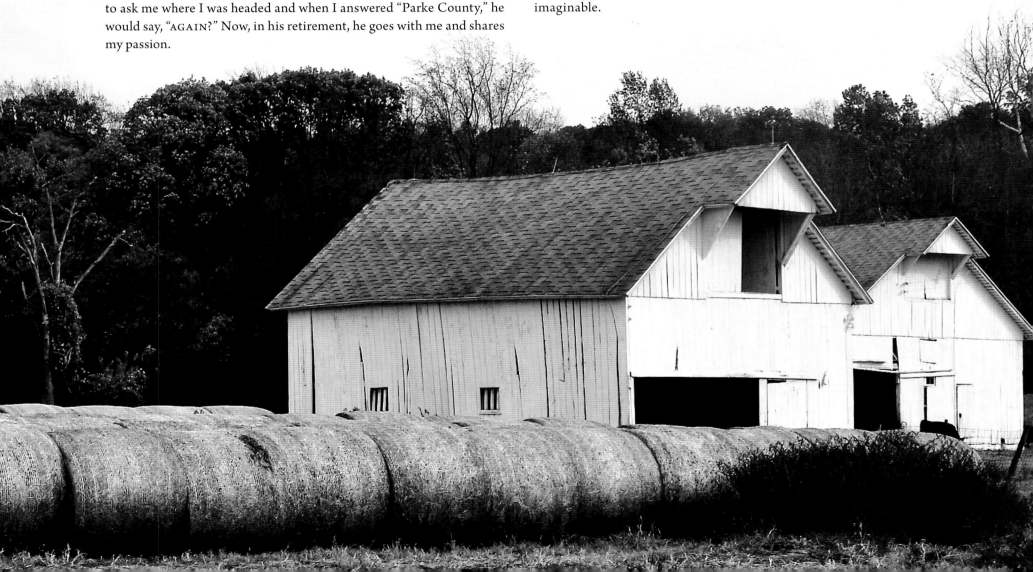

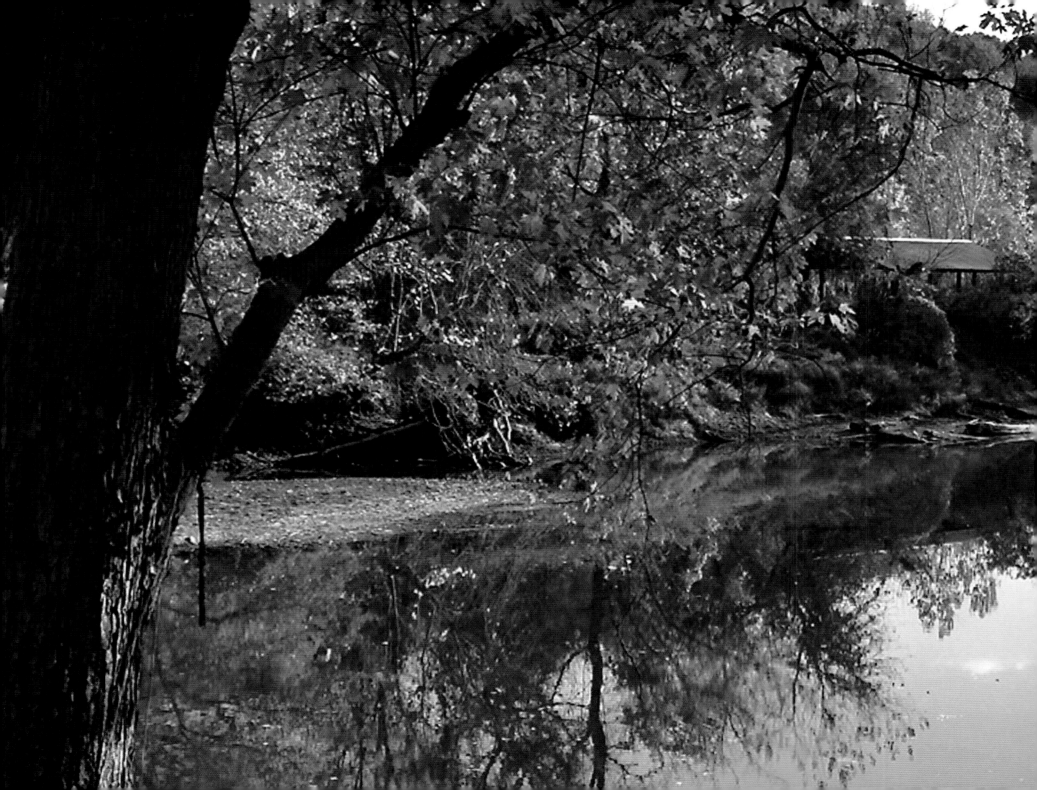

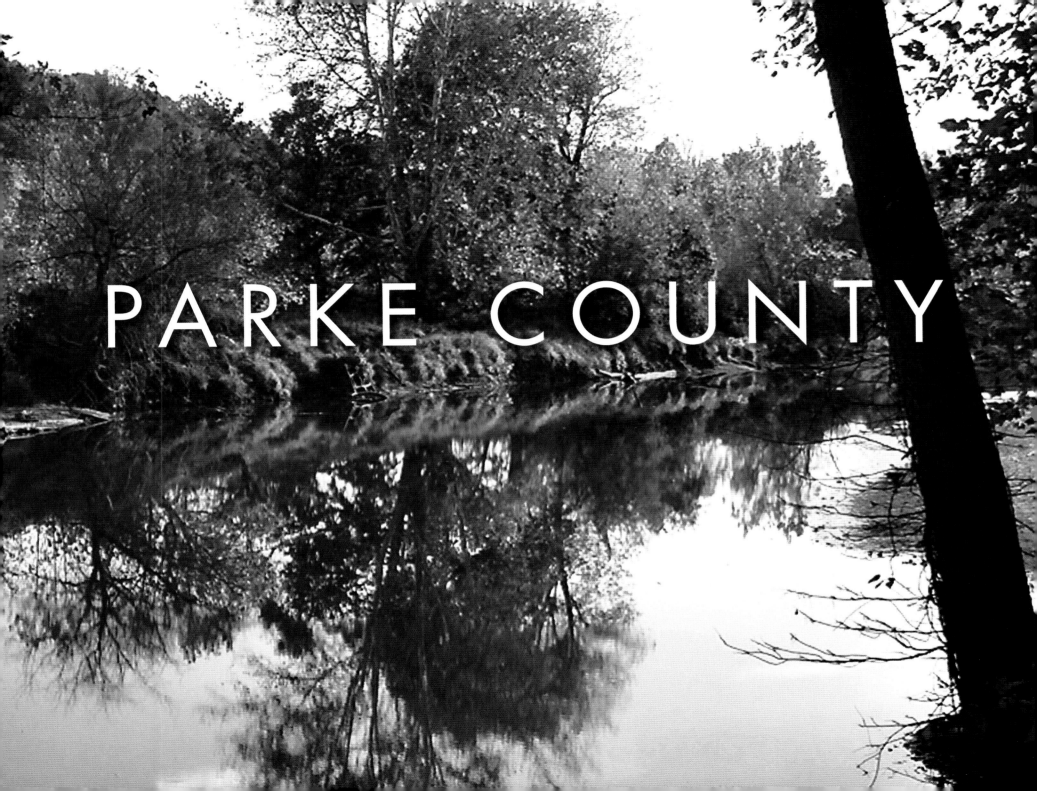

PARKE COUNTY

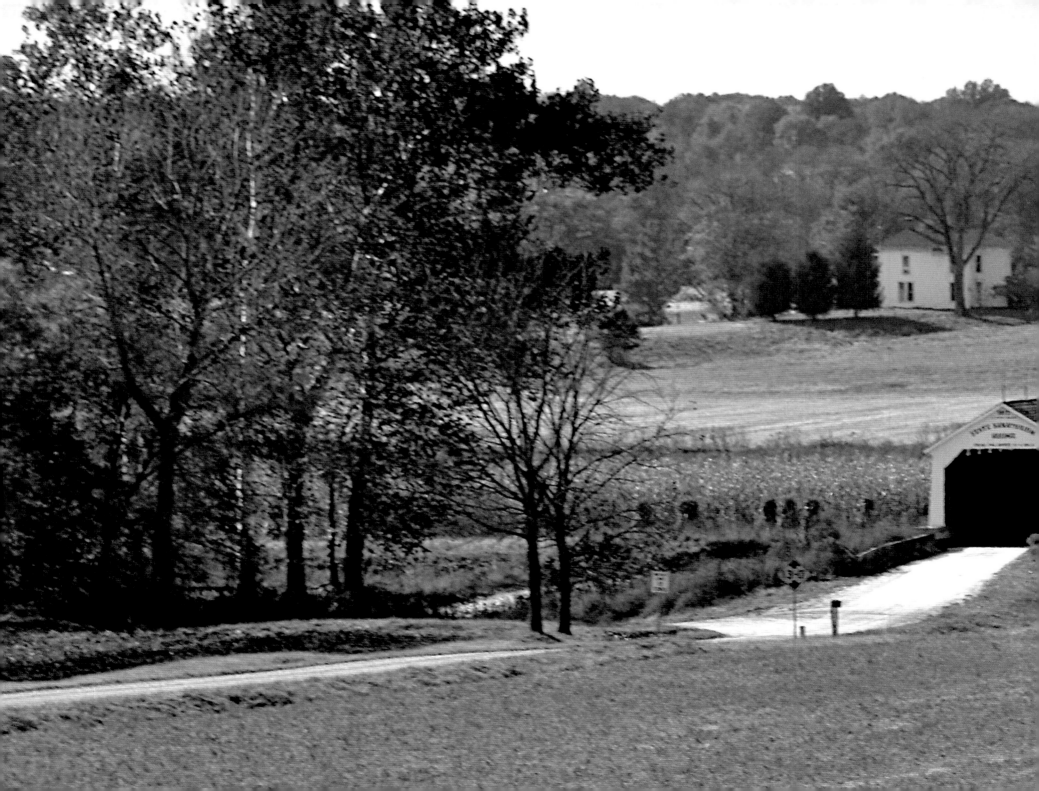

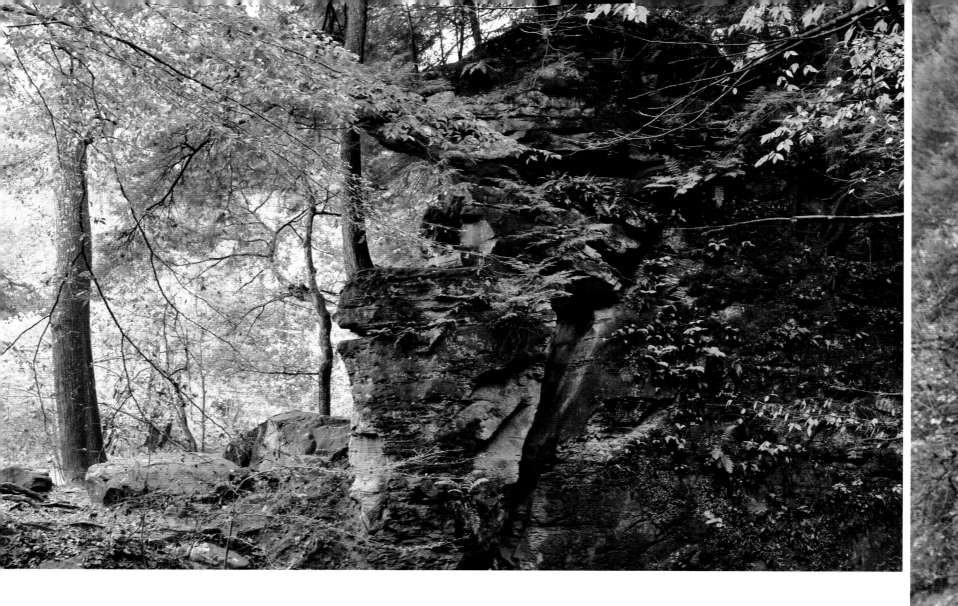

TURKEY RUN STATE PARK *(above)*

TURKEY RUN STATE PARK AND SUGAR CREEK *(facing)*

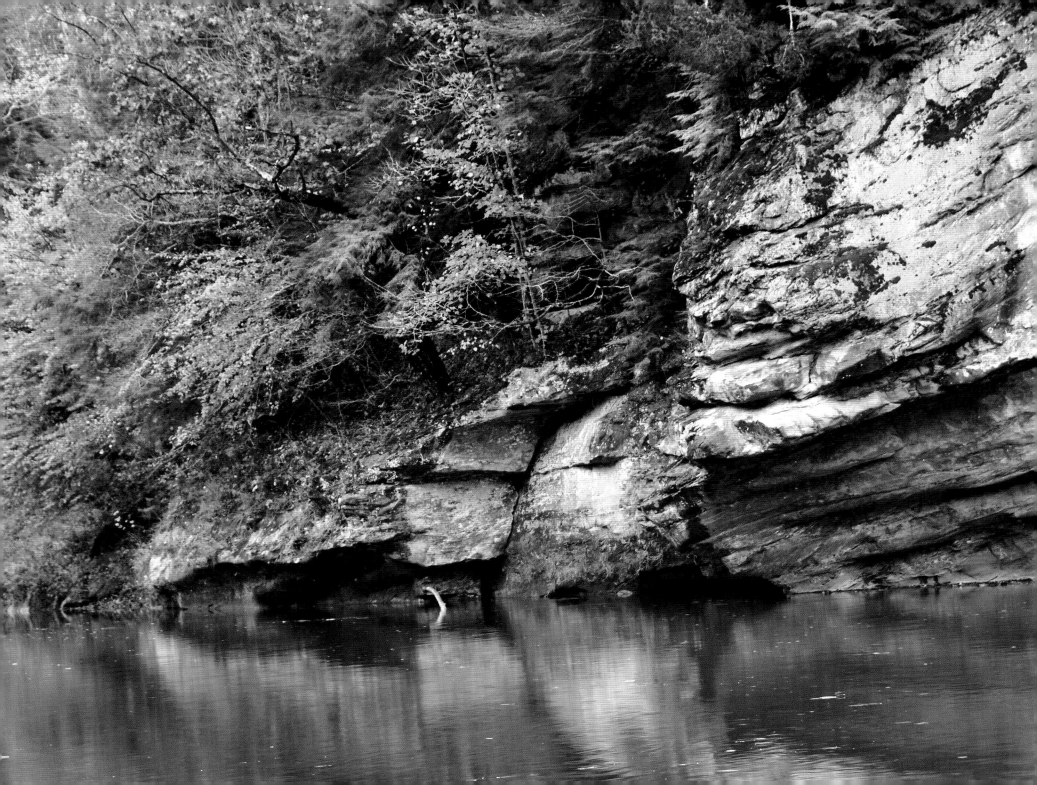

Our county, normally a quiet, thinly populated patch of winding back roads, cornfields, and small burgs, attracts visitors like moths to lamplight this time of year. It is a disruption to the peace we normally have here, but one that is necessary for the money it injects into the rural veins of our economy.

— A Windy Hill Almanac

PHILLIPS BRIDGE

4

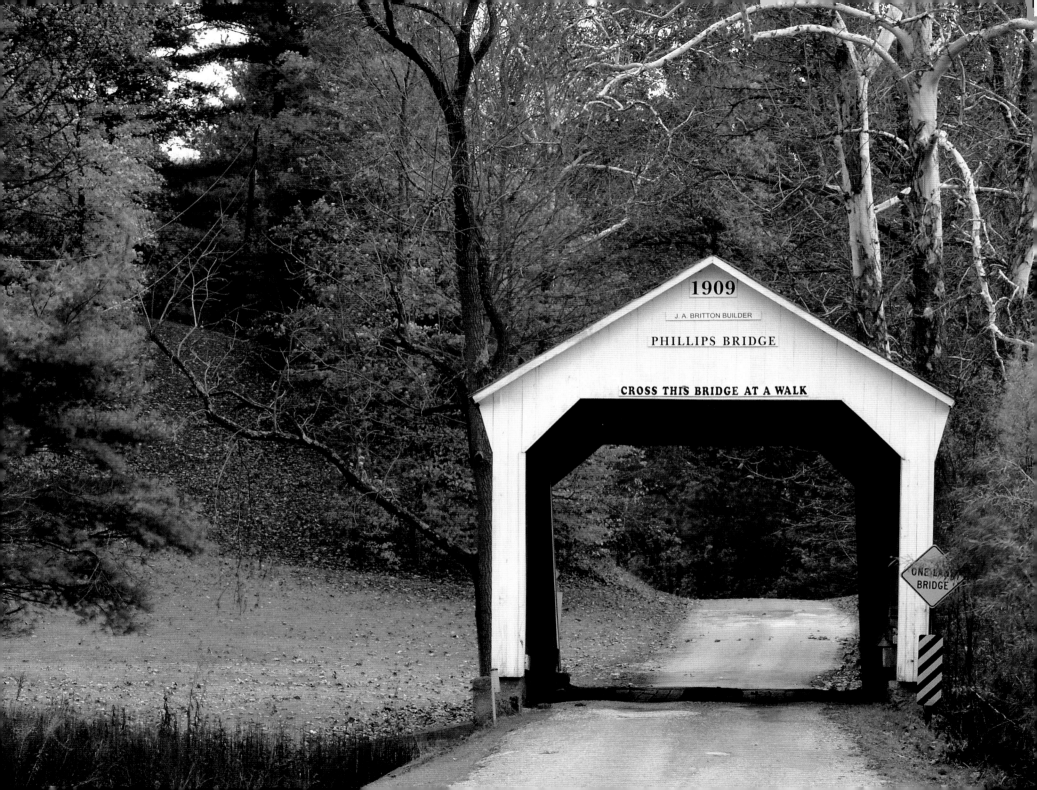

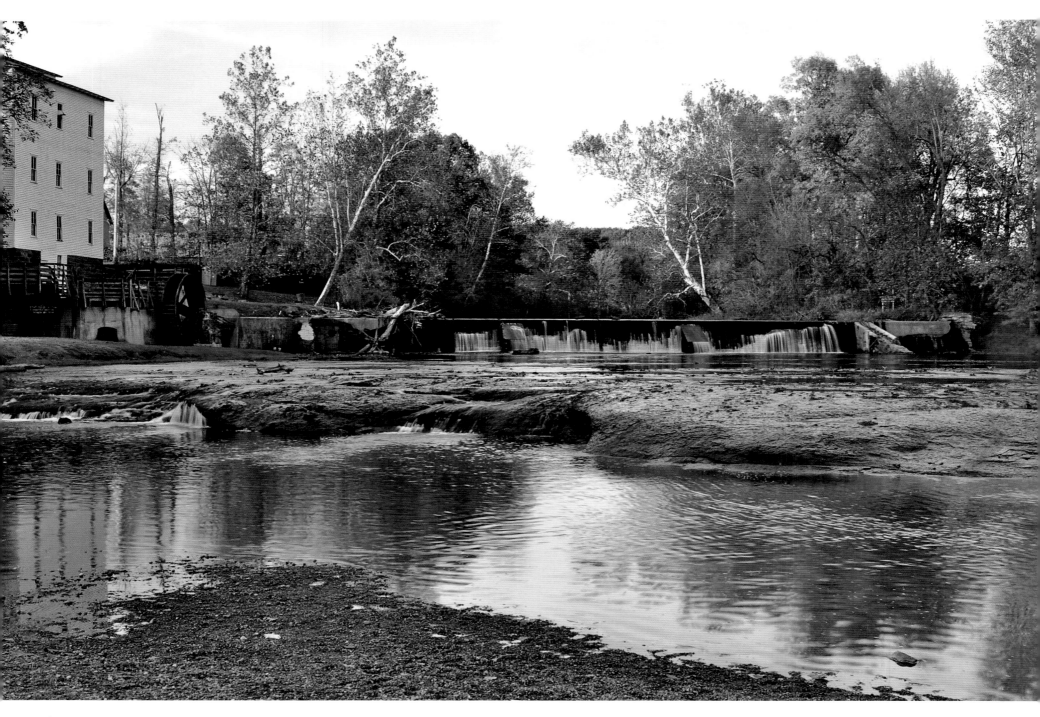

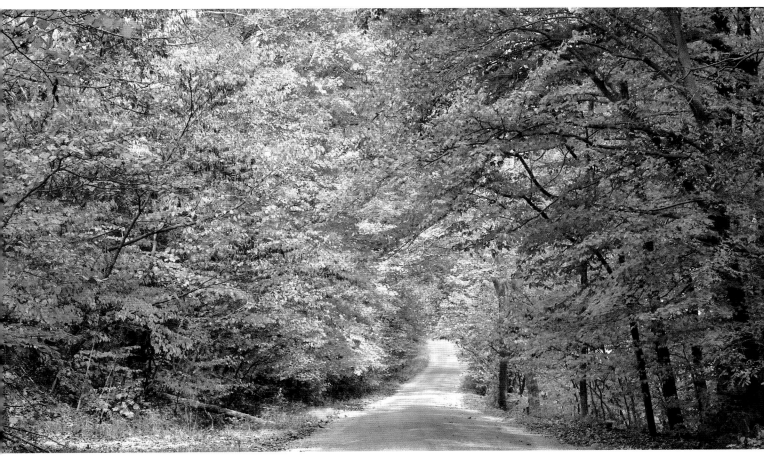

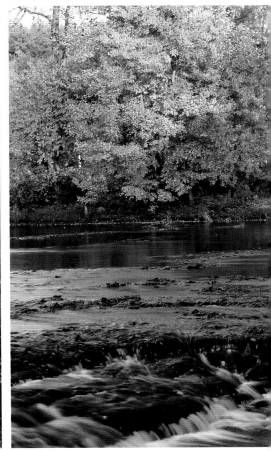

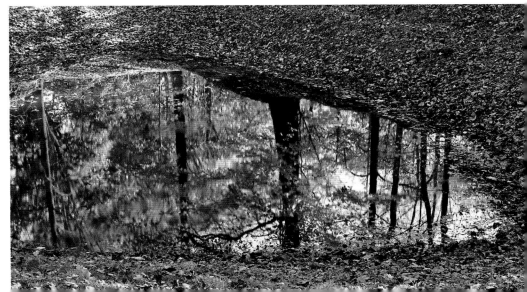

MANSFIELD MILL AND BIG RACCOON CREEK *(facing)*

ROAD NEAR MONTEZUMA *(above)*

BIG RACCOON CREEK *(right, top)*

WESTERN PARKE COUNTY *(right, bottom)*

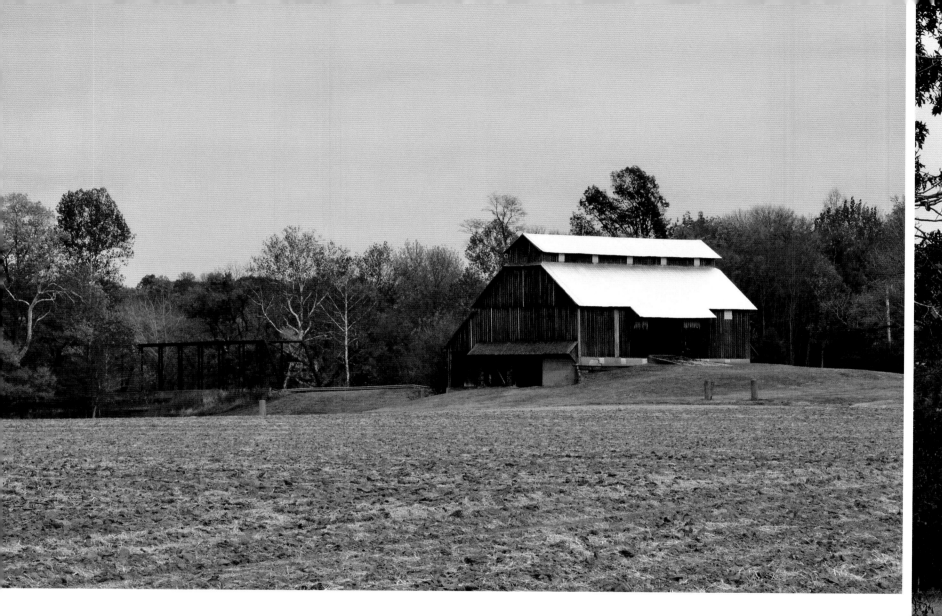

NEAR BRIDGETON

RURAL WABASH VALLEY SCENE *(facing)*

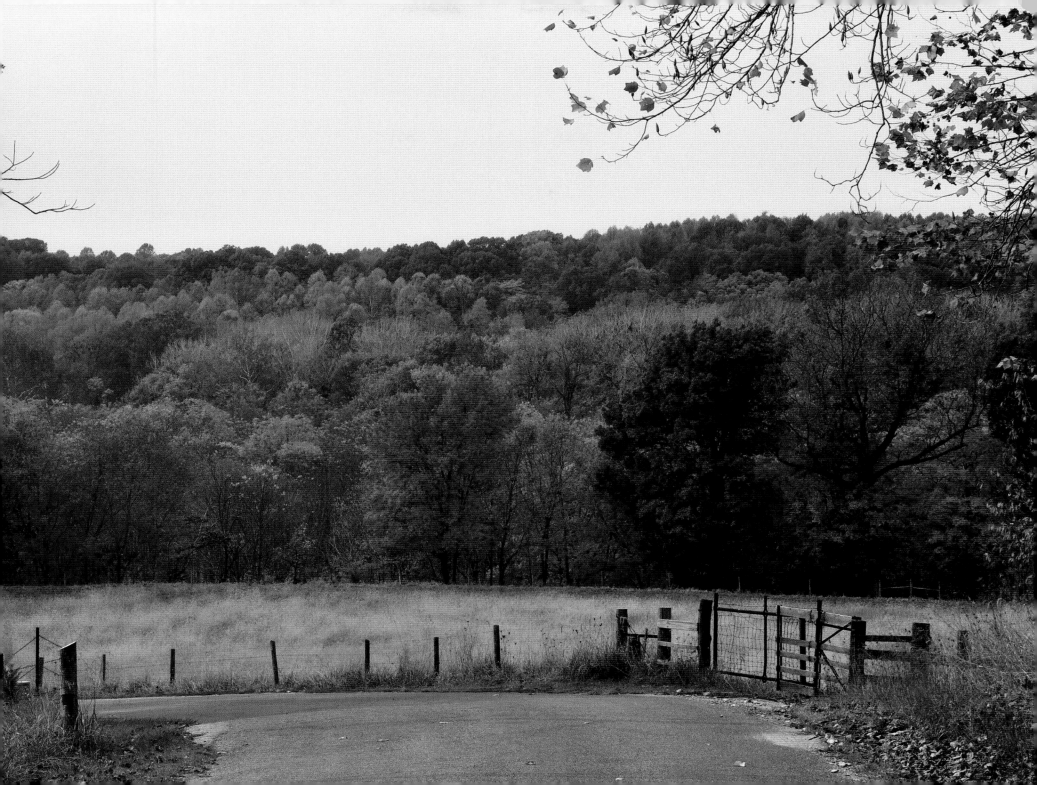

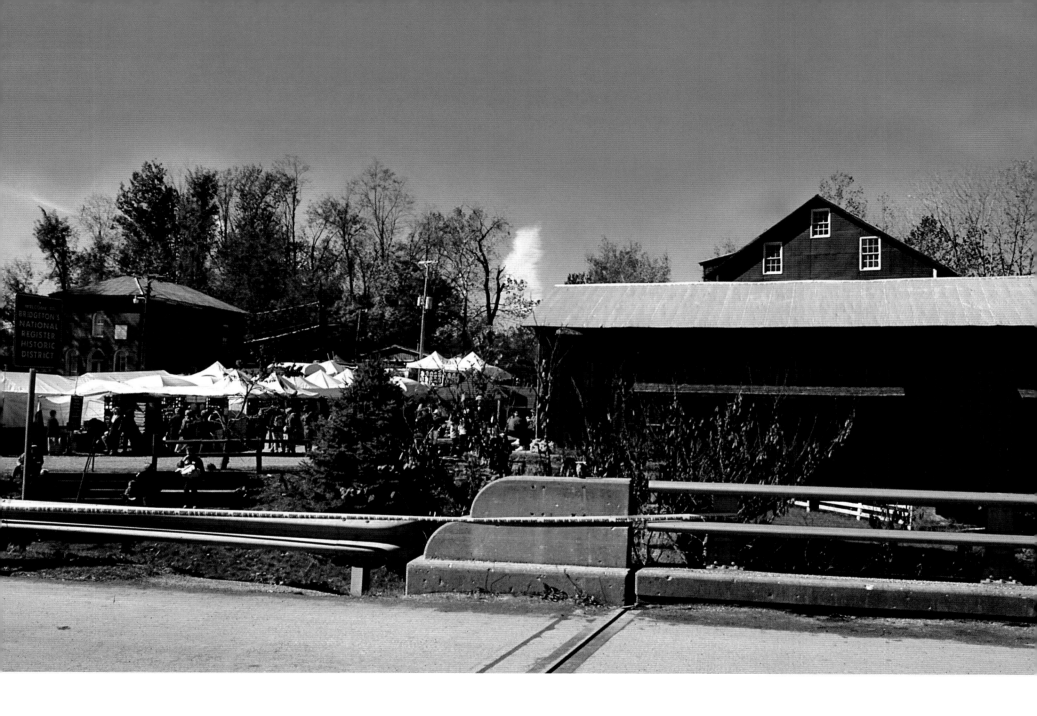

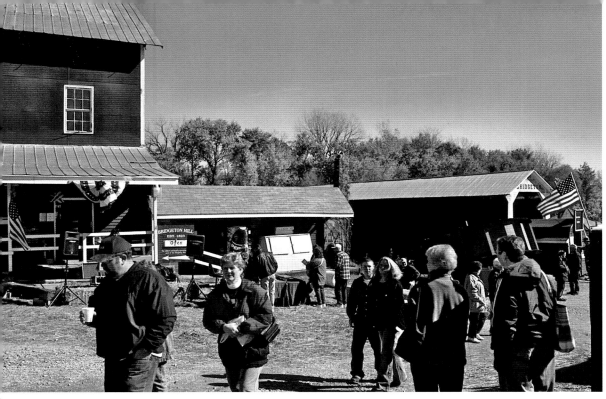

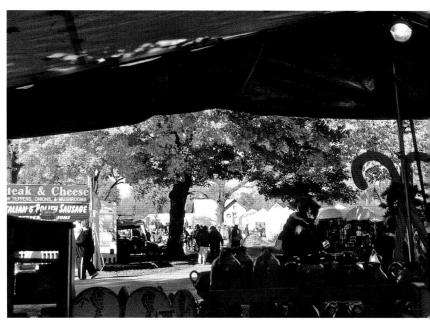

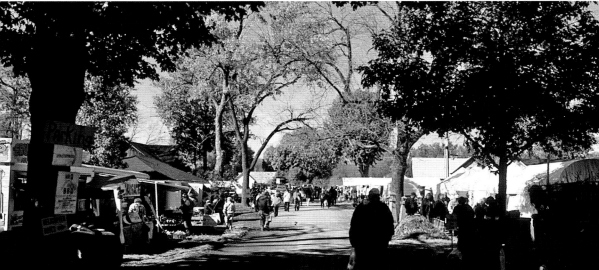

COVERED BRIDGE FESTIVAL IN BRIDGETON

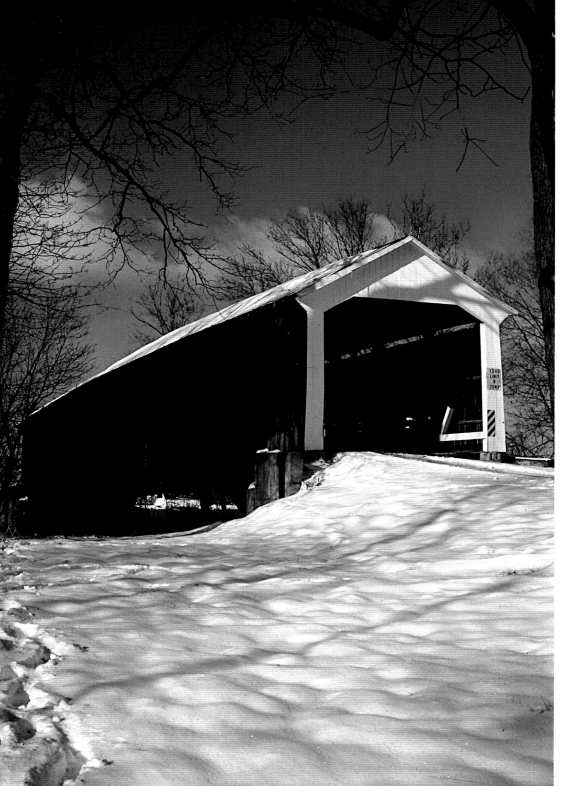

MCALLISTER BRIDGE

CAITLIN BRIDGE *(facing)*

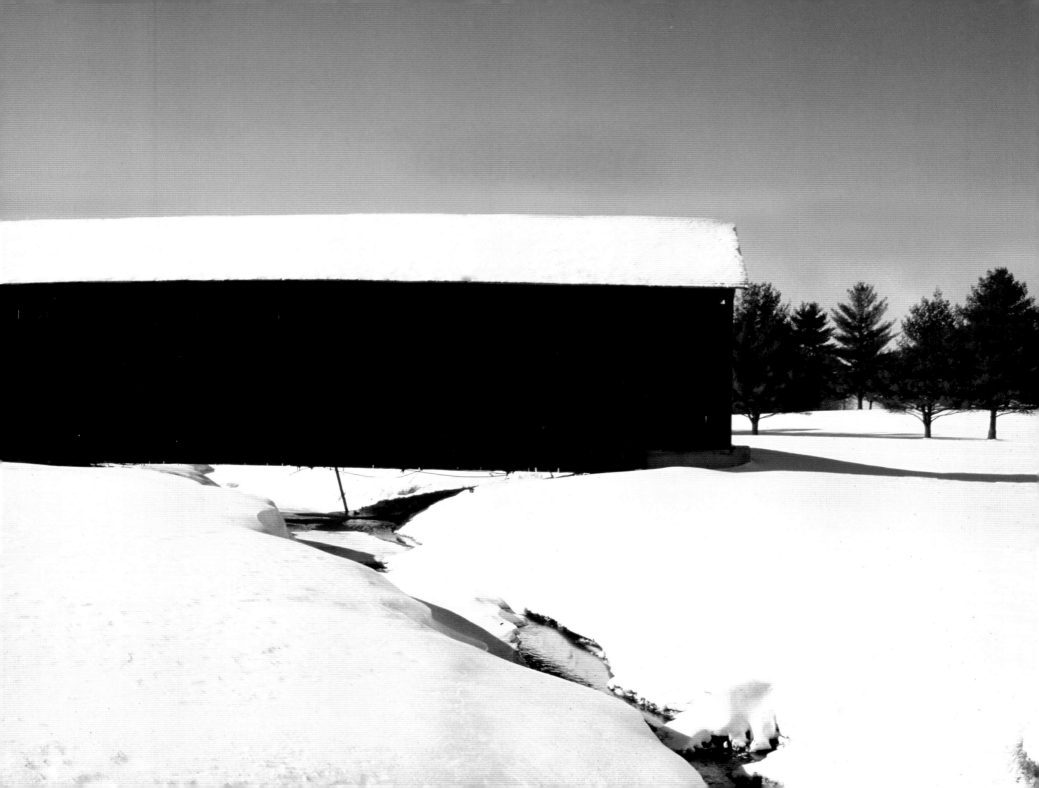

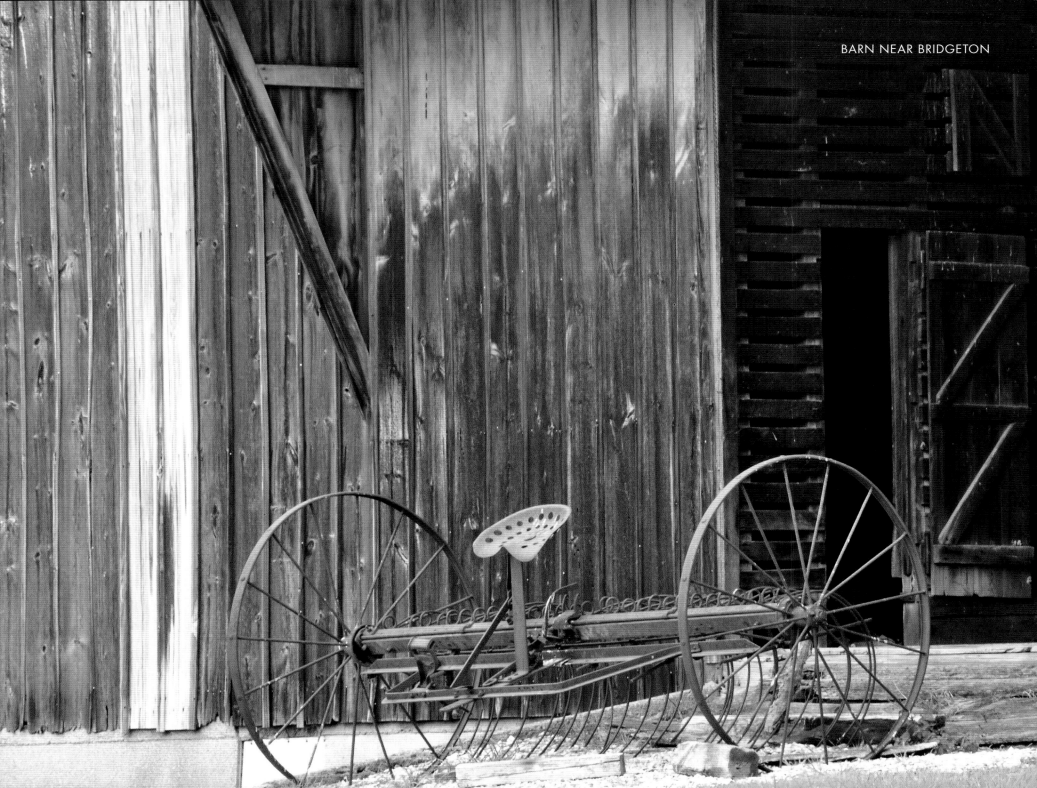

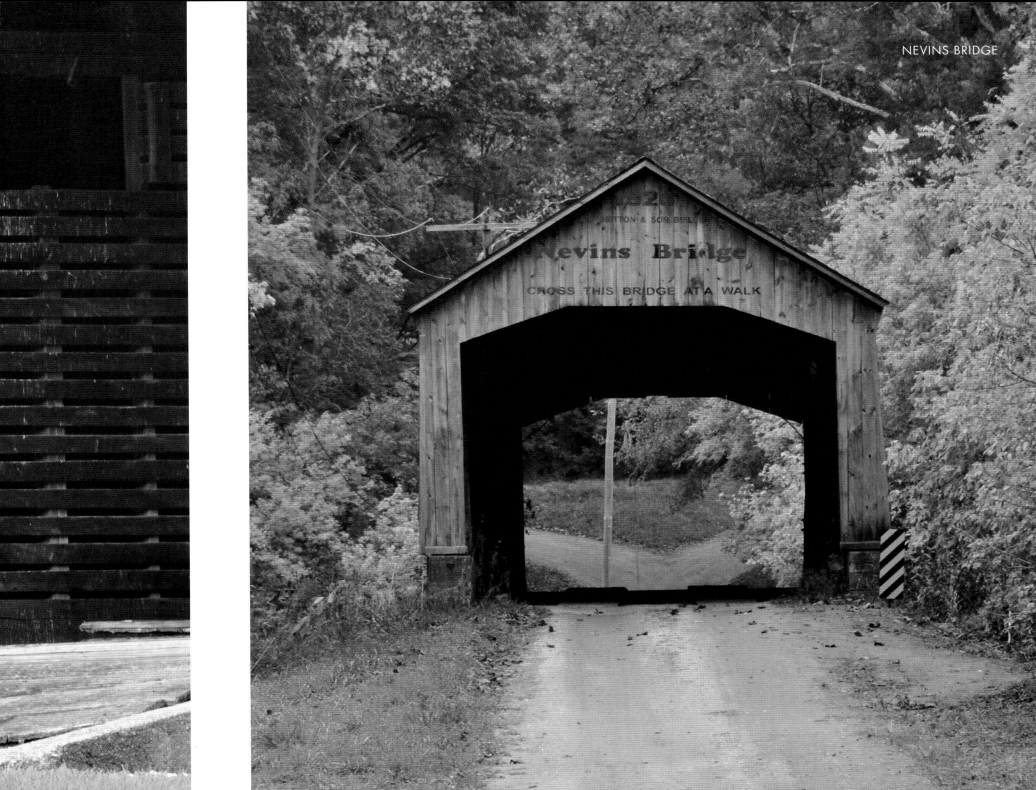

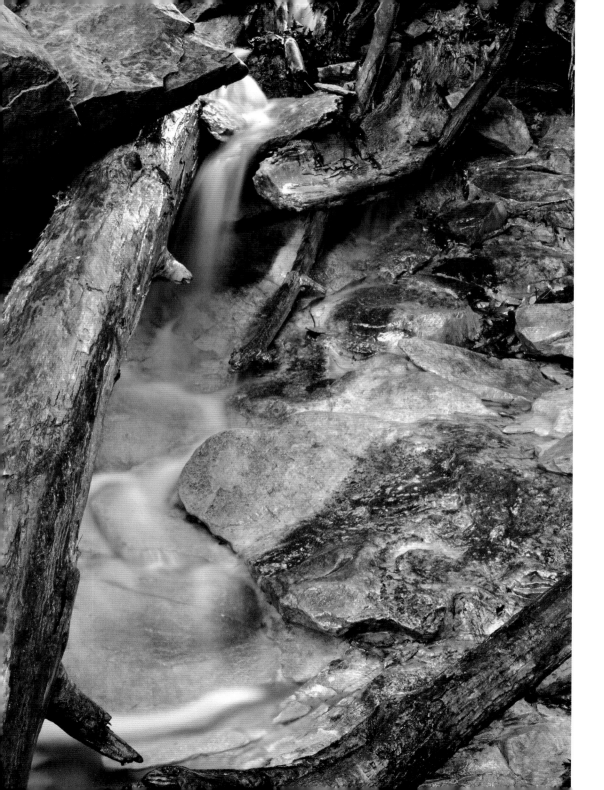

It has been said
that science knows less
about what goes on
in the dirt under our
own feet than it does
about the far reaches
of deep space.
I guess that's true
because we've always
been taught to keep
our heads up,
rather than down.

—A Windy Hill Almanac

SHADES STATE PARK

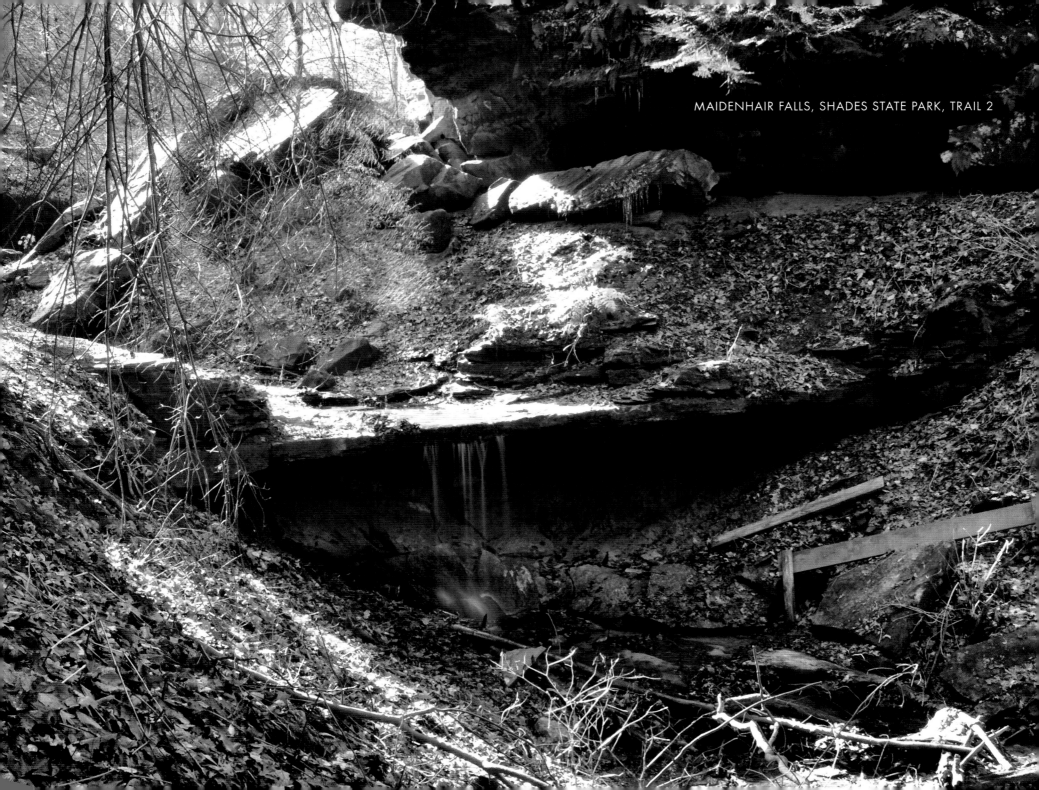

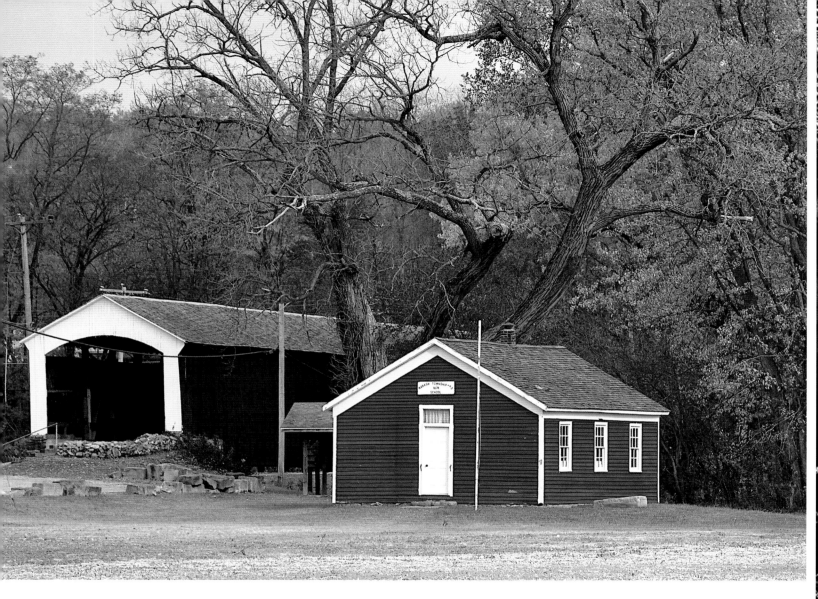

MECCA BRIDGE AND SCHOOLHOUSE

RUSH CREEK BRIDGE *(facing)*

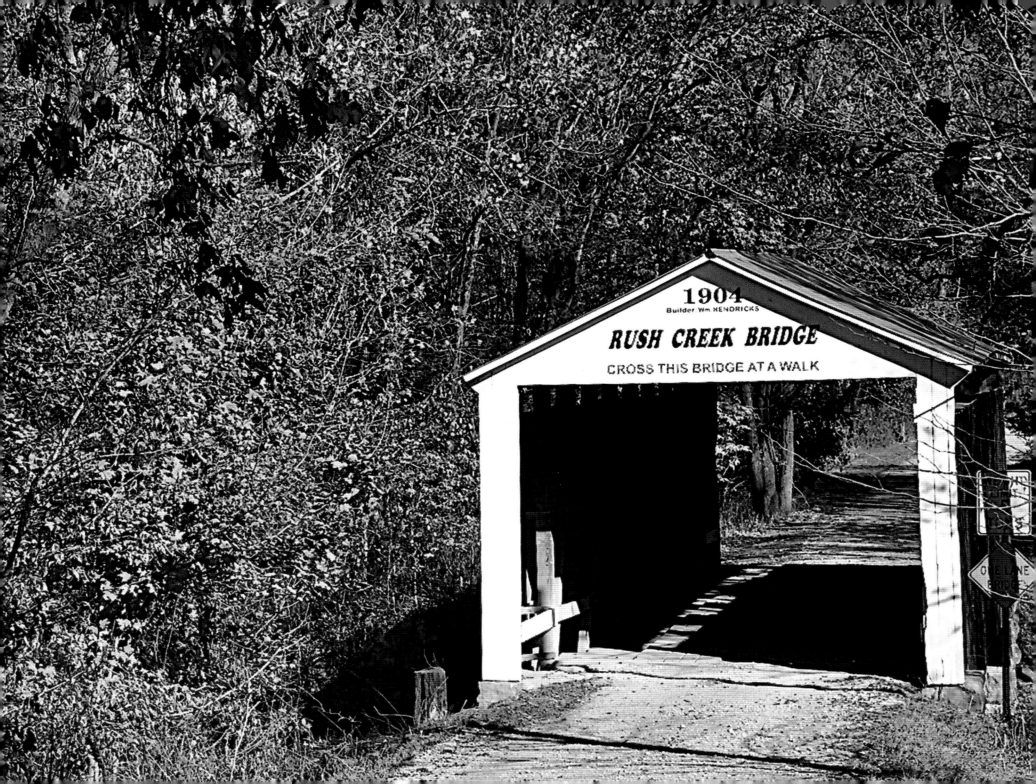

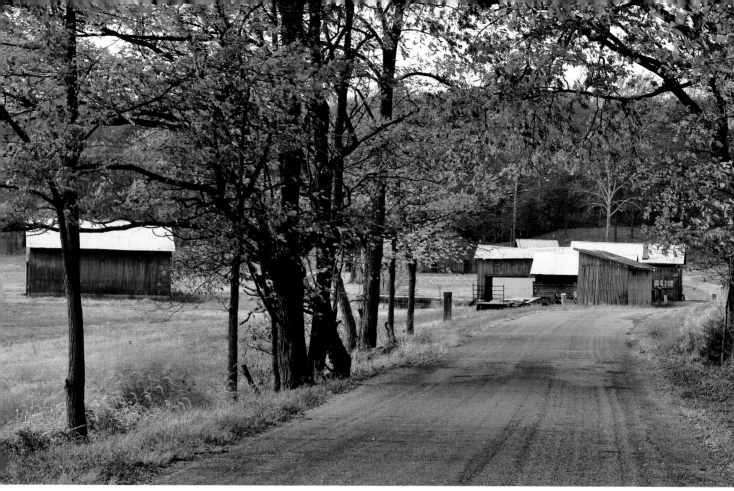

RURAL SCENE NEAR BRIDGETON
(above)

BARN NEAR ANNAPOLIS *(right)*

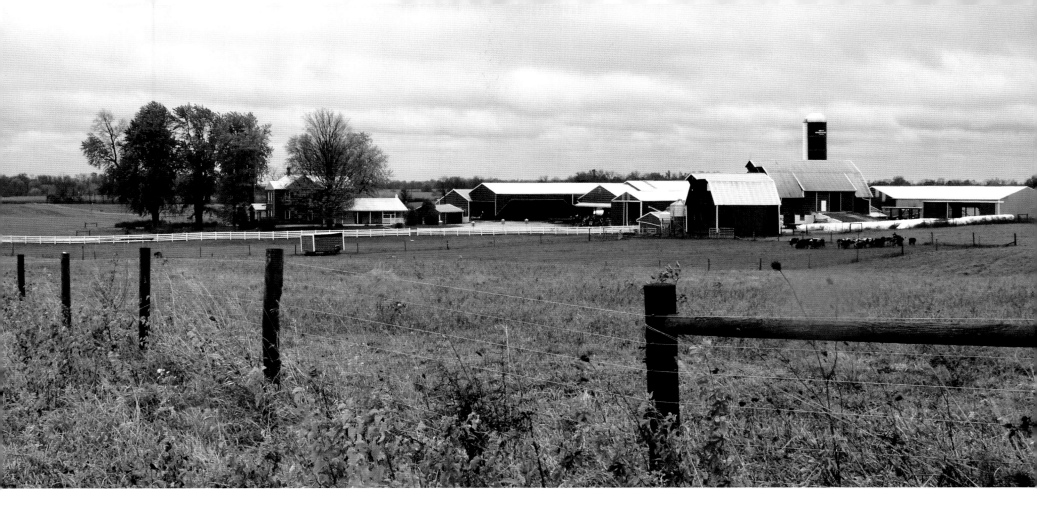

Every so often, I think we should take wonder in everyday things,

in the ordinary, in the commonplace, and the undistinguished.

—A Place Near Home

AMISH FARM AND
DISTANT BYRON CHURCH

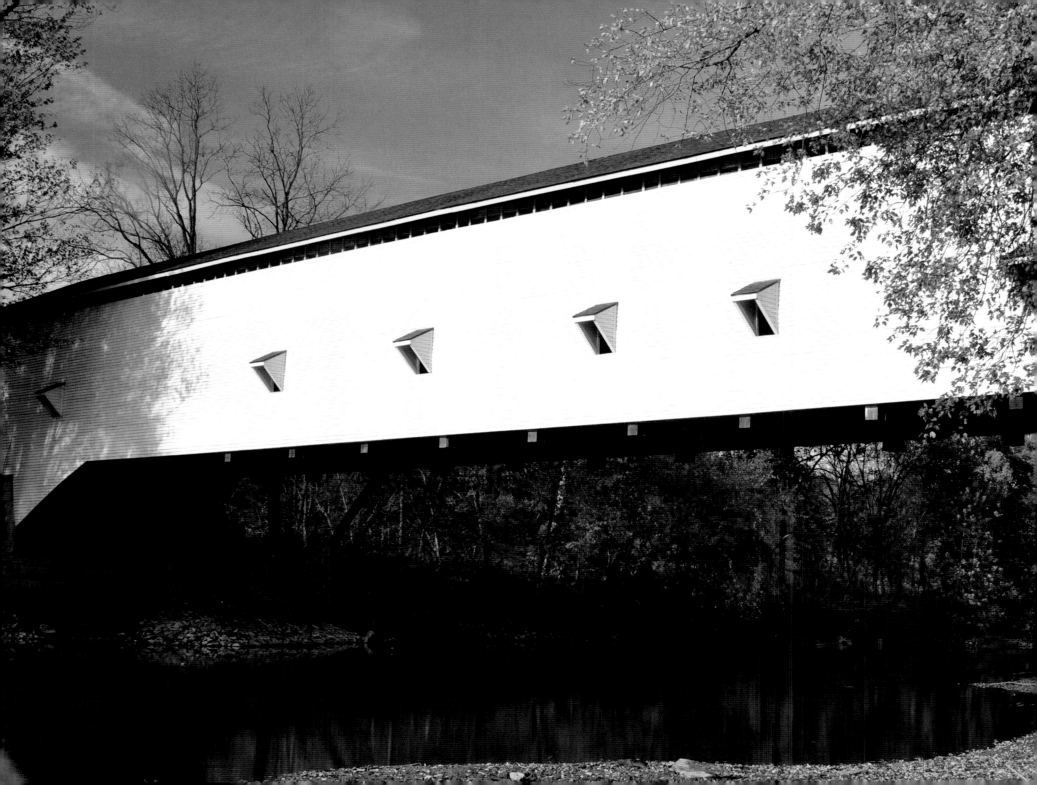

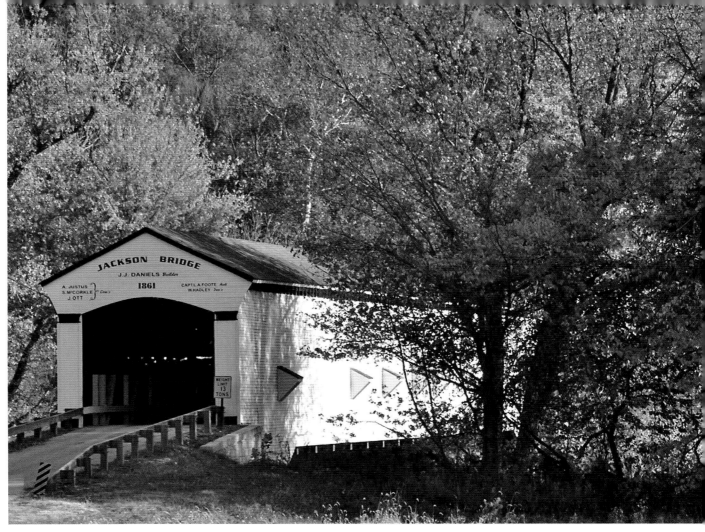

JACKSON BRIDGE (above)

JACKSON BRIDGE, CROSSING SUGAR CREEK (facing)

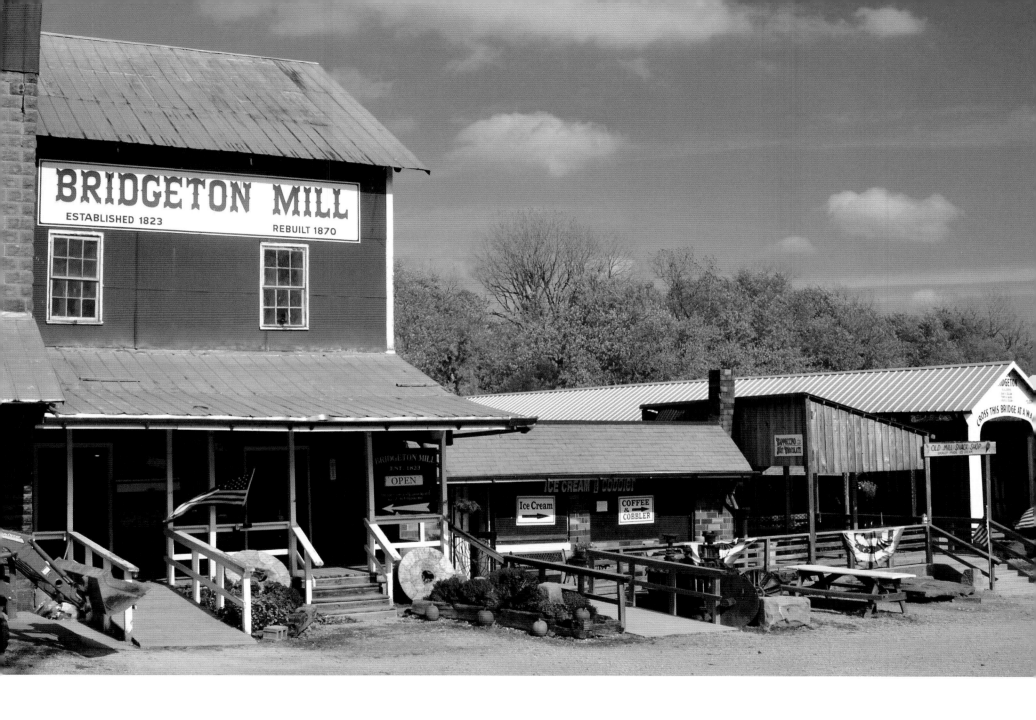

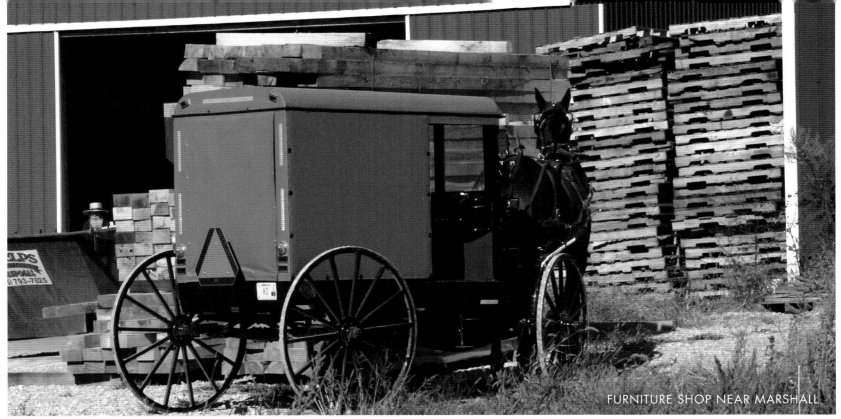
FURNITURE SHOP NEAR MARSHALL

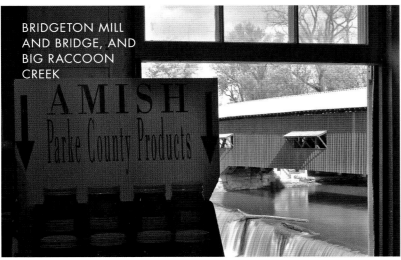
BRIDGETON MILL AND BRIDGE, AND BIG RACCOON CREEK

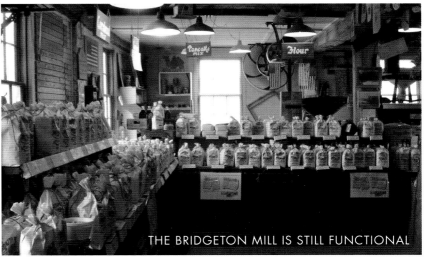
THE BRIDGETON MILL IS STILL FUNCTIONAL

25

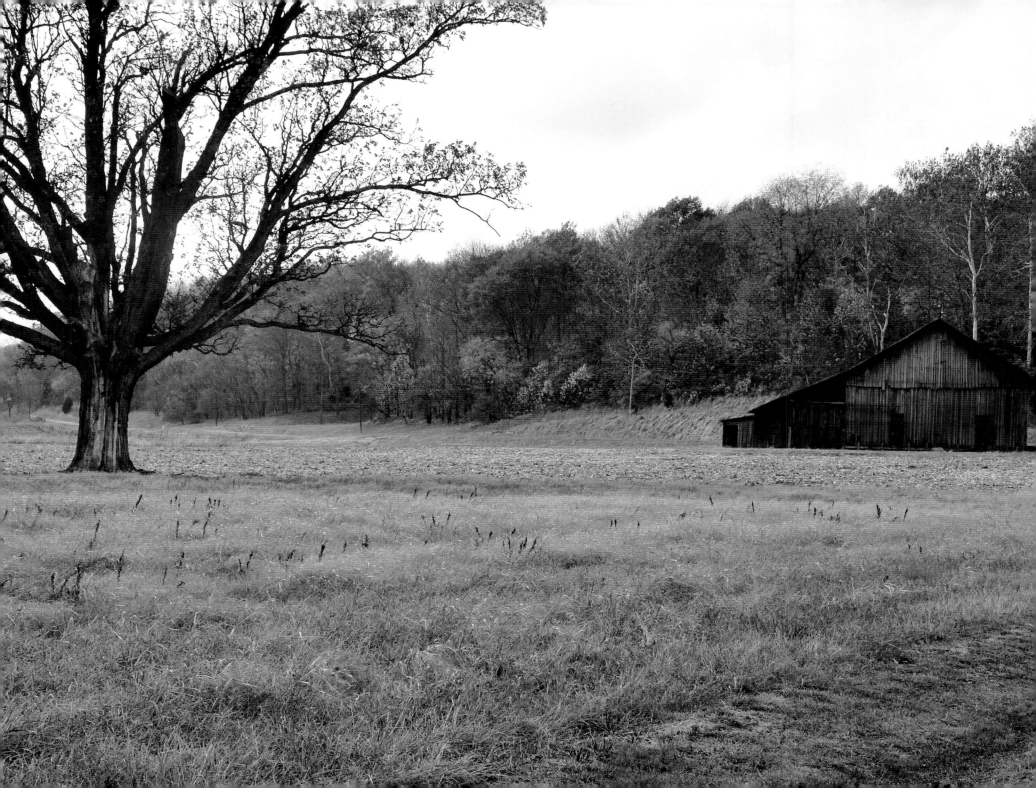

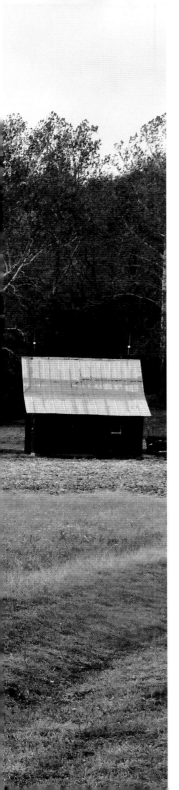

For me, it is now the best time of the year.

The soybeans are turning to bronze, the ivies run red

up tree trunks, and the first phase of fall

is helping us take notice of how beautiful our [woods] are.

I find myself driving slowly on my way home

so I can see our valley change with the days;

I linger before stepping into the house in the evening,

just to get one last glimpse of our trees.

— *A Place Near Home*

RURAL SCENE NEAR BRIDGETON

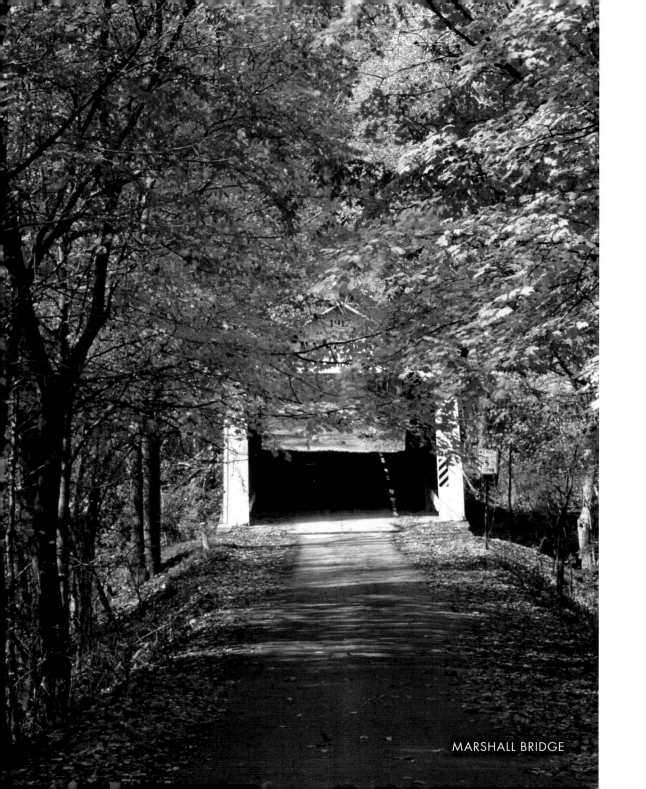

MARSHALL BRIDGE

NORTHERN PARKE COUNTY COLOR

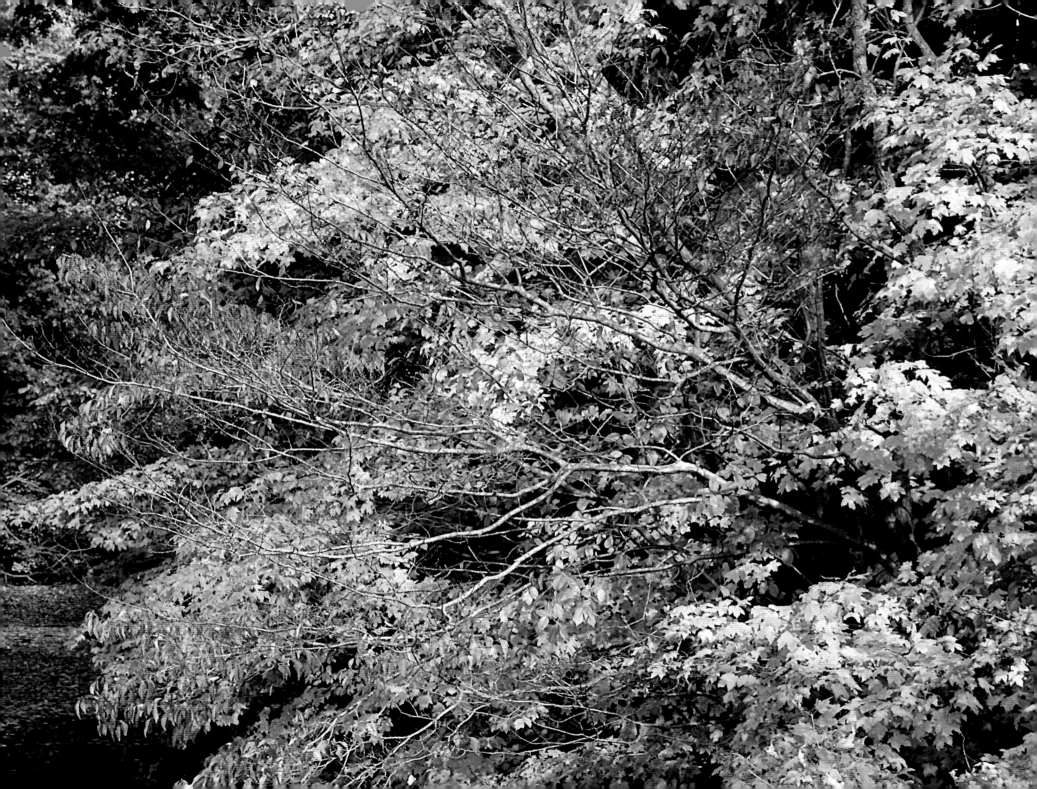

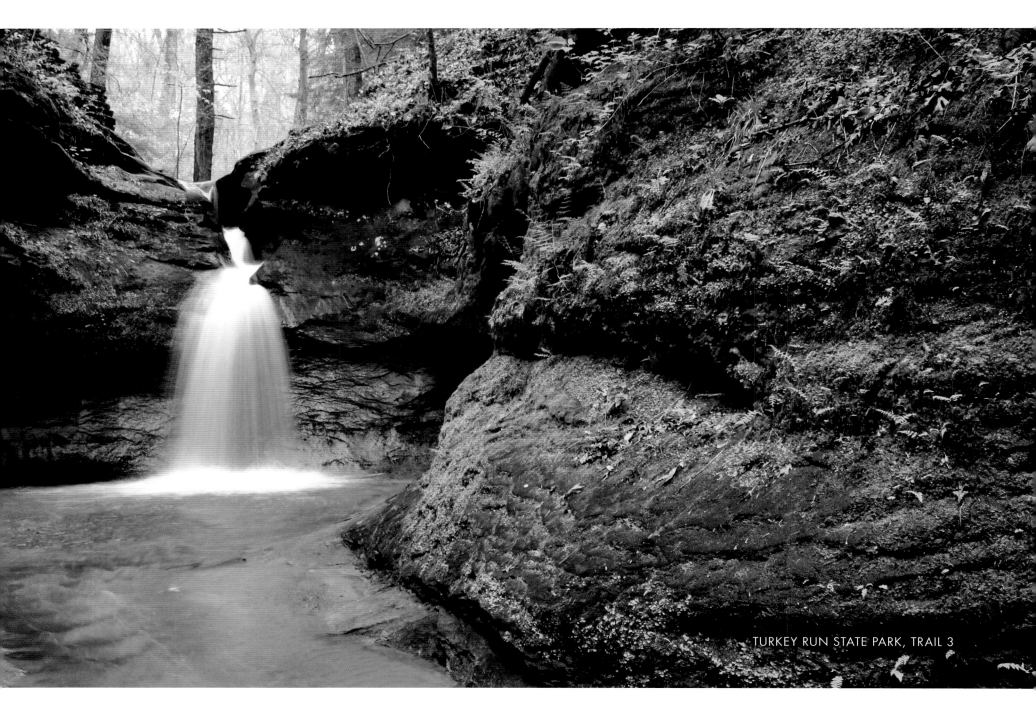

TURKEY RUN STATE PARK, TRAIL 3

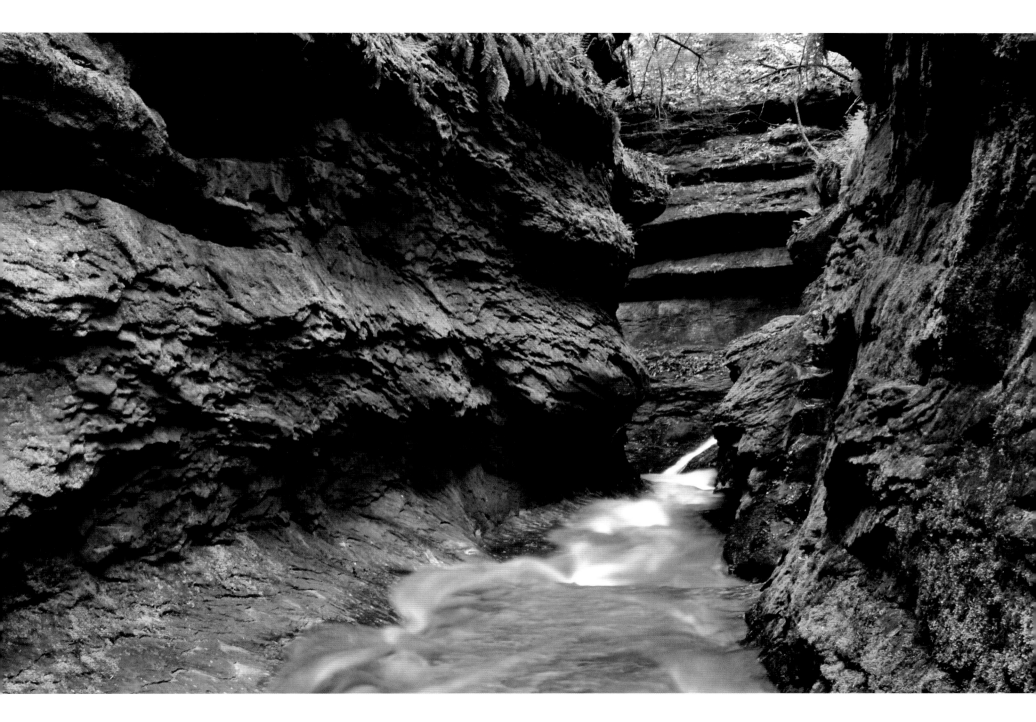

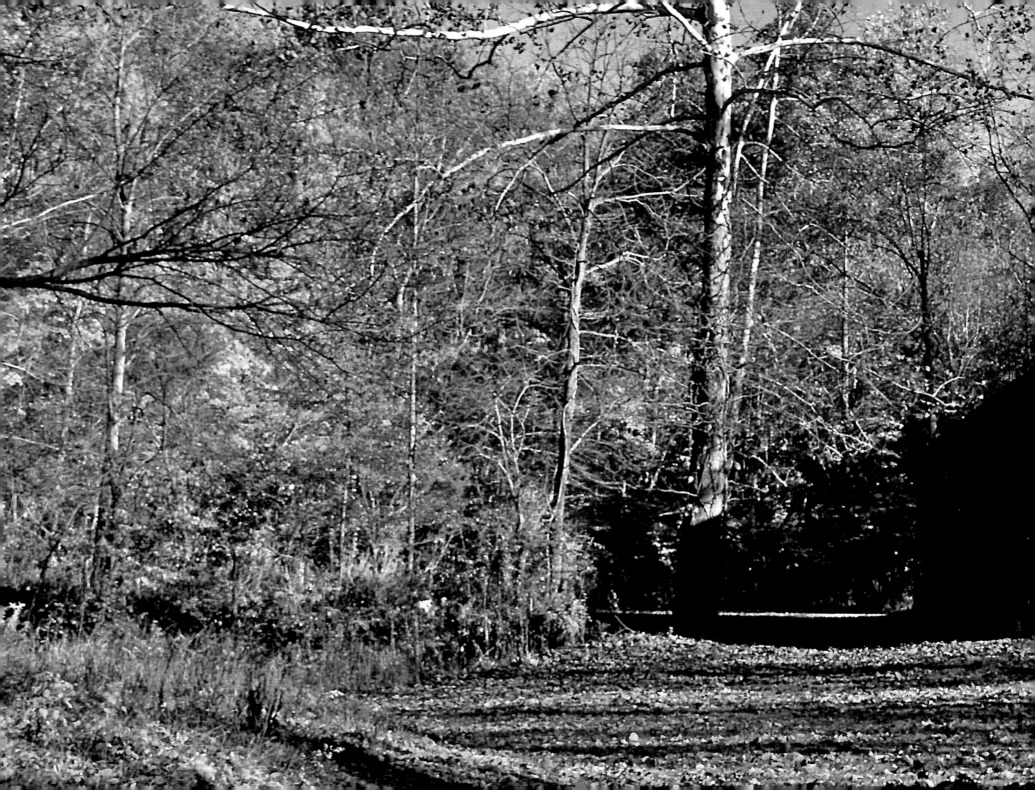

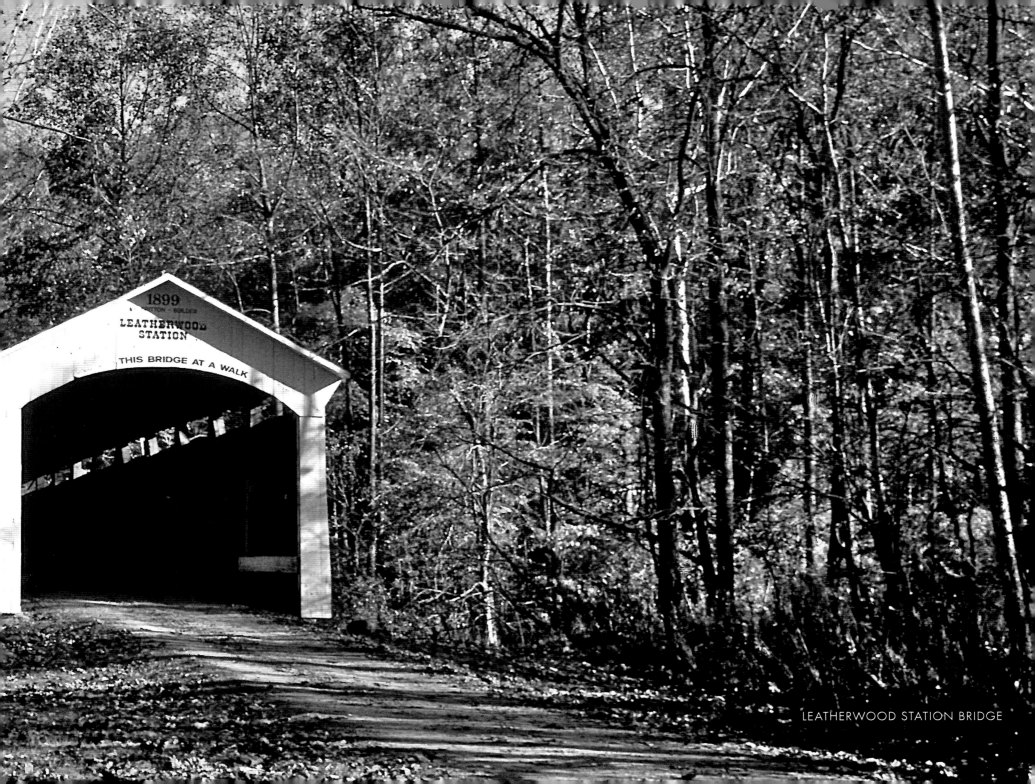

LEATHERWOOD STATION BRIDGE

I used to wonder what attracted all of these people to our county, why they'd fight the traffic and the crowds. . . . They leave towns and air conditioning and online shopping behind to become inspectors of hedge apples and examiners of weeds, and [are awed by] the sight of wooden gates and fading barns. I don't wonder about that anymore, and haven't for a long time.

— A Windy Hill Almanac

SUGAR CREEK, NEAR GRANGE CORNER

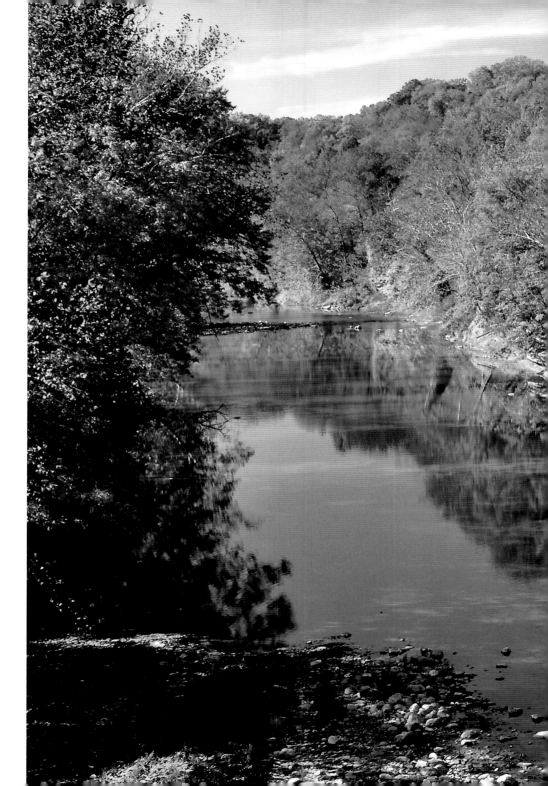

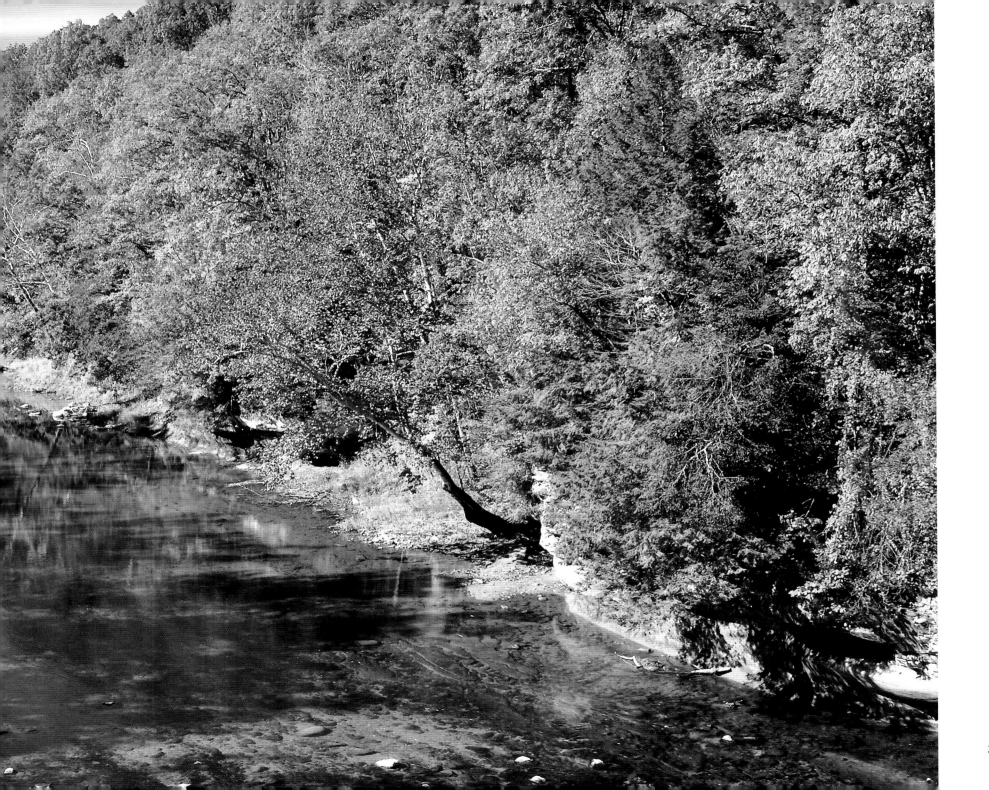

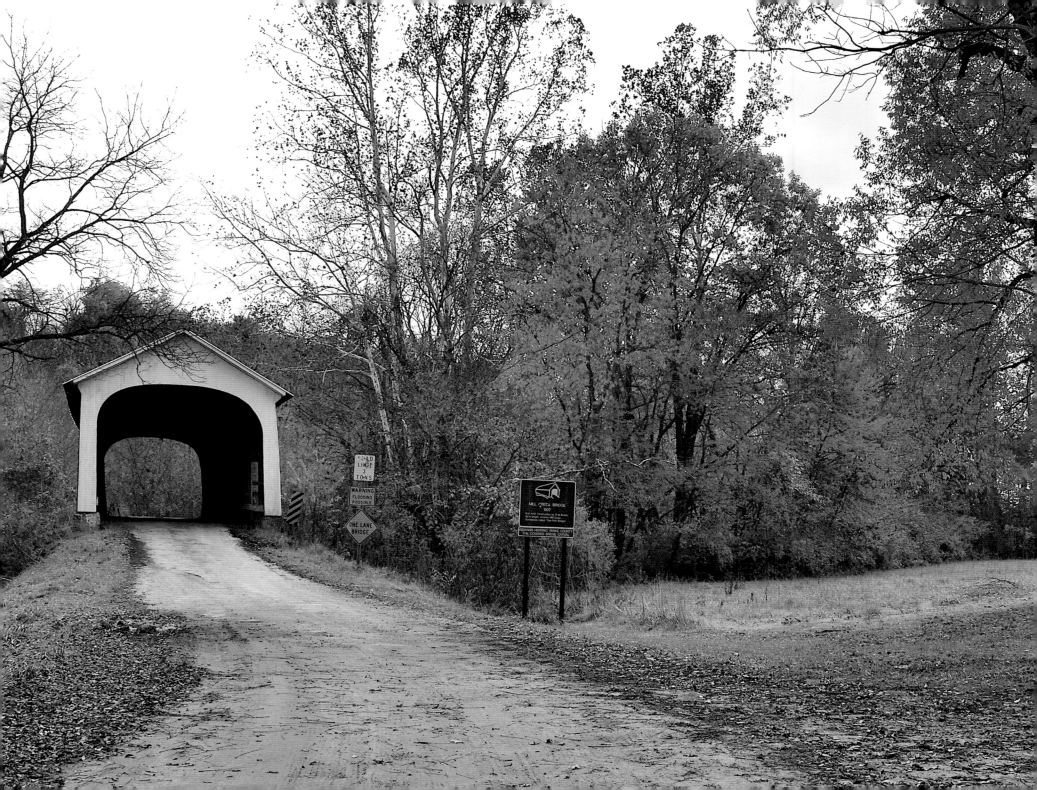

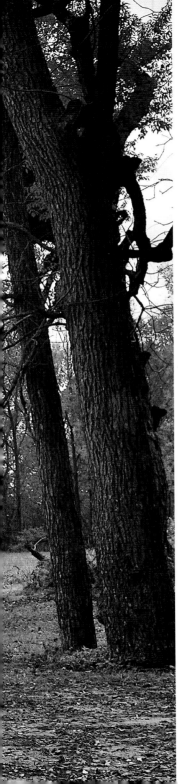
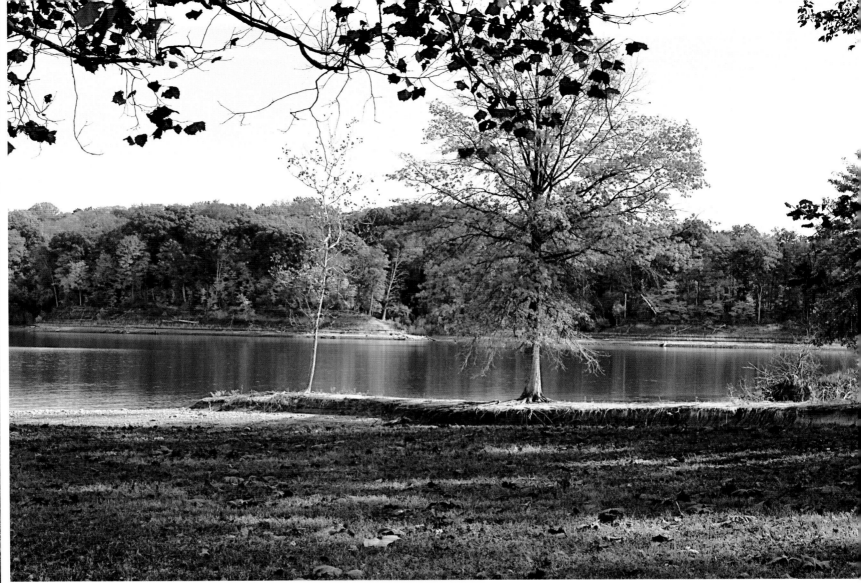

RACCOON LAKE STATE RECREATION AREA

MILL CREEK BRIDGE *(facing)*

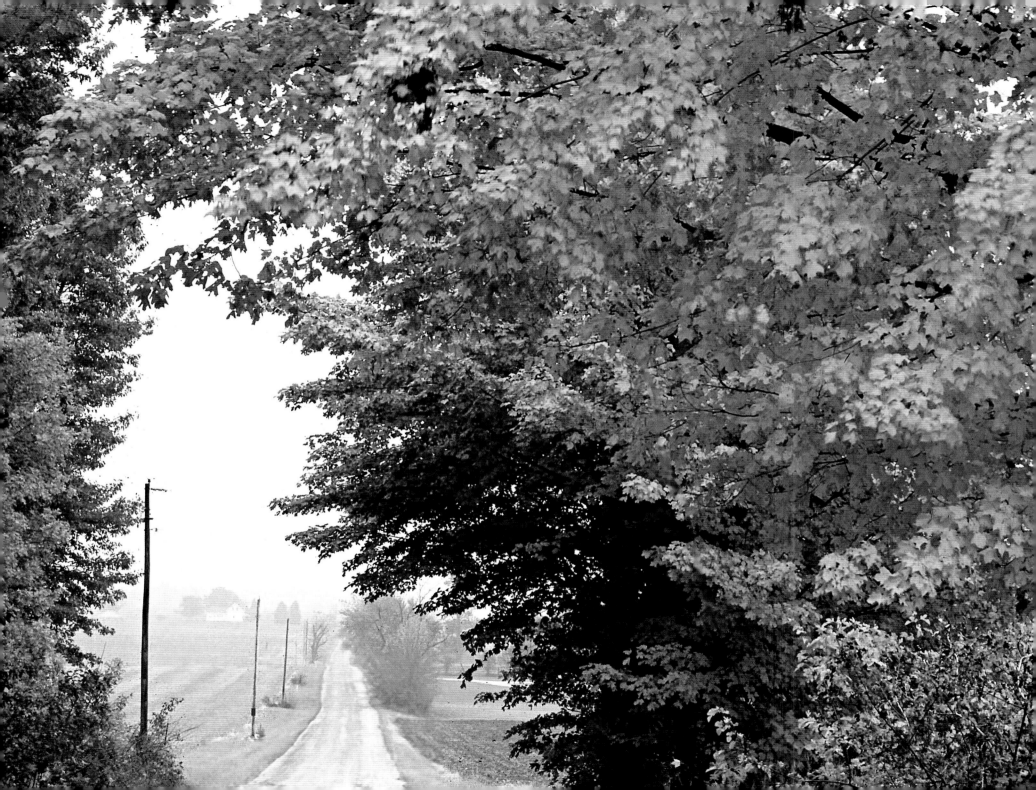

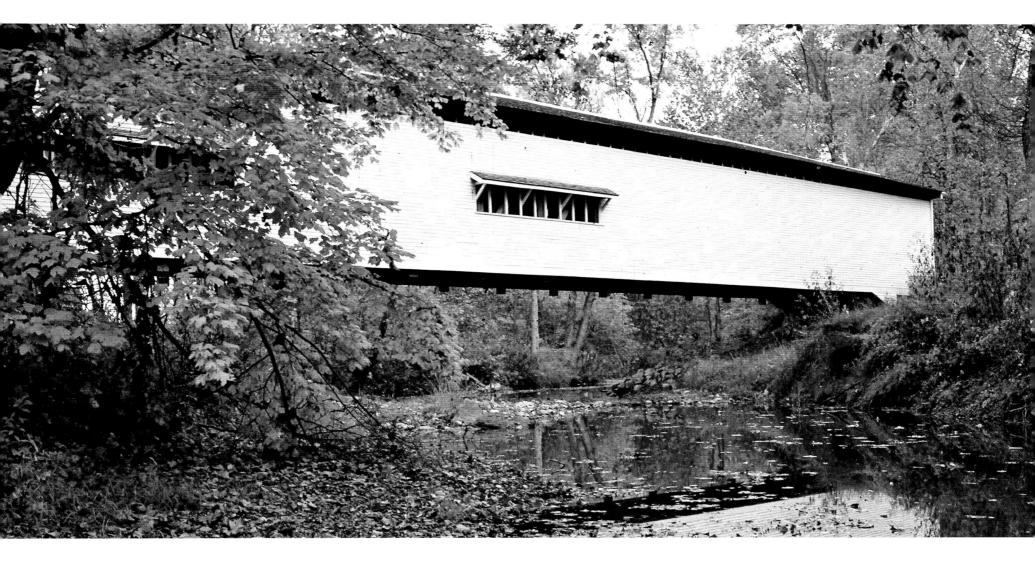

PORTLAND MILLS BRIDGE, CROSSING LITTLE RACCOON CREEK

RURAL SCENE NEAR BYRON *(facing)*

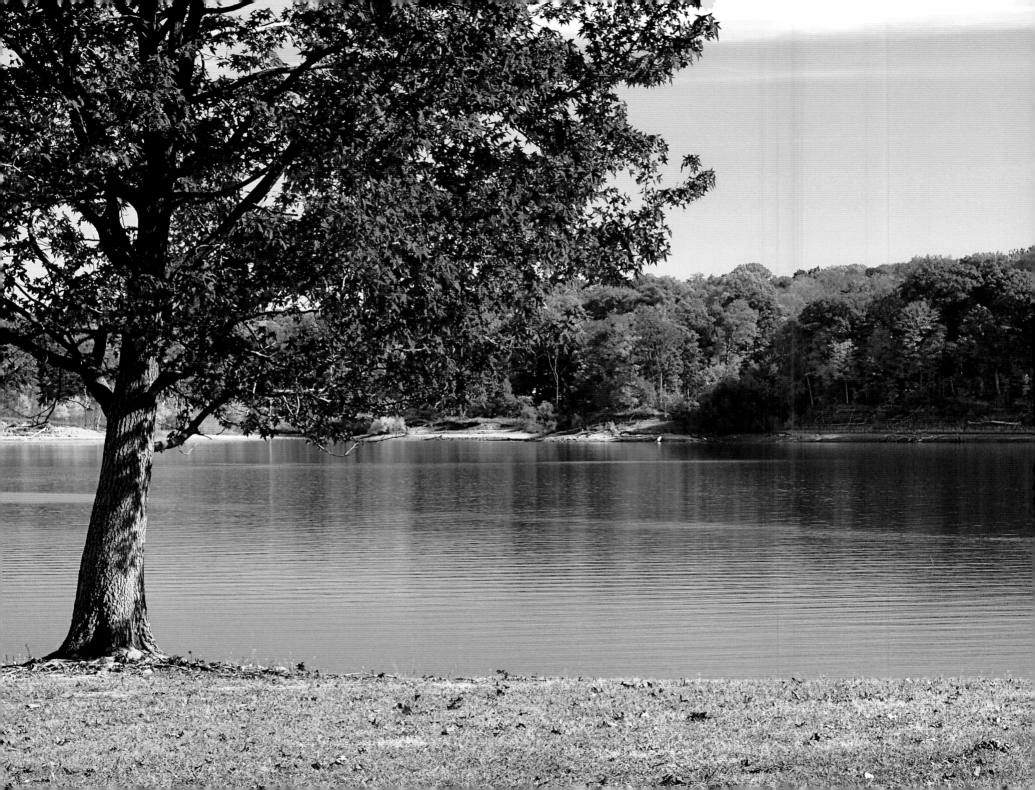

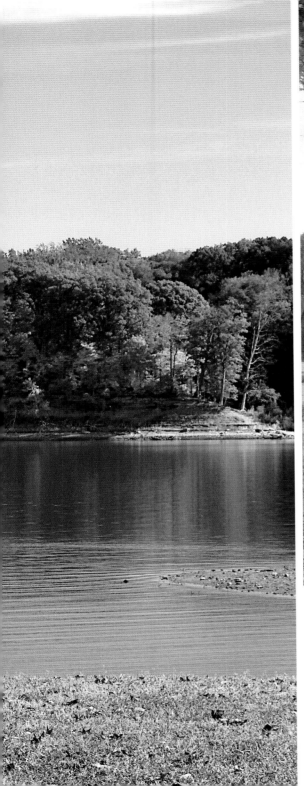

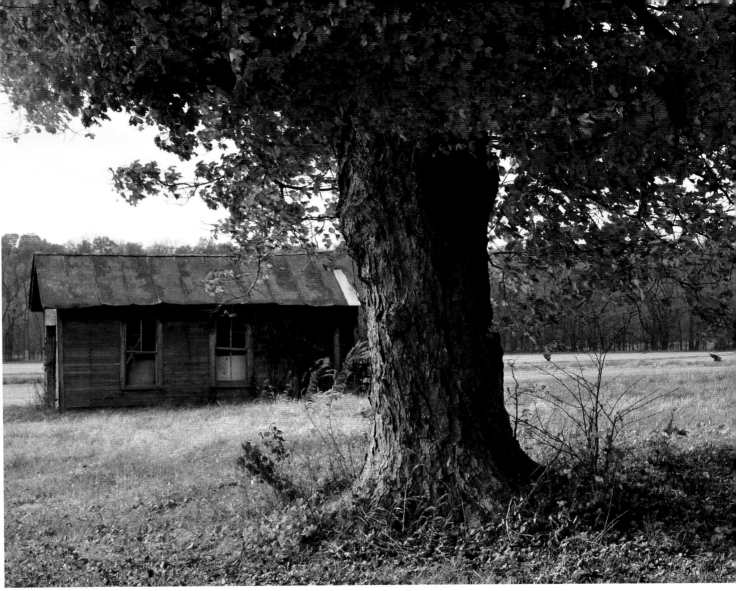

NEAR BRIDGETON

RACCOON LAKE STATE RECREATION AREA *(facing)*

41

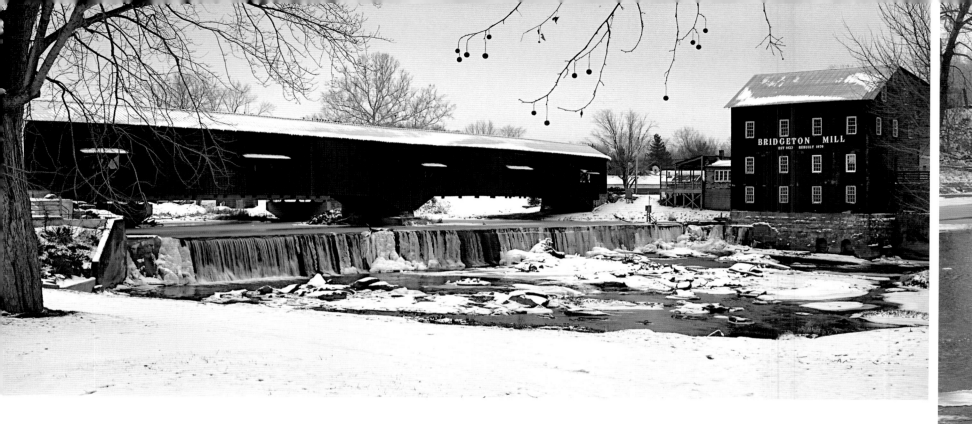

The poet David Budbill reminds us that winter is "the best time" to discover who we are. In the "Quiet, contemplation time / away from the rushing world" we can find our "inner landscape."

—The Long Goodbye to Winter

BRIDGETON BRIDGE AND MILL, CROSSING BIG RACCOON CREEK

MANSFIELD BRIDGE, CROSSING BIG RACCOON CREEK *(facing)*

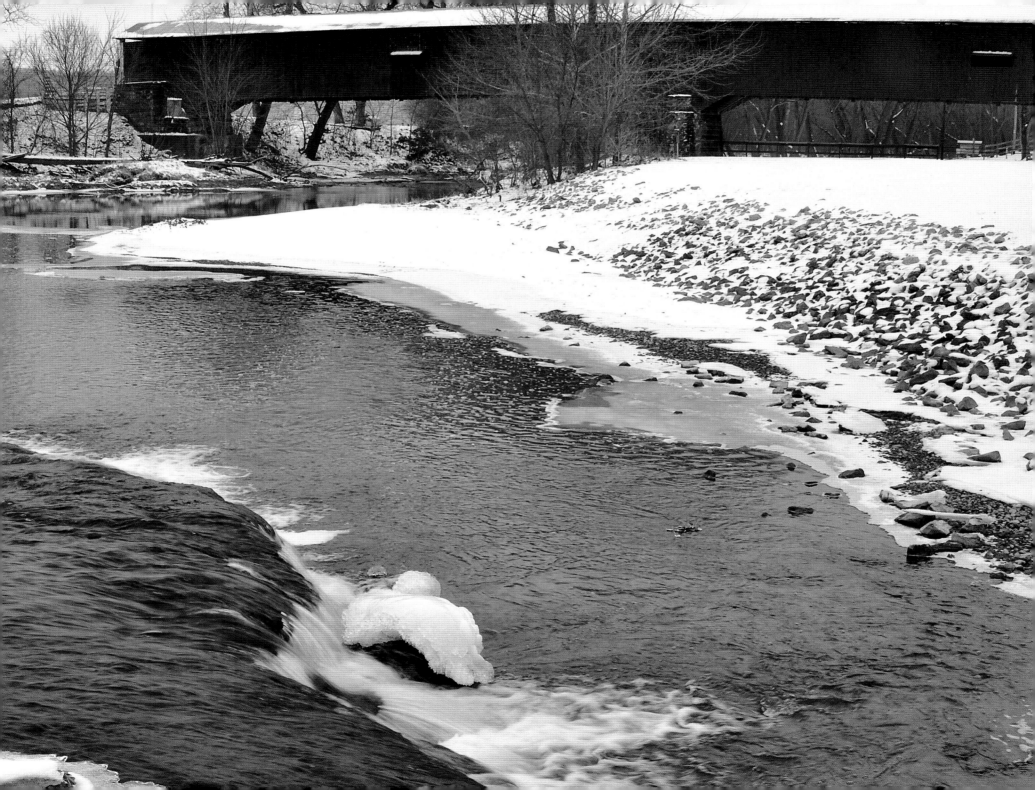

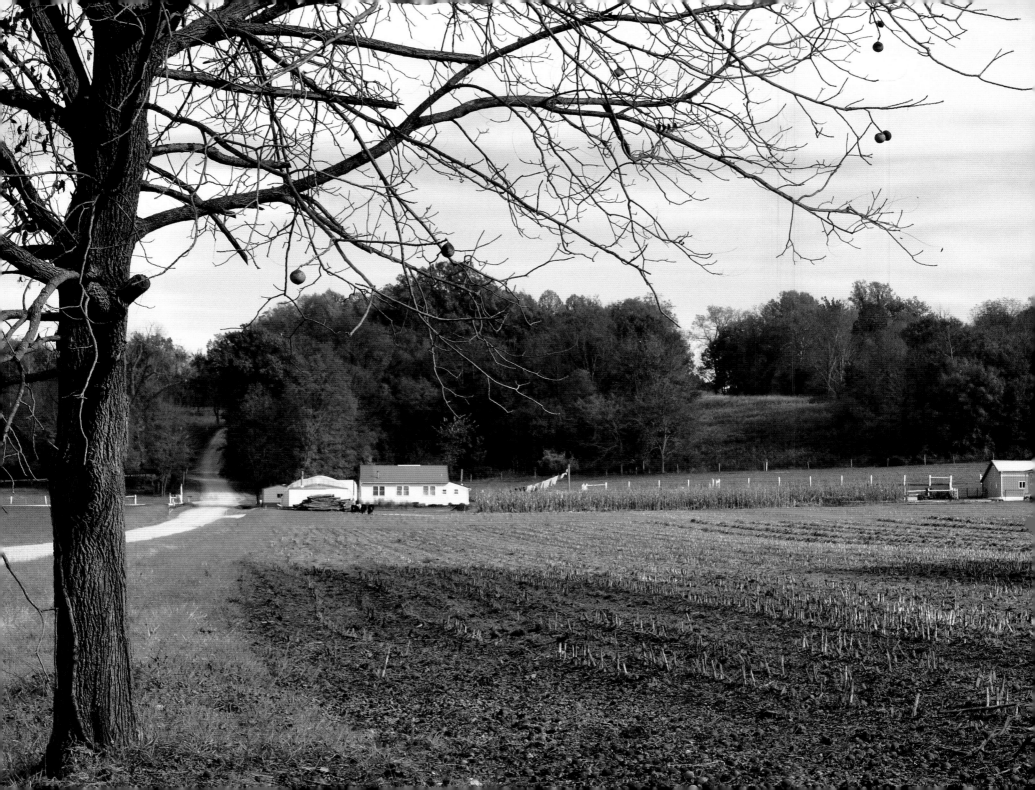

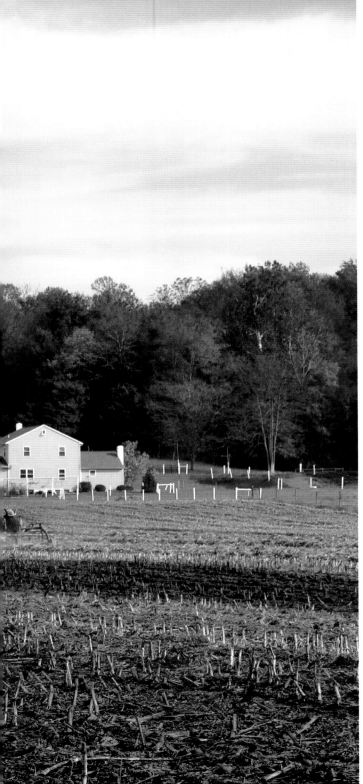

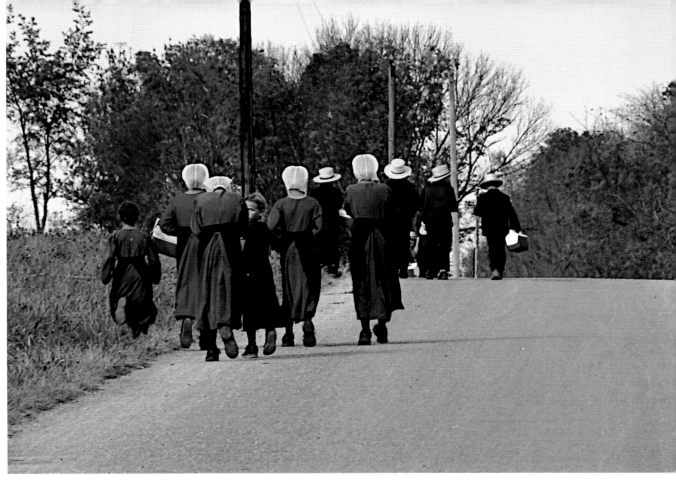

NEAR MILLIGAN

AMISH FARMER NEAR MILLIGAN *(facing)*

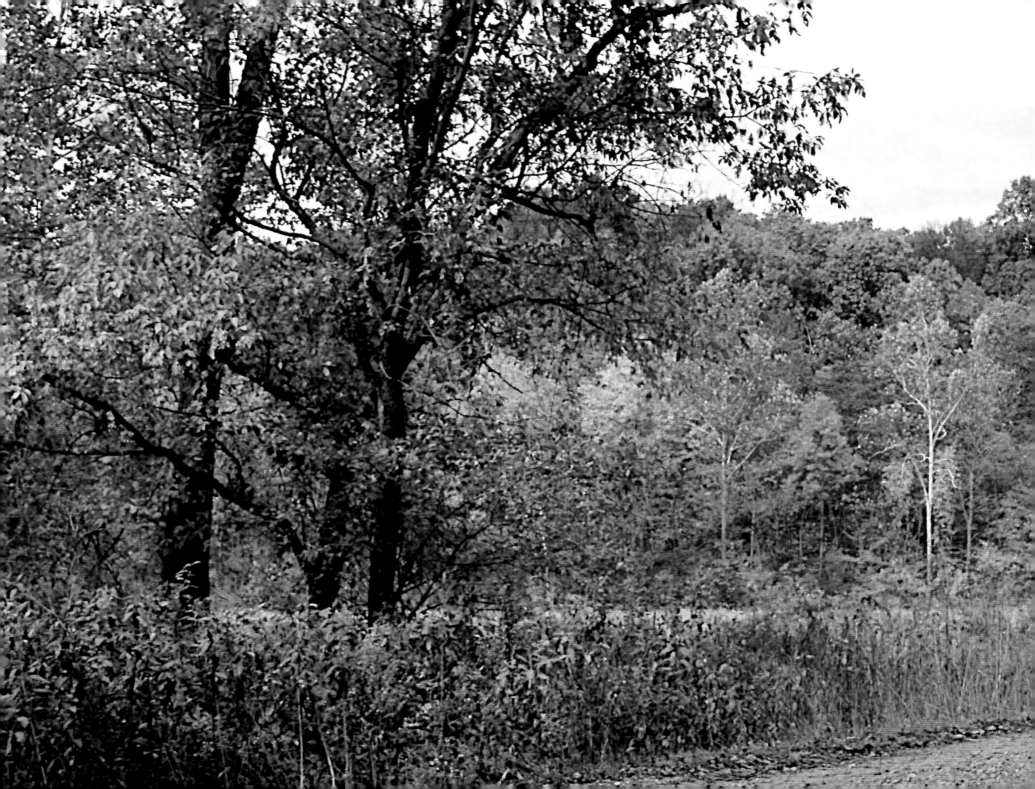

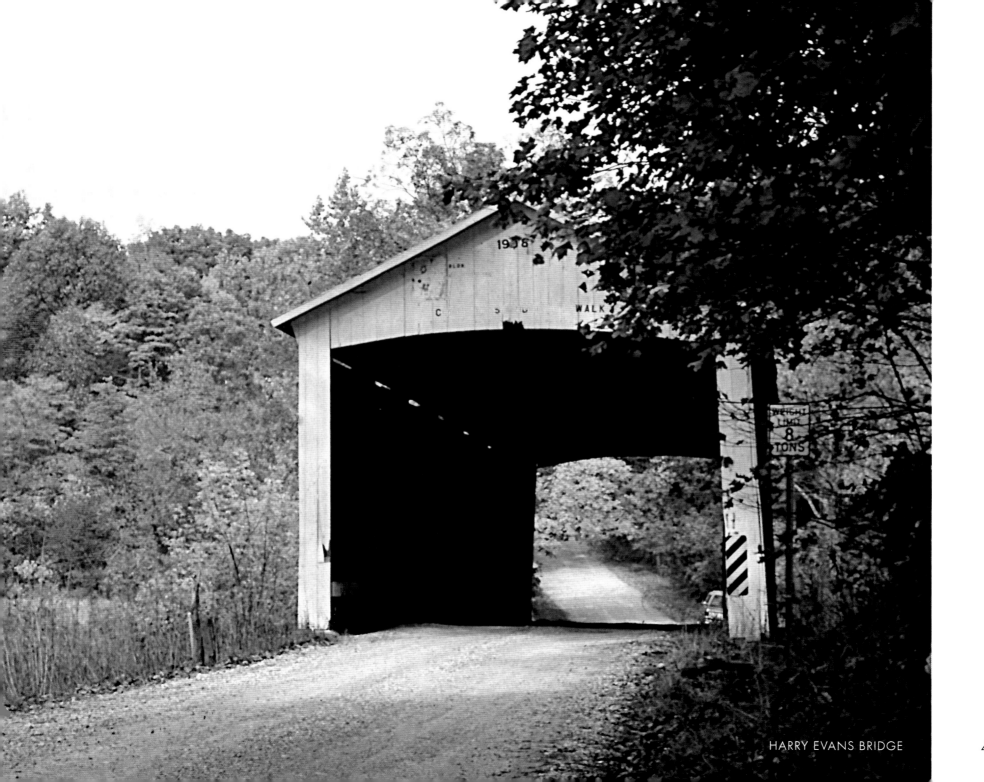

HARRY EVANS BRIDGE

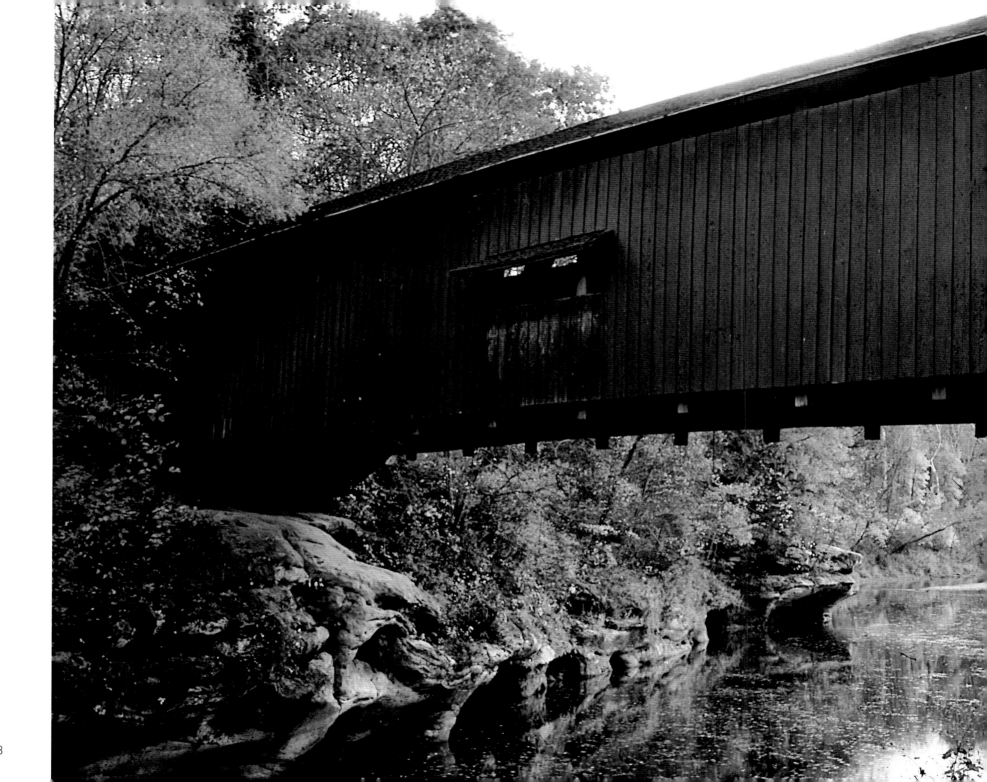

We'd search for holes near the bridge's

foundations, where the water sat in deeper,

cooler stillness, and we'd touch bottom

to feel the mud pack between our toes.

— *Memories Now Water under the Bridge*

NARROWS BRIDGE, CROSSING SUGAR CREEK

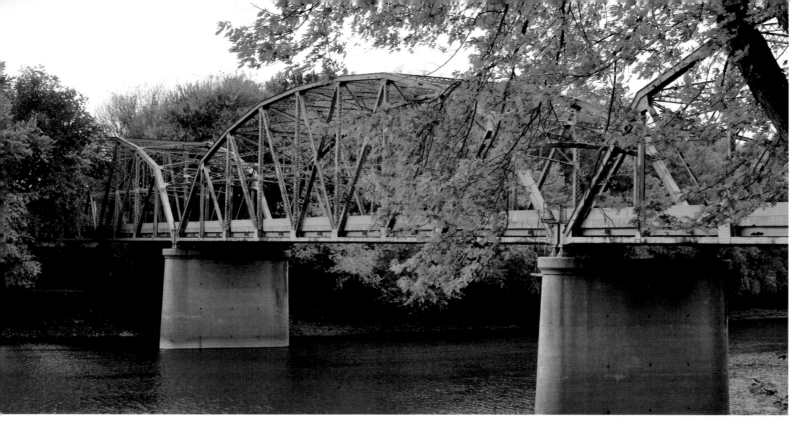

In childhood days

I crossed a wide brown ribbon of water with my grandfather

Who often hummed "We Shall Gather at the River" as he drove.

— Crossing the River

WABASH RIVER AT MONTEZUMA

WESTERN PARKE COUNTY'S WABASH RIVER VALLEY *(facing)*

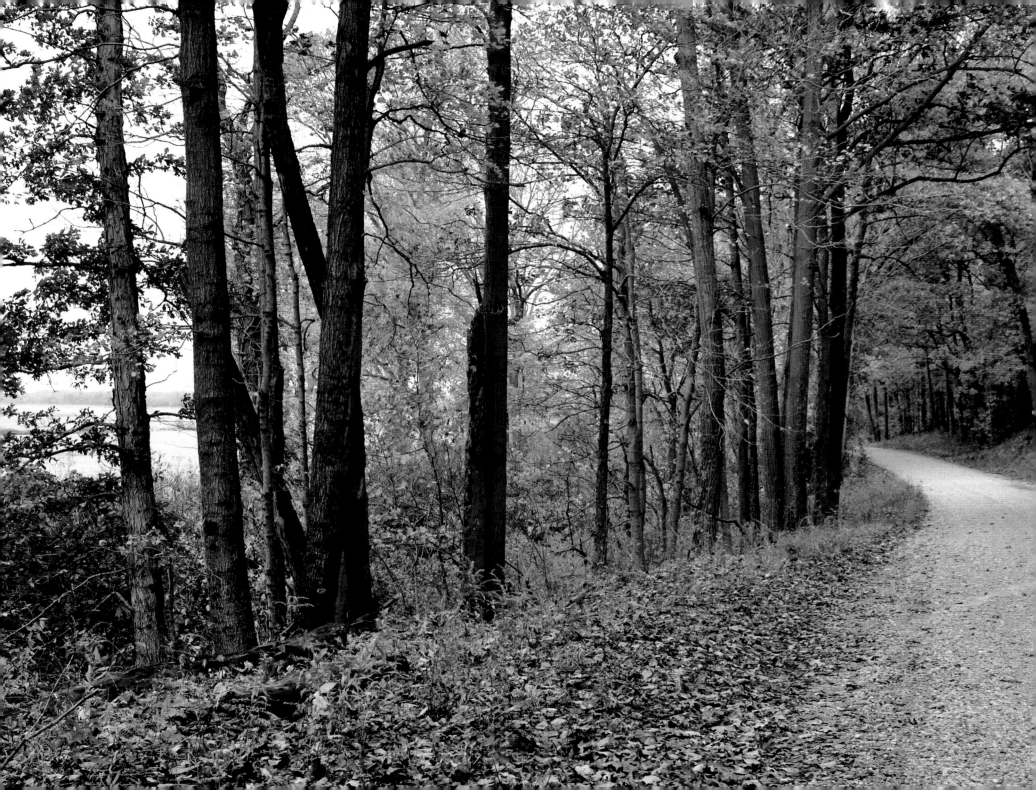

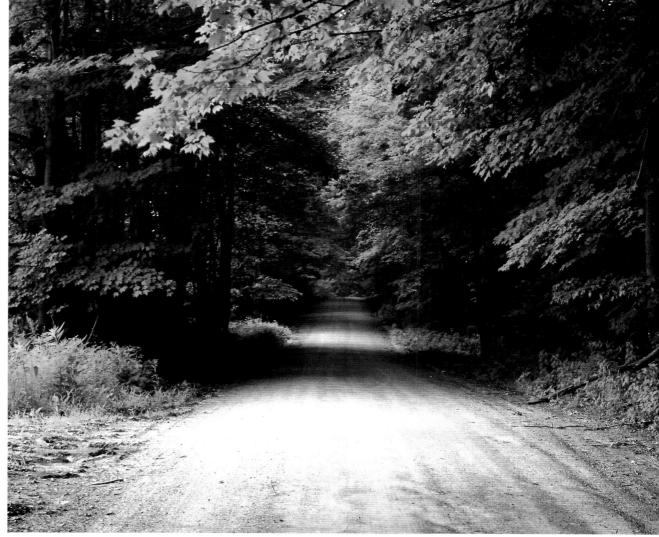

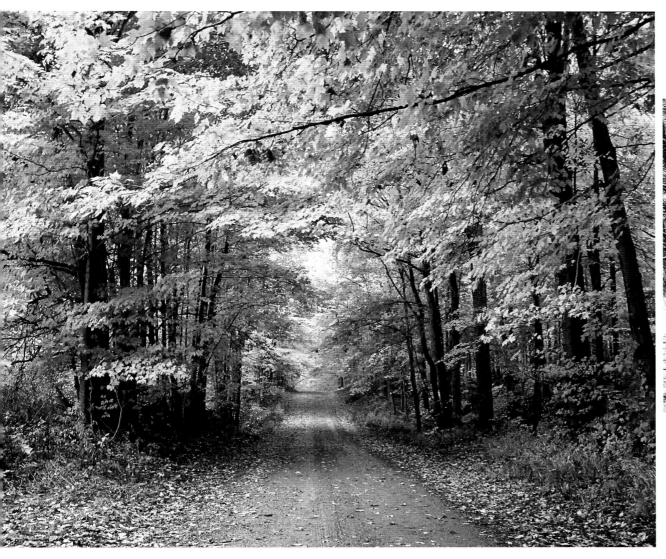

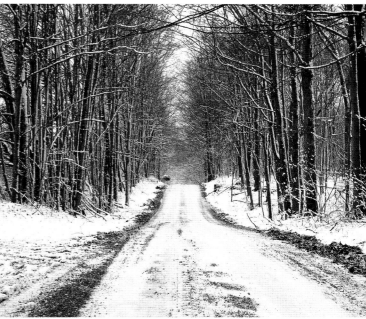

ONE-LANE ROAD NEAR BRYON

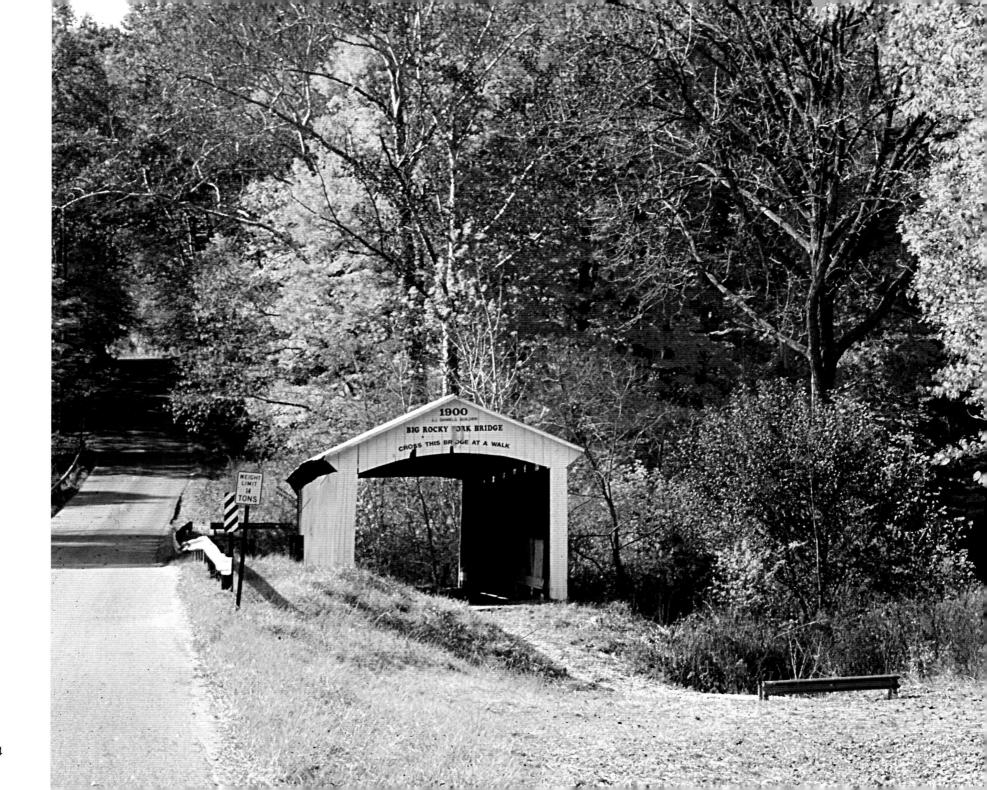

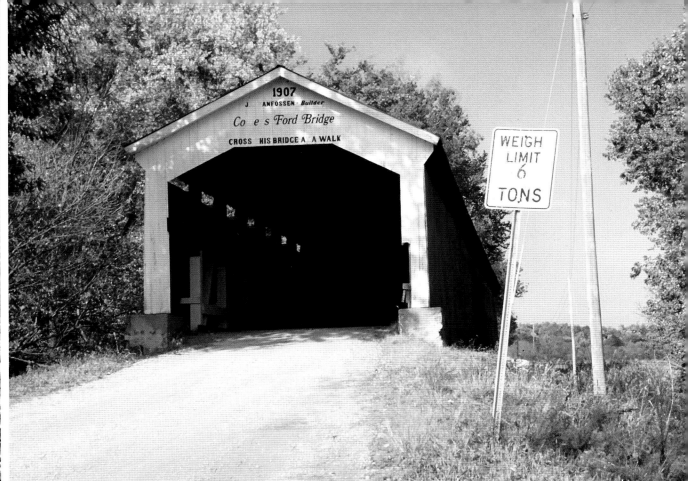

CONLEY'S FORD BRIDGE

BIG ROCKY FORK BRIDGE (facing)

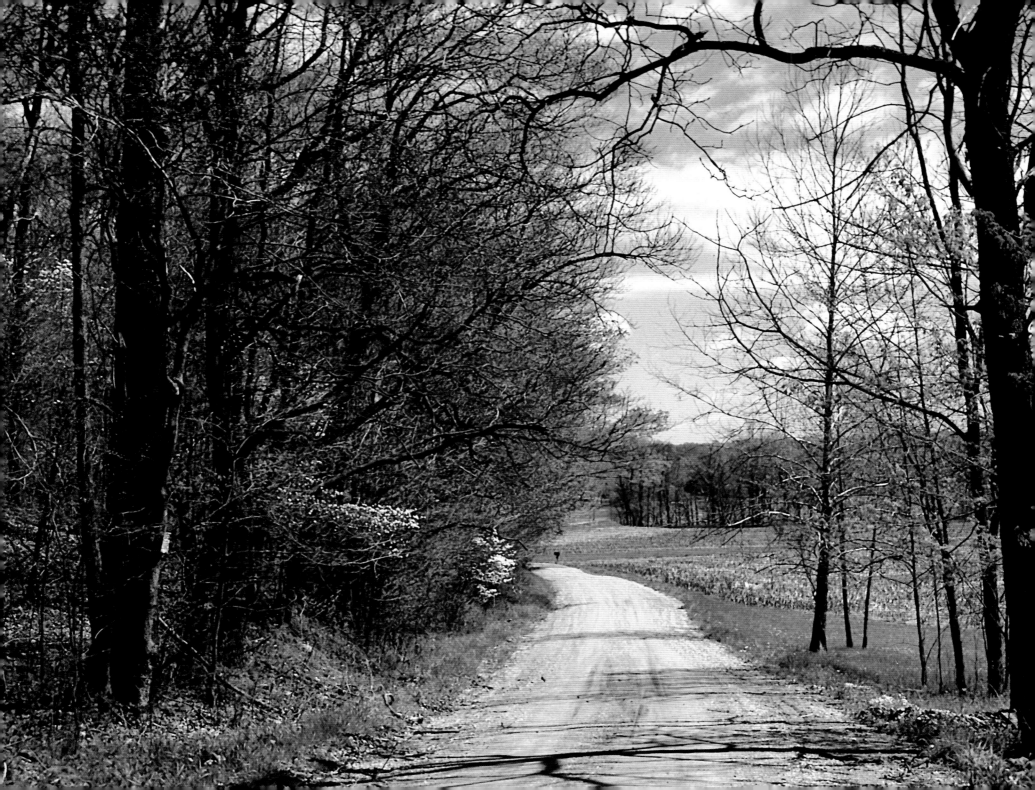

It was a warm and

green afternoon and

a fresh blue breeze

blew in from the west

like a new

spring friend.

—A Windy Hill Almanac

OUTSIDE MANSFIELD *(facing)*

RACCOON STATE RECREATION AREA

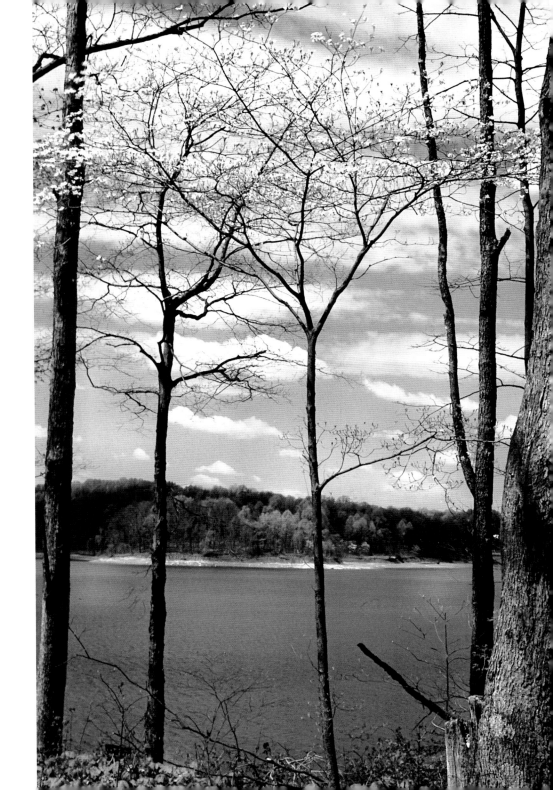

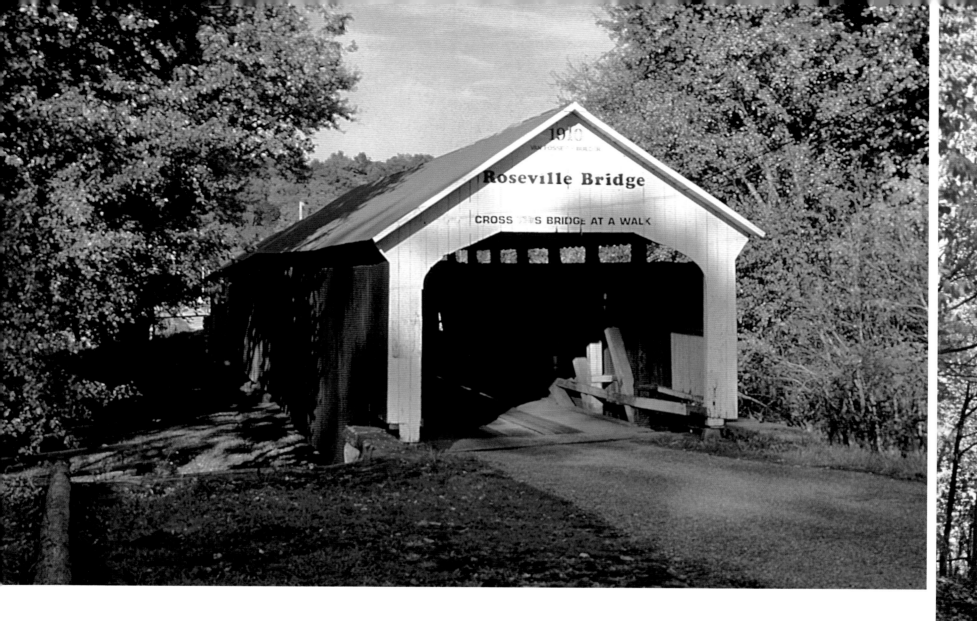

ROSEVILLE BRIDGE

MELCHER BRIDGE *(facing)*

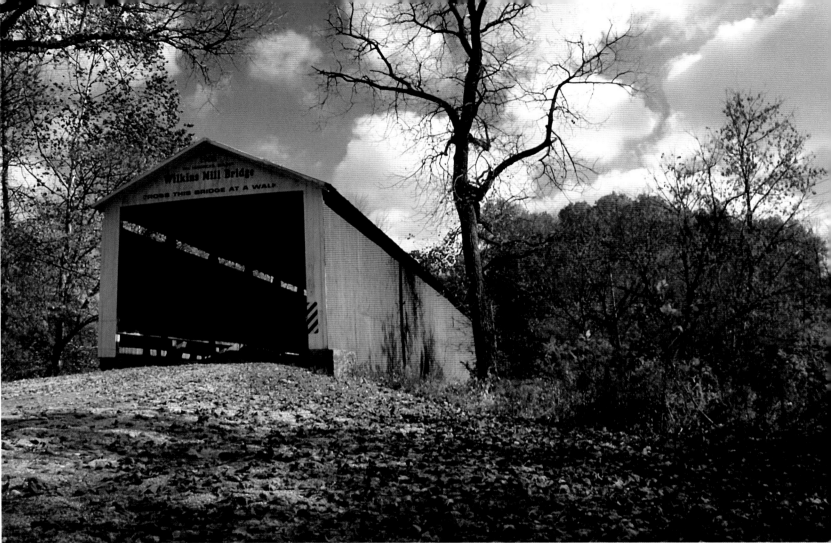

WILKINS MILL BRIDGE

CROOKS BRIDGE *(facing)*

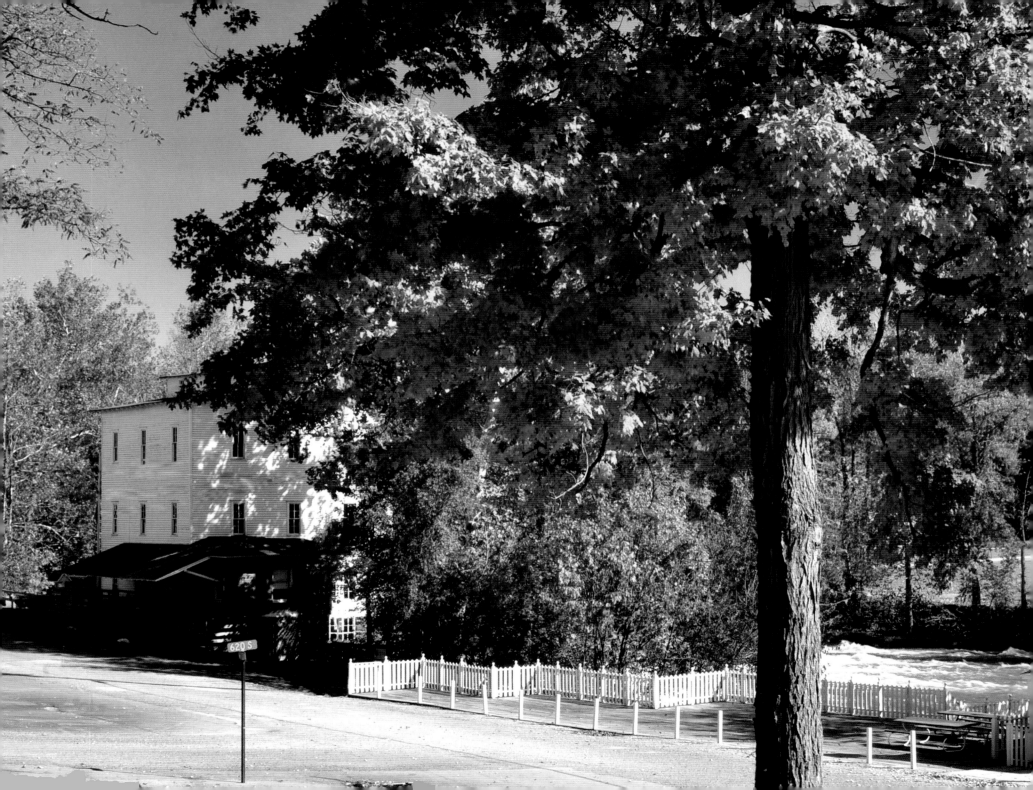

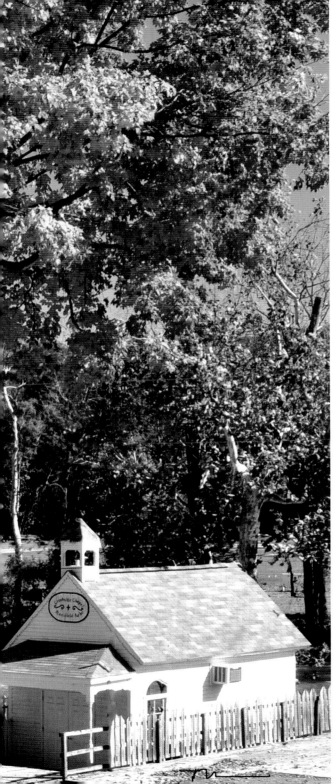

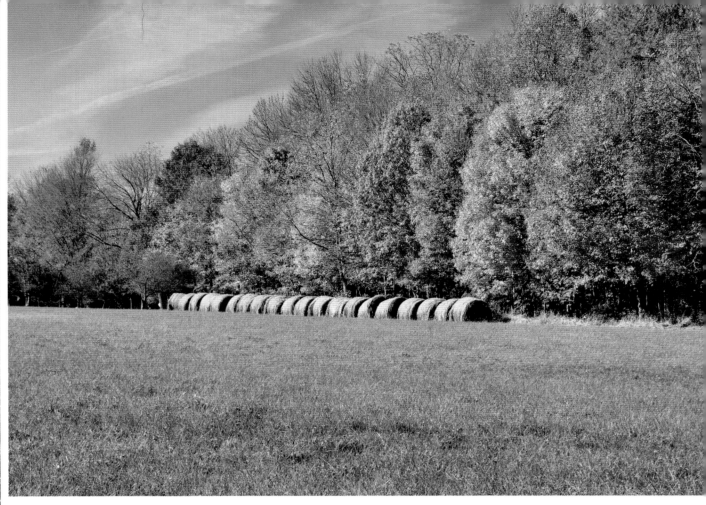

RURAL SCENE NEAR MANSFIELD

MANSFIELD *(facing)*

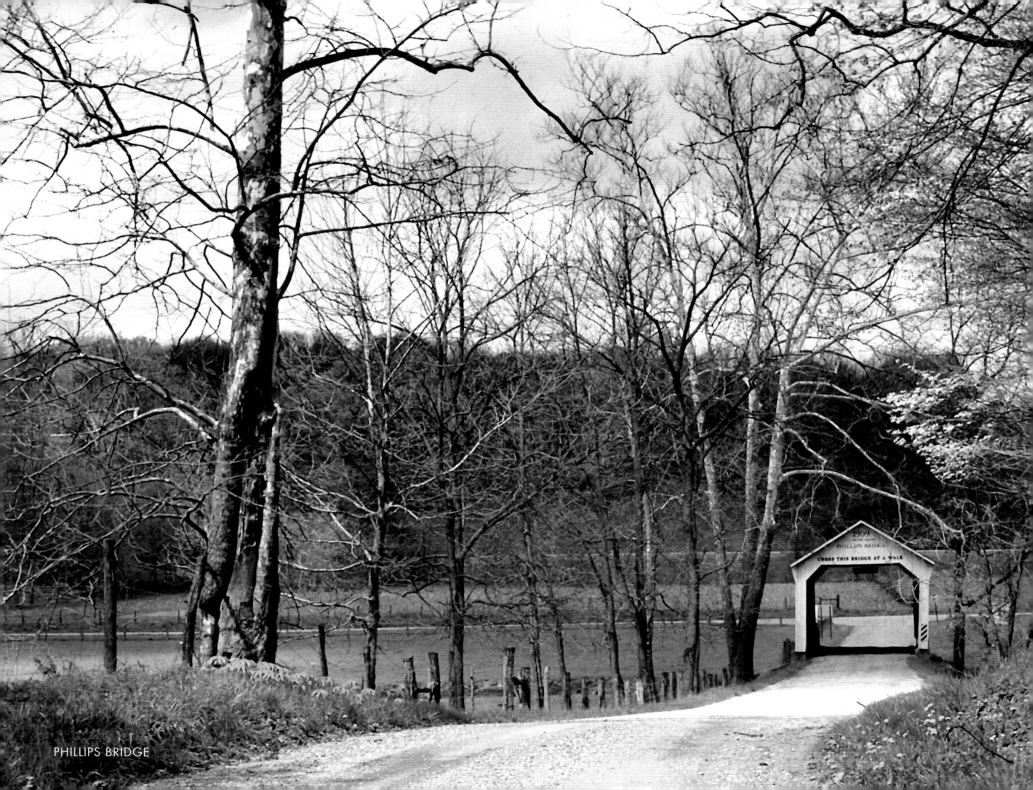

PHILLIPS BRIDGE

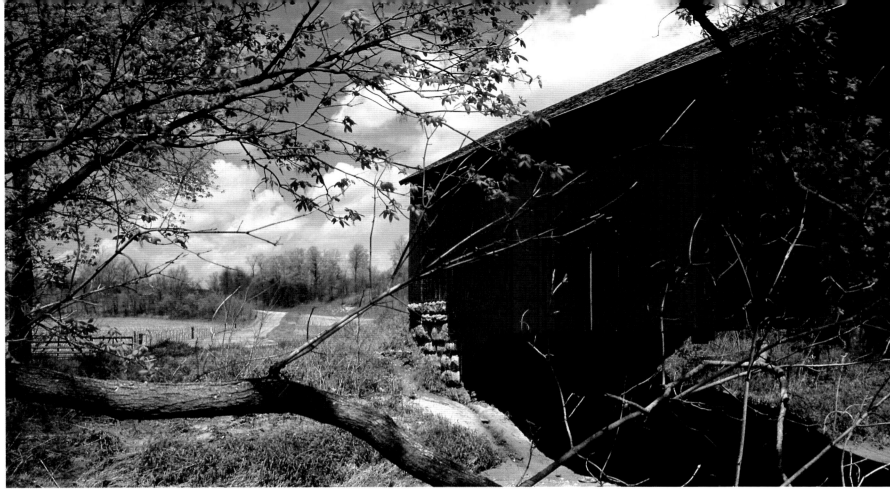

I have been keeping a journal of sorts in my head for a fortnight now,

stashing away reports of birds and buds and sounds in the crammed cabinets

of my mind, all in a file marked, "The New Season."

—A Windy Hill Almanac

SIMS SMITH BRIDGE

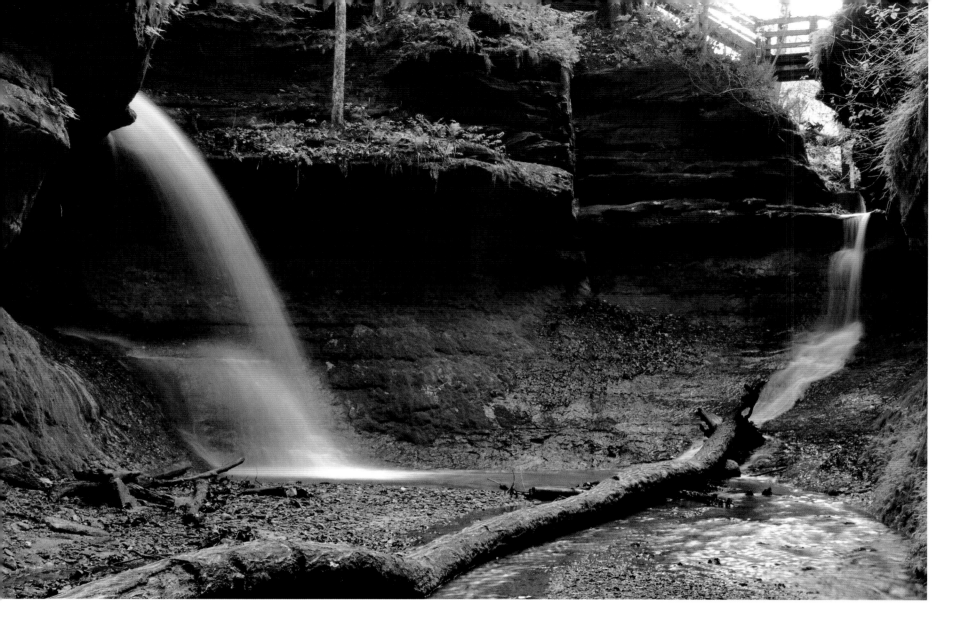

DEVIL'S PUNCH BOWL, SHADES STATE PARK

TURKEY RUN STATE PARK, TRAIL 3 *(facing)*

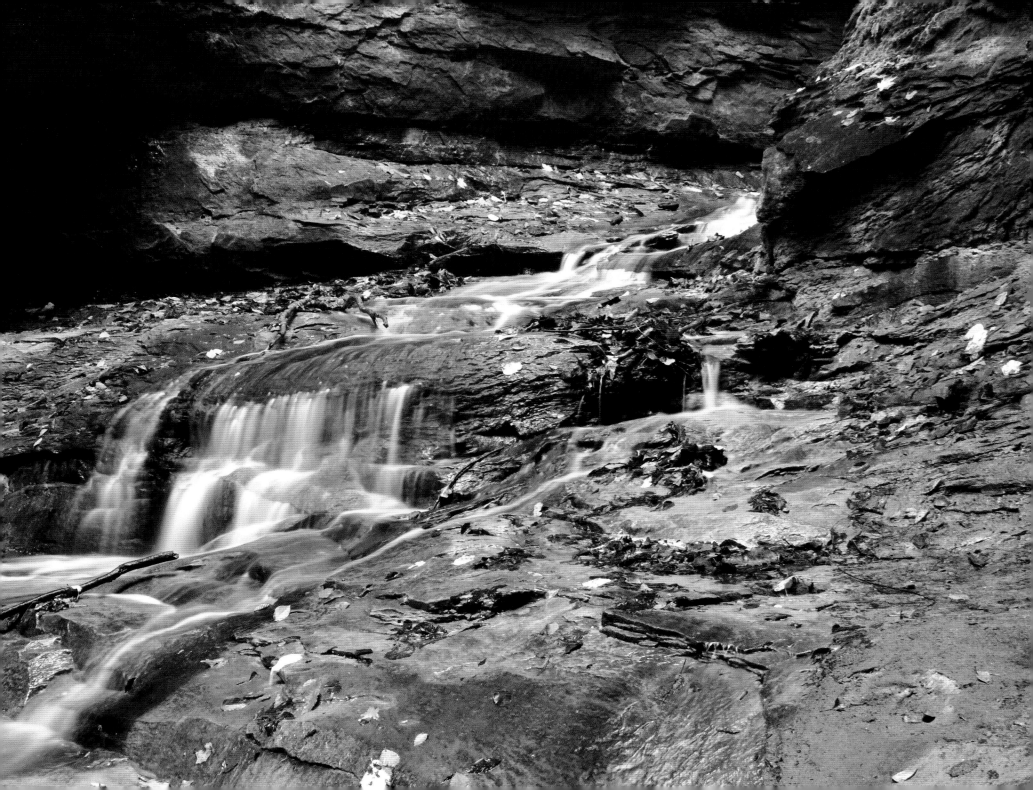

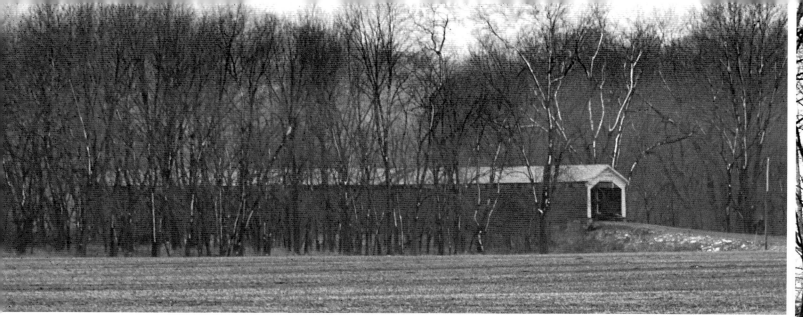

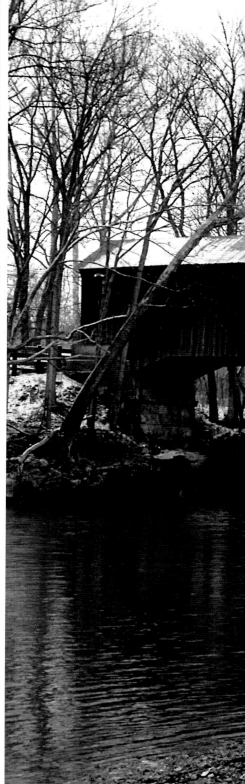

I was surprised to see that the creek ran clear, that not a single berg of ice floated along in its steady current. Shelves of ice along the banks and clinging to the roots of cottonwoods were thin reminders of higher water and even colder temperatures, and I stood on a bit of a bluff above the water and listened to the water slide by beneath me.

— *The Long Goodbye to Winter*

CONLEY'S FORD BRIDGE

COX FORD BRIDGE, CROSSING SUGAR CREEK *(facing)*

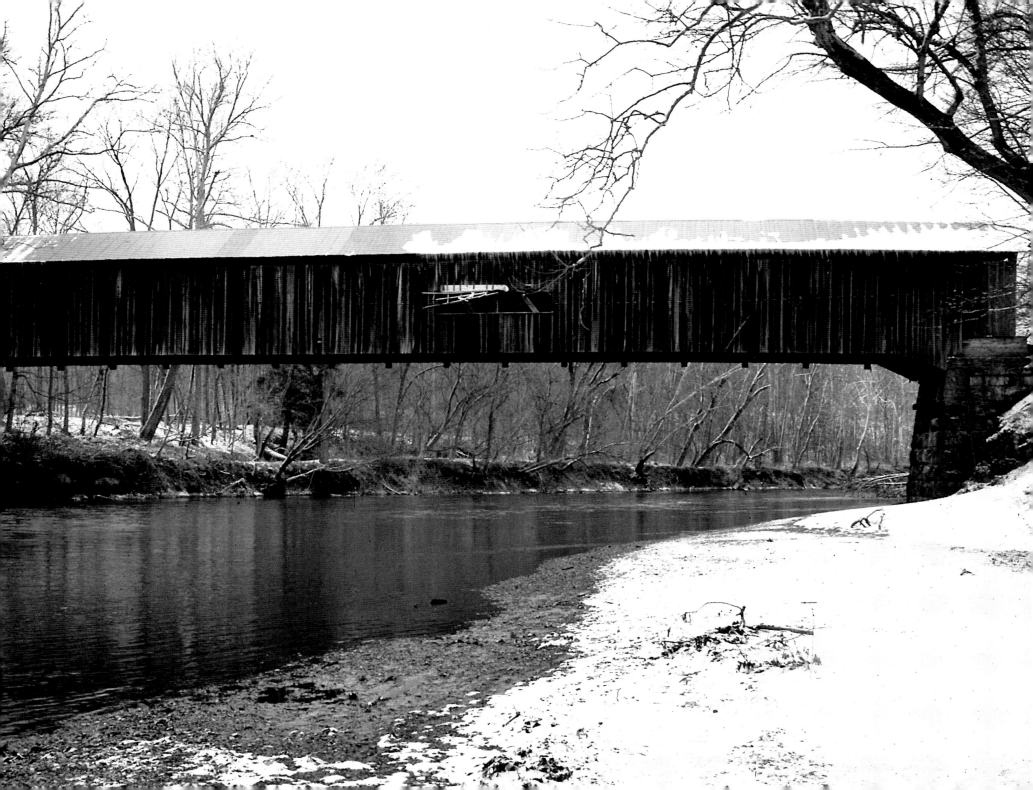

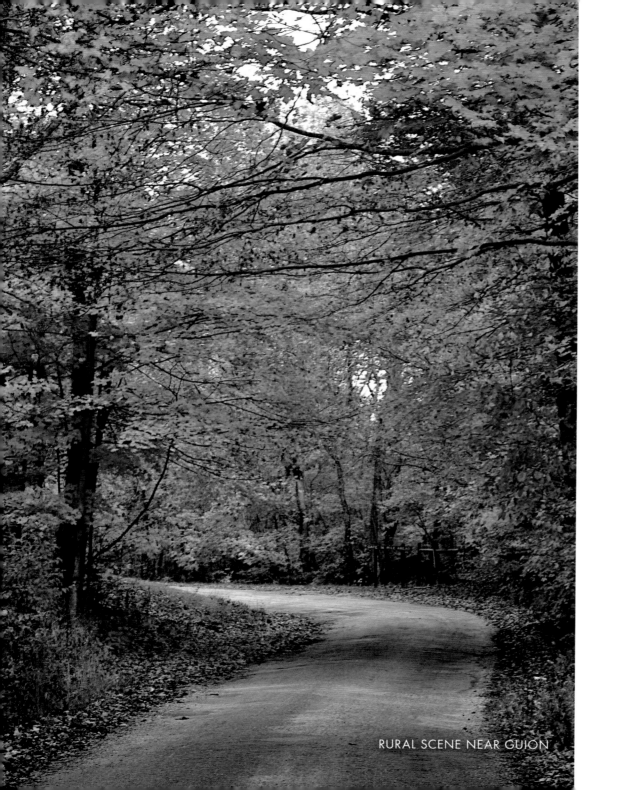

RURAL SCENE NEAR GUION

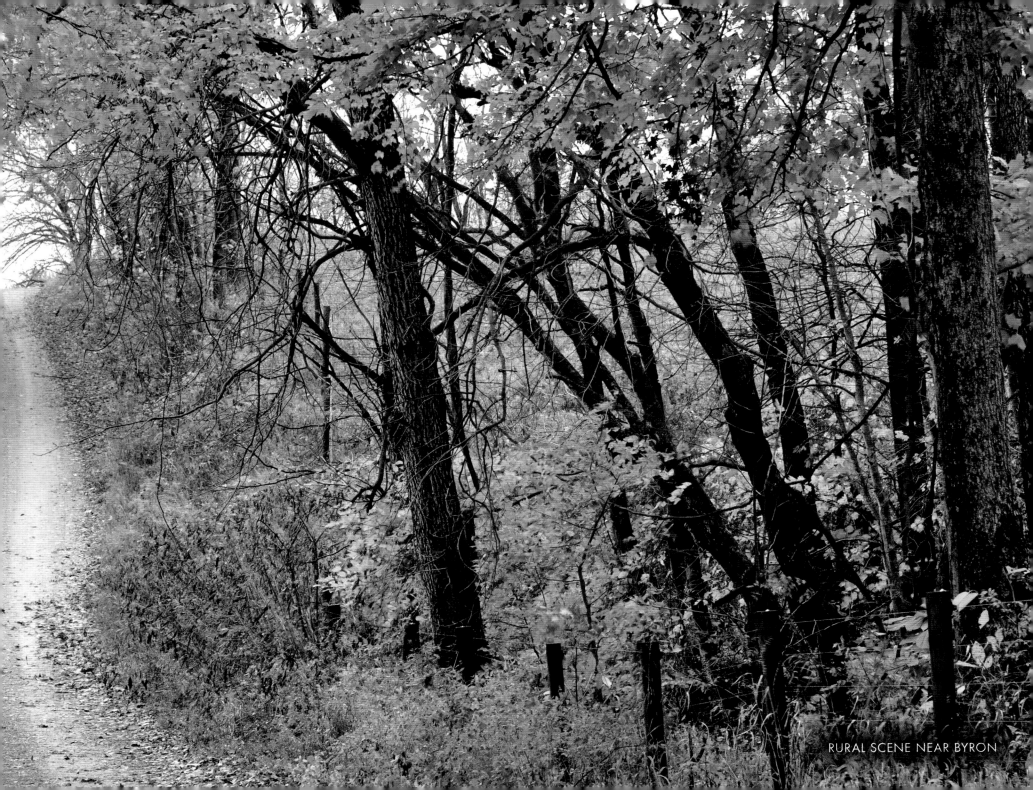

RURAL SCENE NEAR BYRON

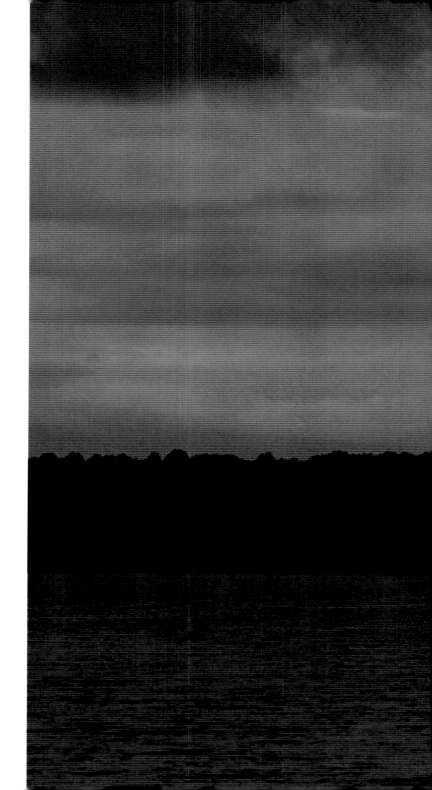

For the first time that night,

I noticed how soft the evening breeze was

as it touched my face.

—*A Place Near Home*

LAKE WAVELAND

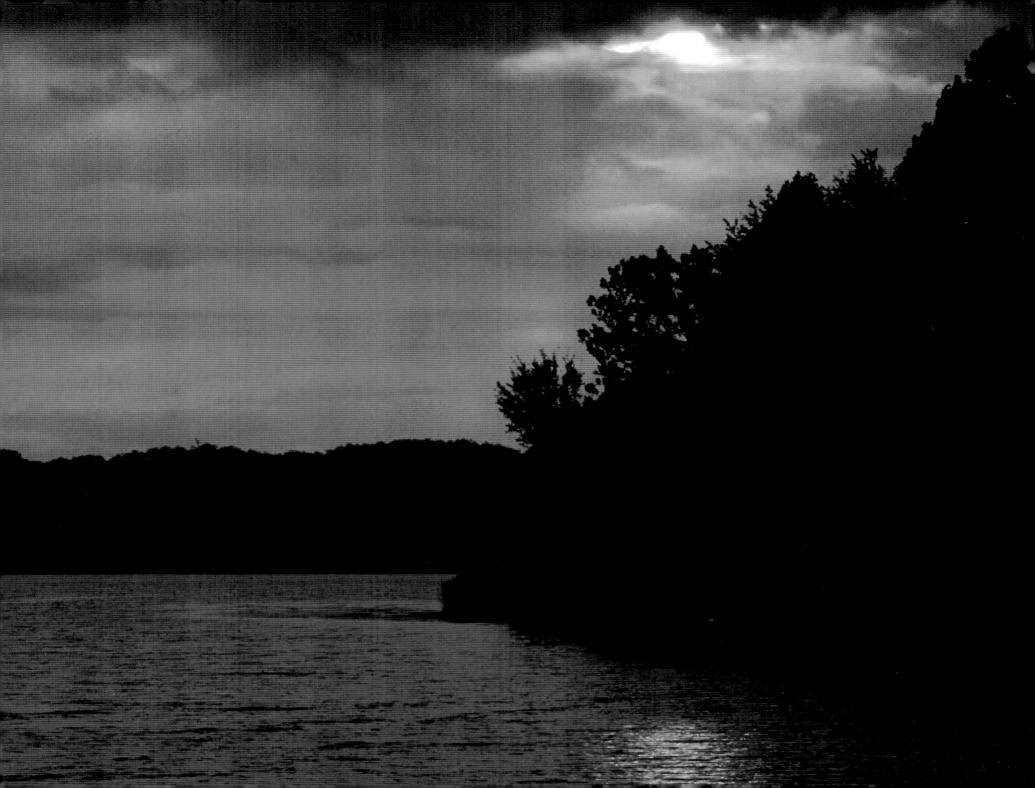

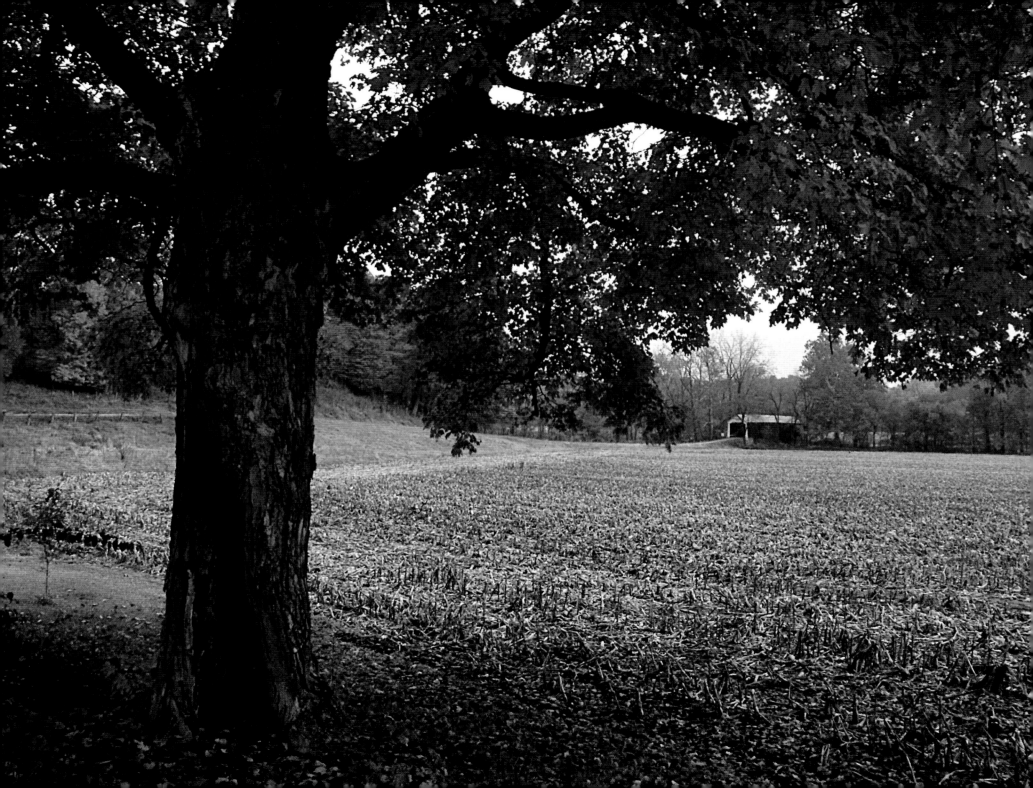

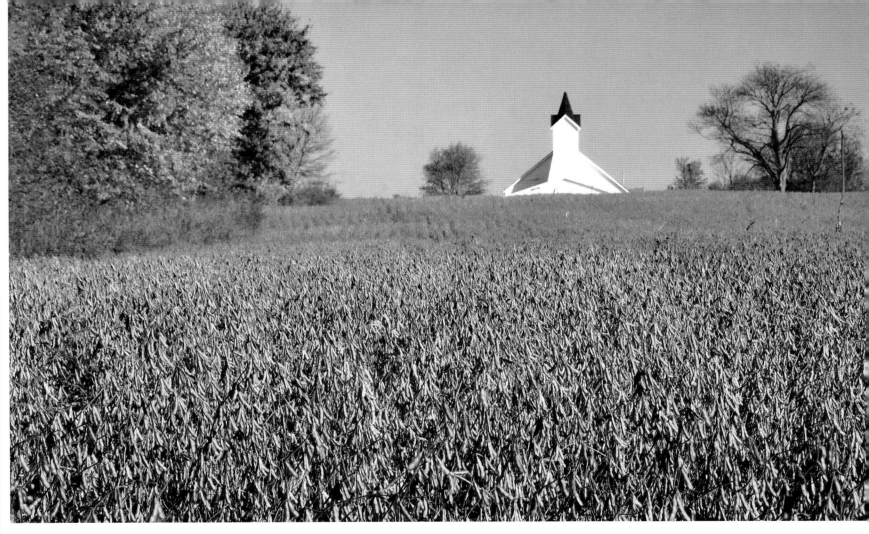

BRYON CHURCH

BROWSHER FORD BRIDGE *(facing)*

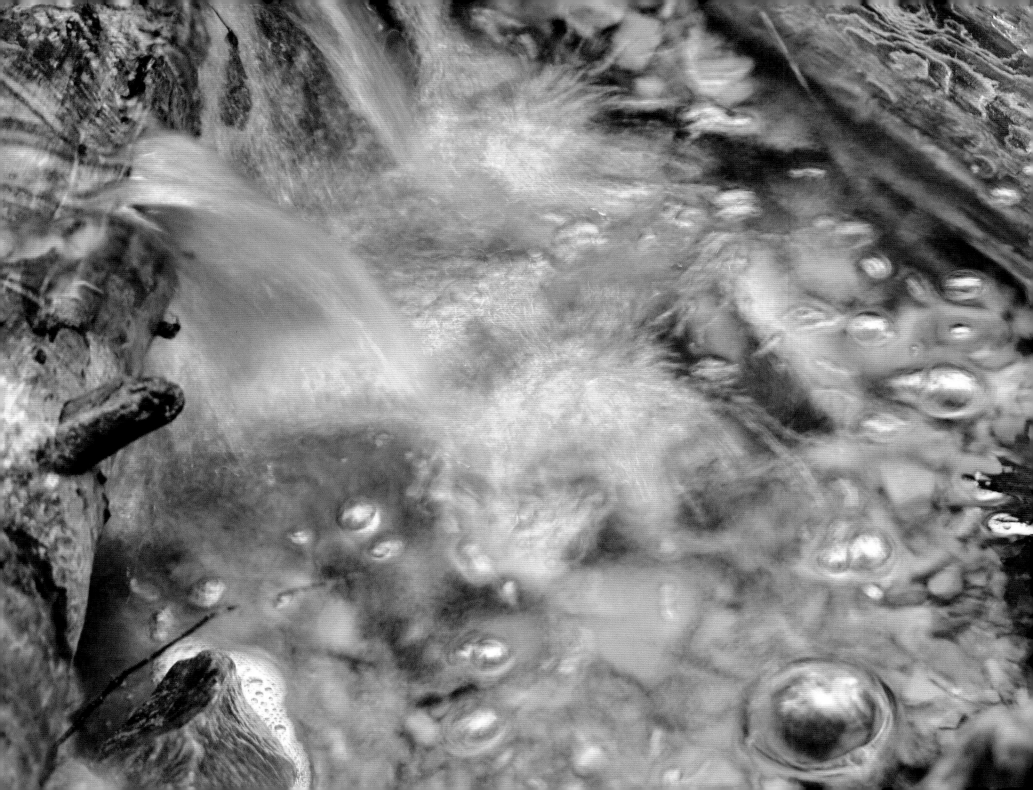

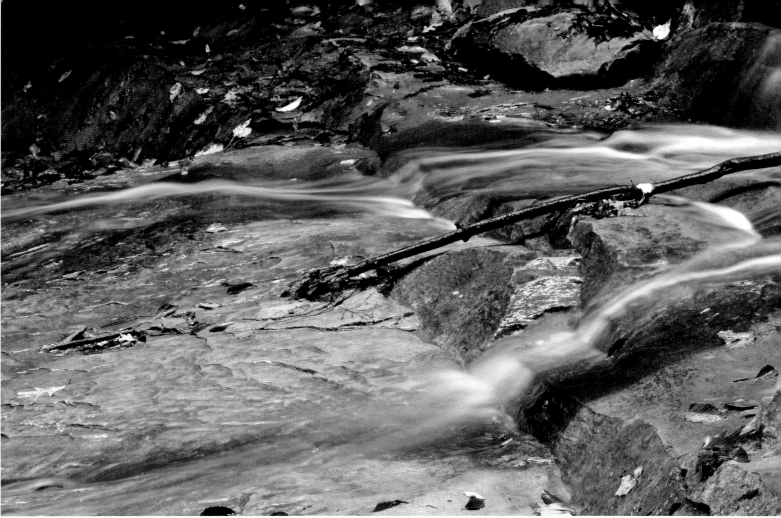

TURKEY RUN STATE PARK

SHADES STATE PARK *(facing)*

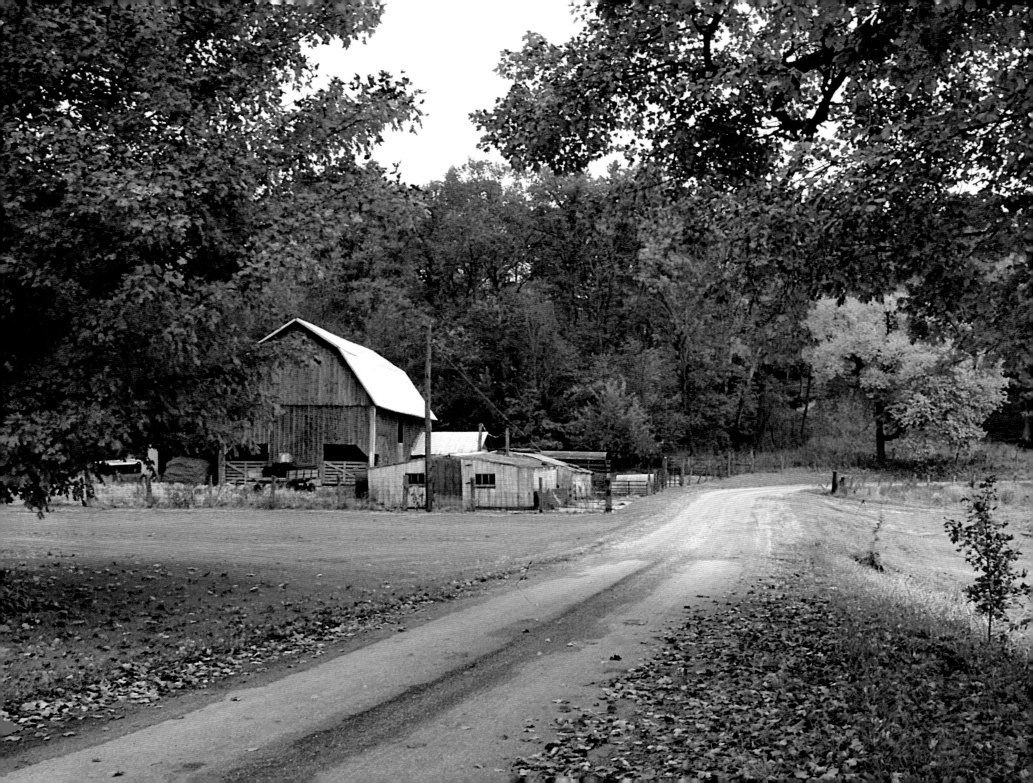

I am walking my road in the cool of the evenings,

and I have begun to notice that the fencerows

and fields are changing their colors for autumn,

not unlike those of us who will soon be scrounging in

the closet for a favorite, faded flannel shirt to slip on.

—A Windy Hill Almanac

NEAR HOWARD

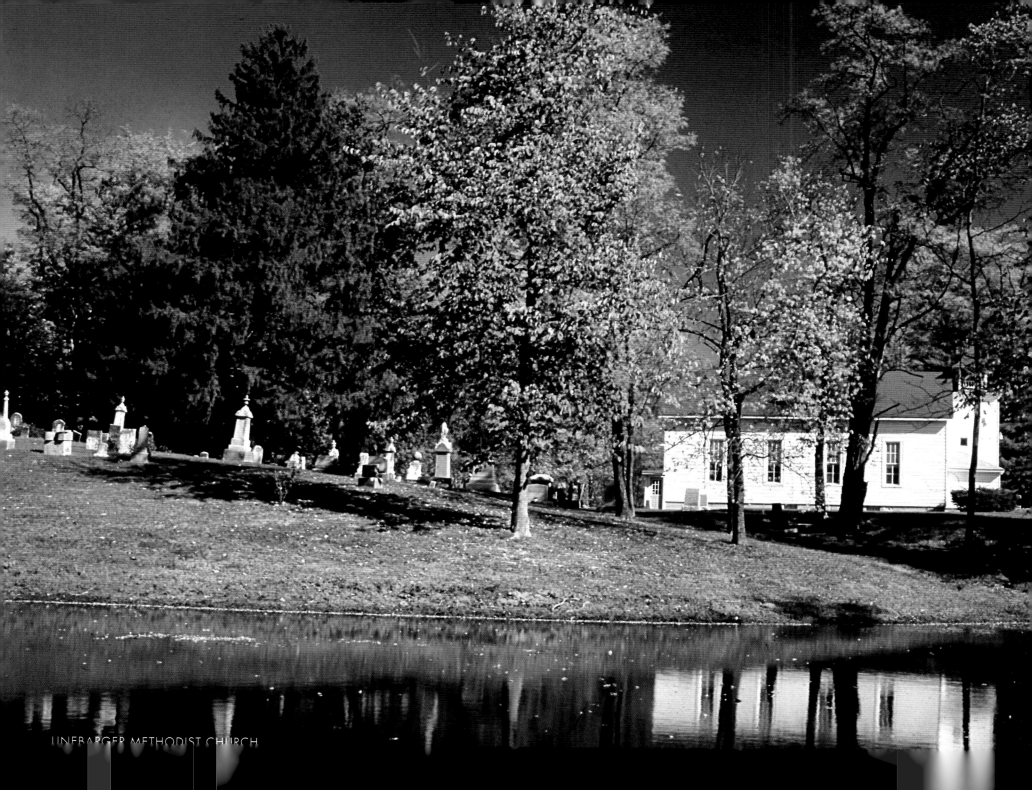

LINEBARGER METHODIST CHURCH

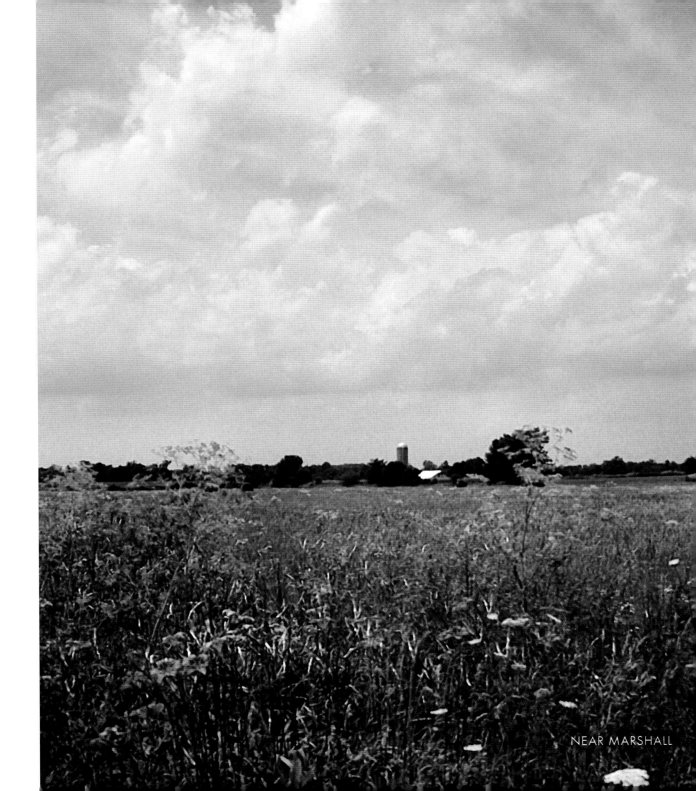

NEAR MARSHALL

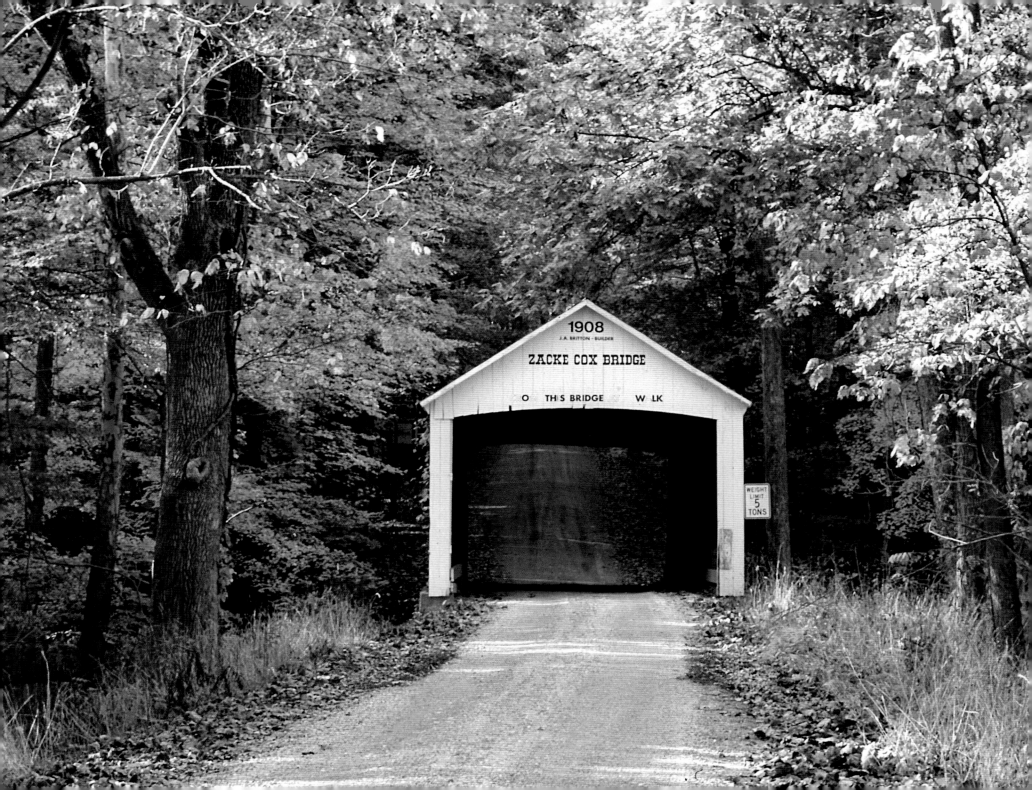

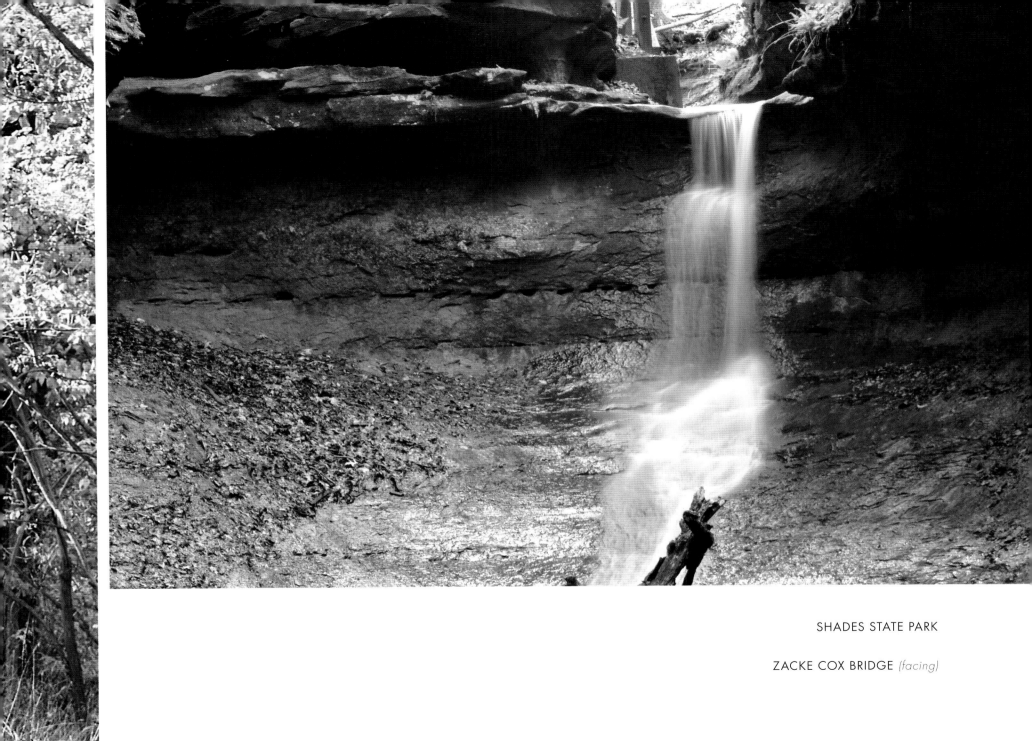

SHADES STATE PARK

ZACKE COX BRIDGE *(facing)*

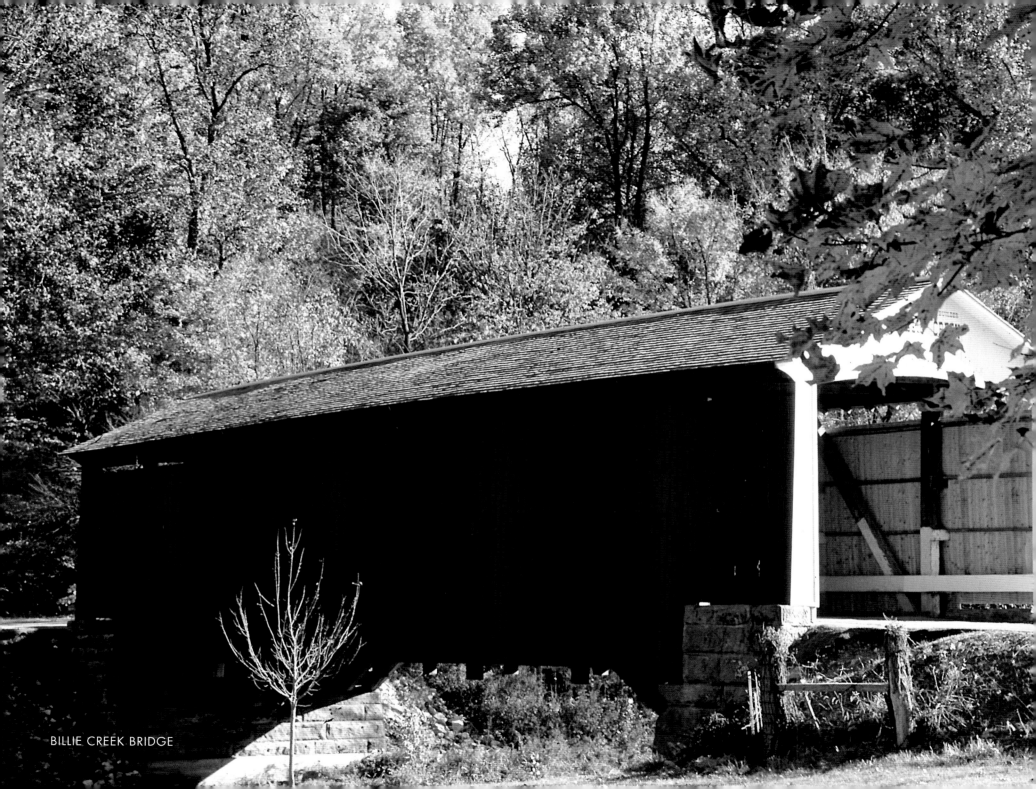
BILLIE CREEK BRIDGE

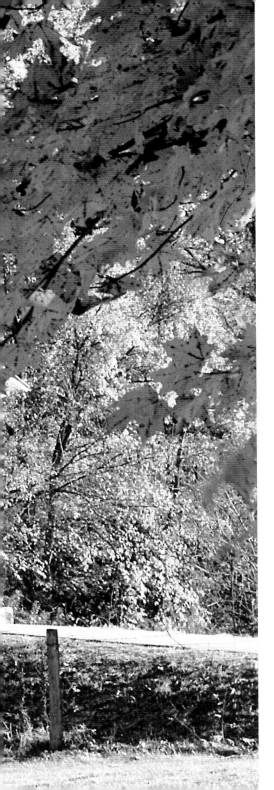
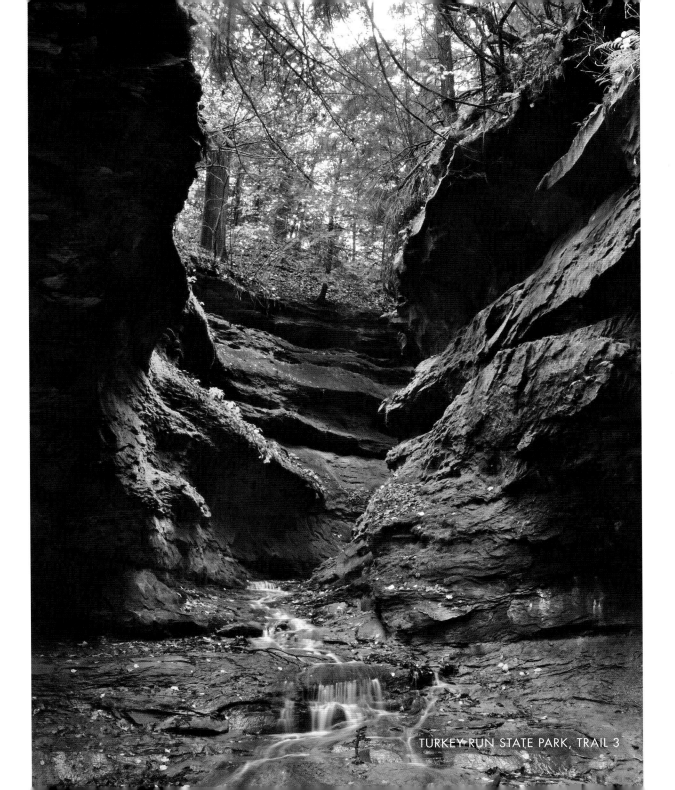

TURKEY RUN STATE PARK, TRAIL 3

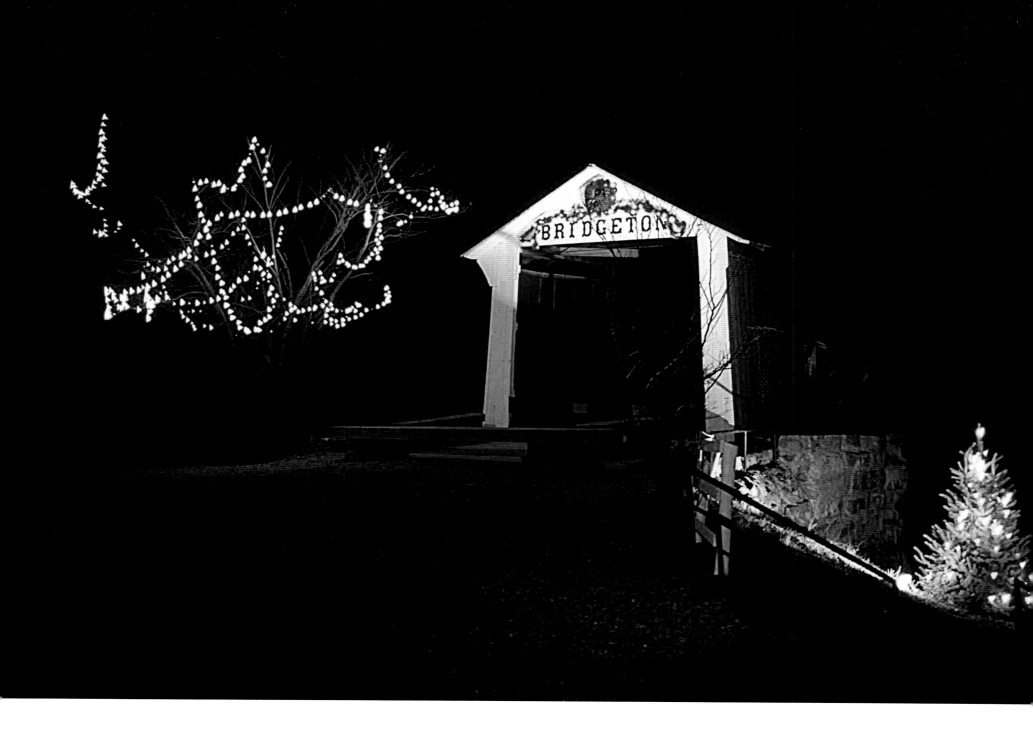

PARKE COUNTY COVERED BRIDGE
CHRISTMAS, BRIDGETON BRIDGE
(facing)

PARKE COUNTY COVERED BRIDGE
CHRISTMAS, MANSFIELD

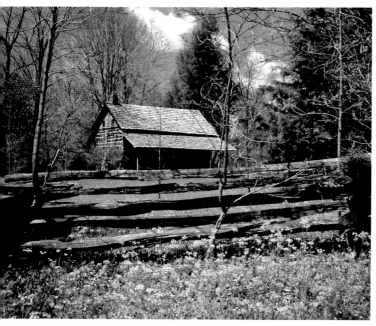

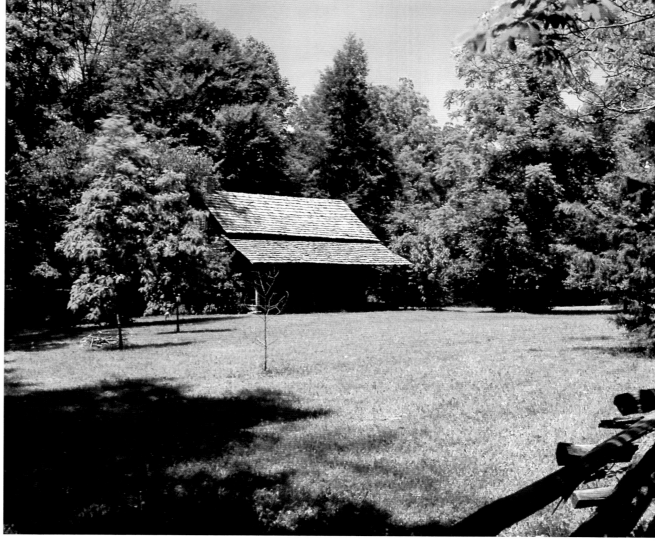

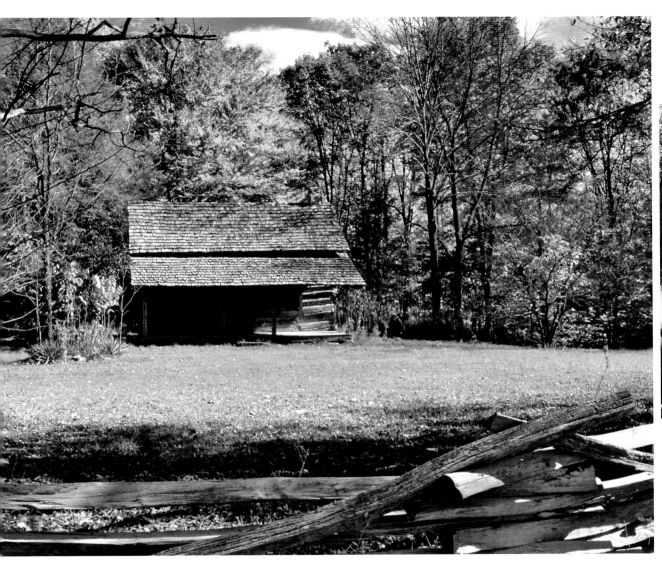

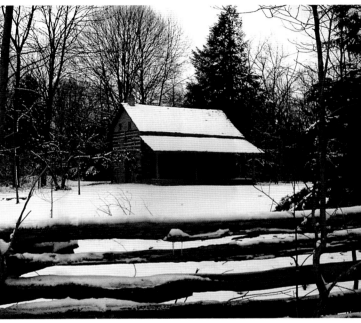

CABIN NEAR MARSHALL

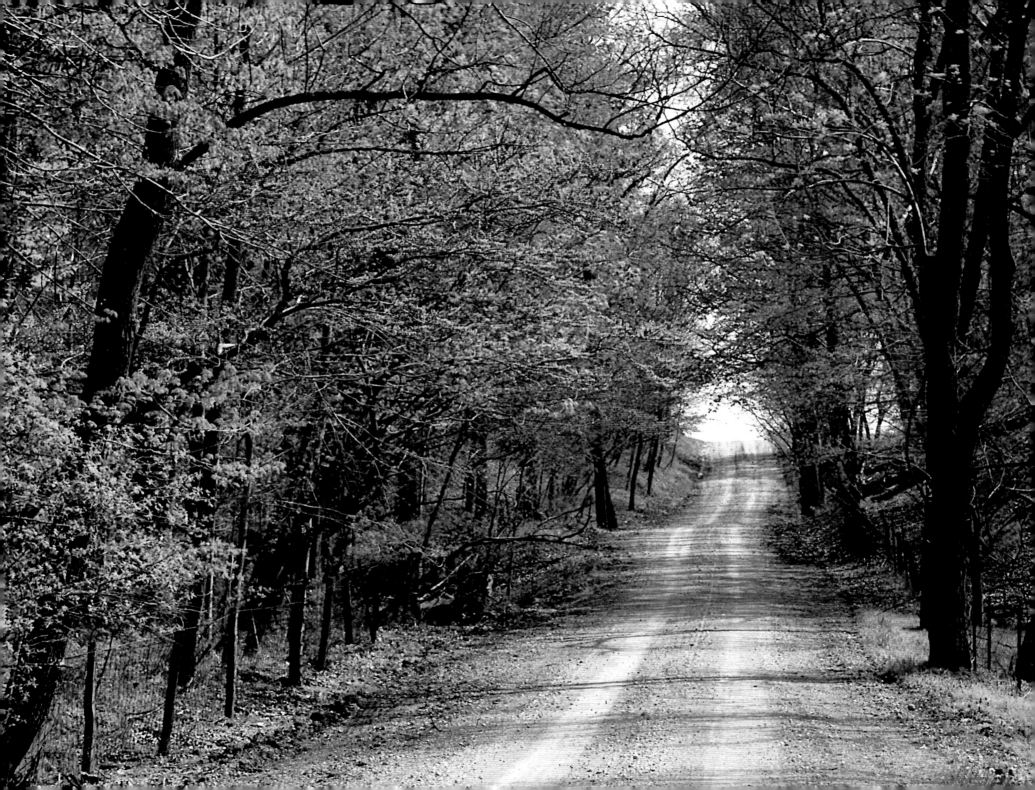

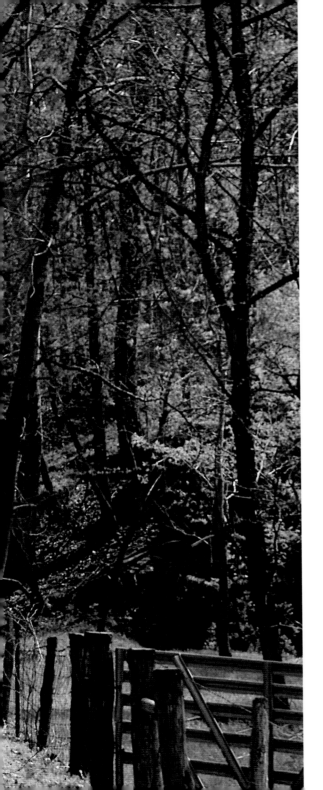

There is something about the woods in the spring that gives me hope. Although I know there are a million life-and-death struggles going on under my feet as I tromp about, I feel that considerable hate and pain and desperation would somehow be resolved by the simple pleasure of watching the shimmering reflection of a brilliant white dogwood on quiet water.

—The Off Season

SOUTHERN PARKE COUNTY

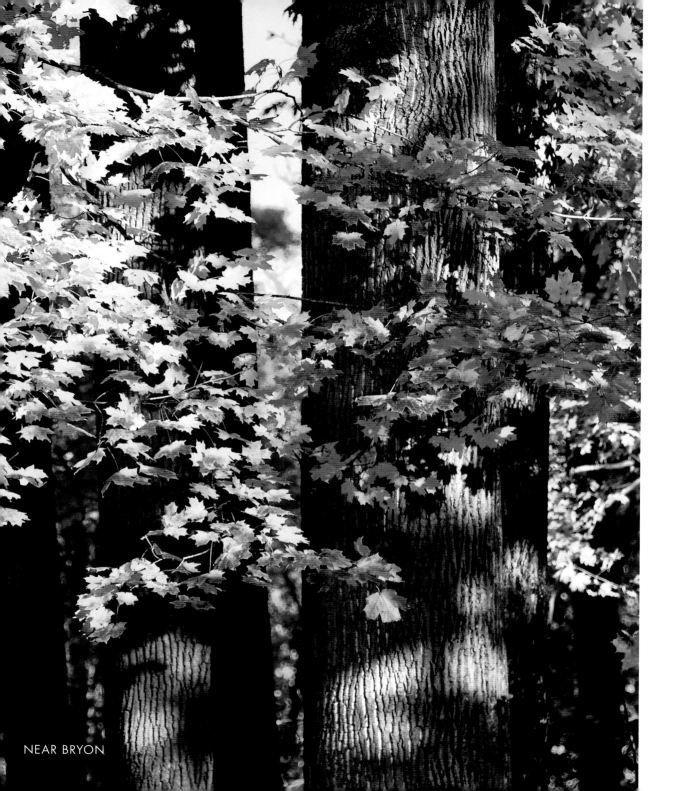

NEAR BRYON

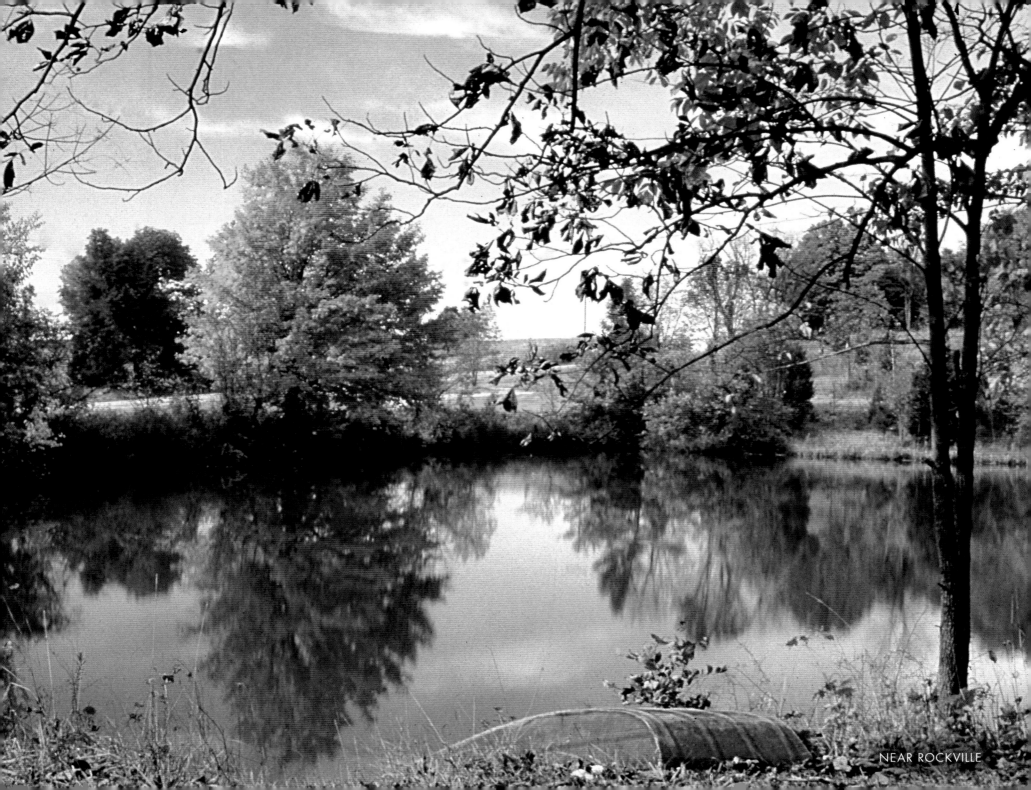

NEAR ROCKVILLE

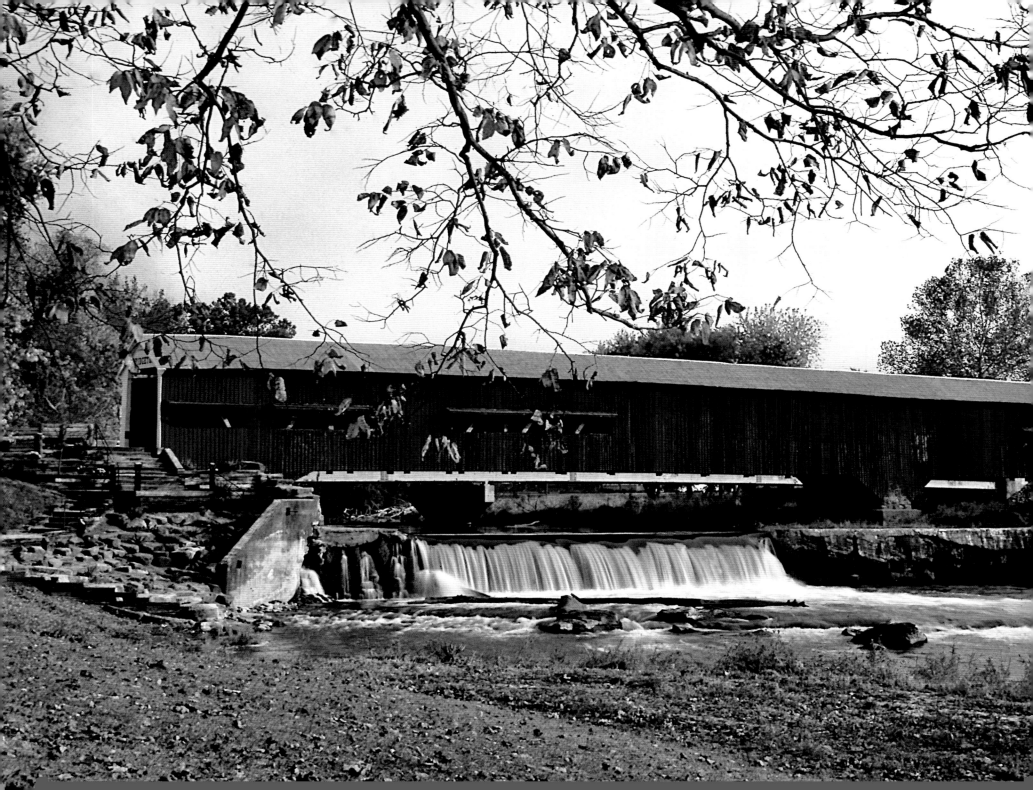

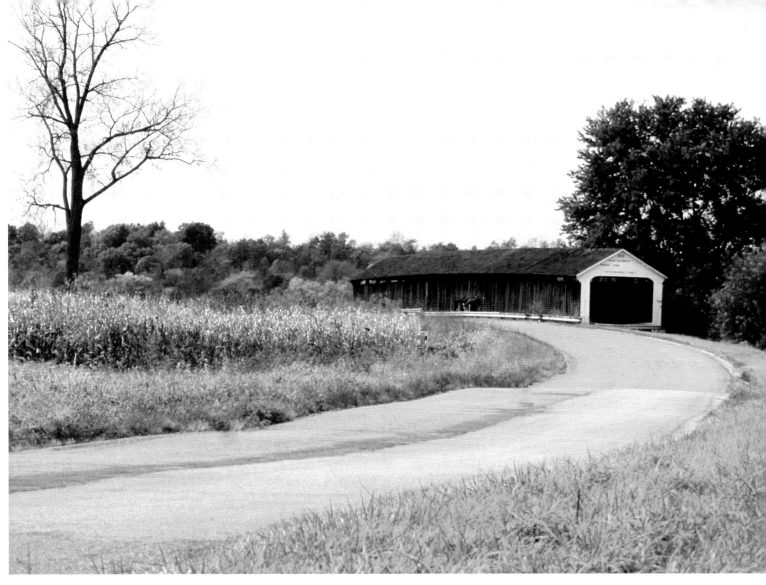

THORPE FORD BRIDGE

BRIDGETON BRIDGE, CROSSING BIG RACCOON CREEK *(facing)*

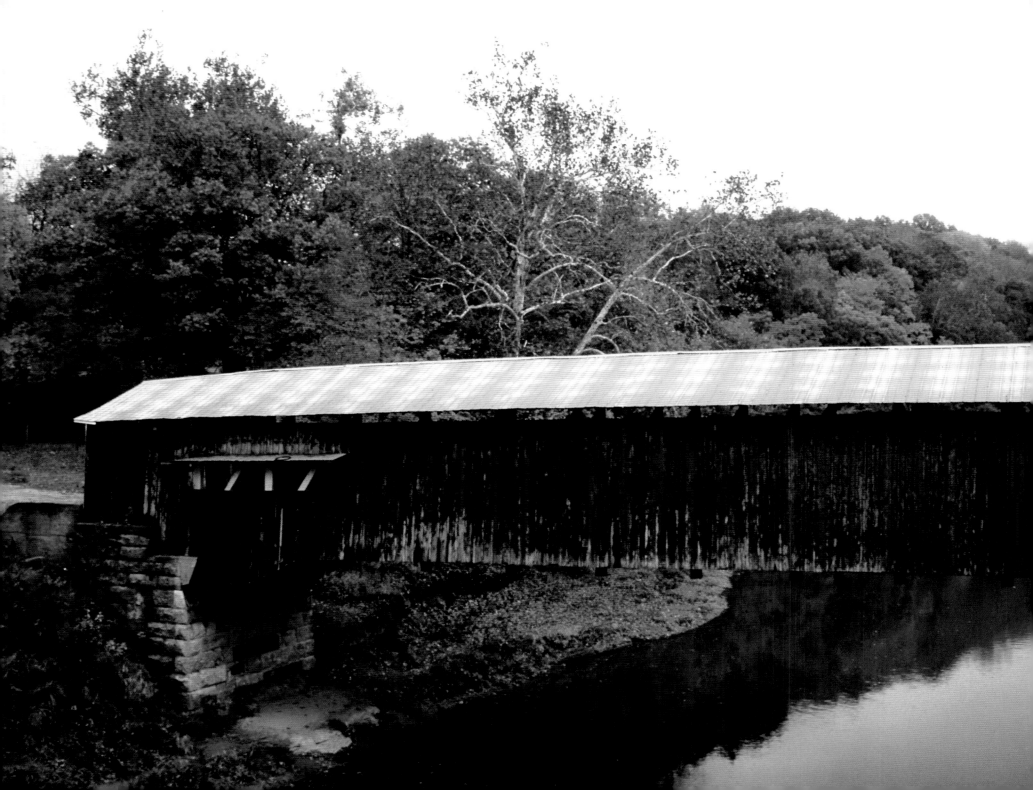

With my friends, I sat by driftwood fires and we talked about girls and baseball and baling hay, and through those evenings we were serenaded by the rattle of the bridge's floorboards as they loosely chattered under the weight of passing cars.

—Memories Now Water under the Bridge

WEST UNION BRIDGE, CROSSING SUGAR CREEK

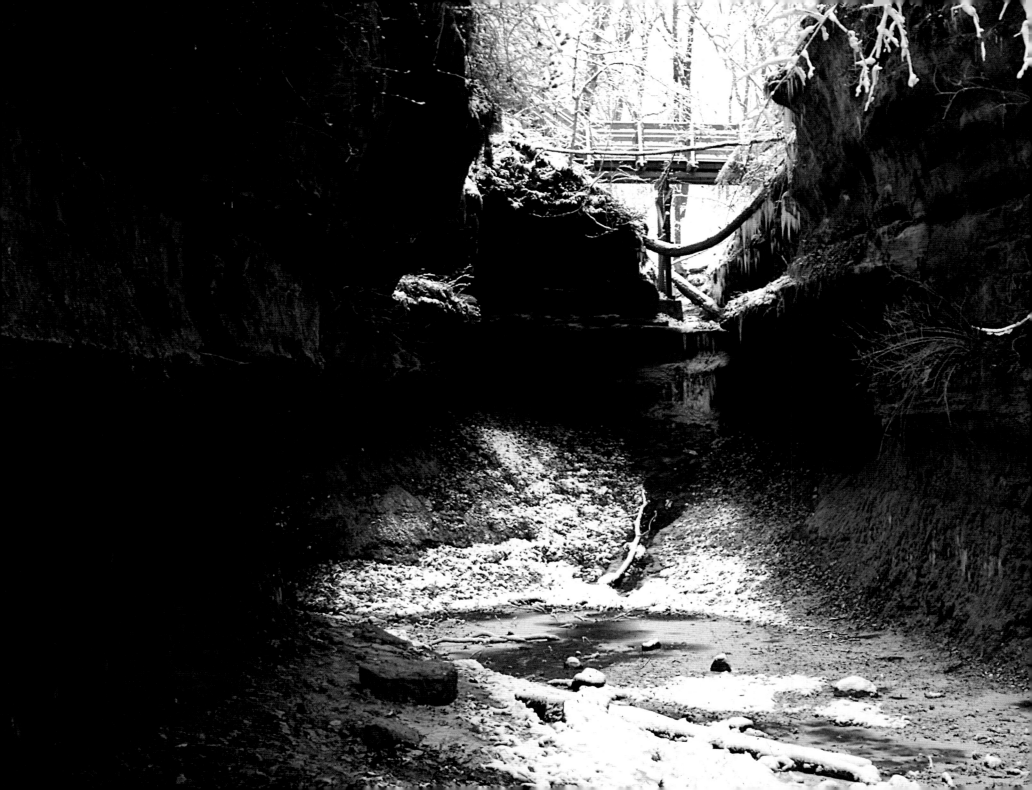

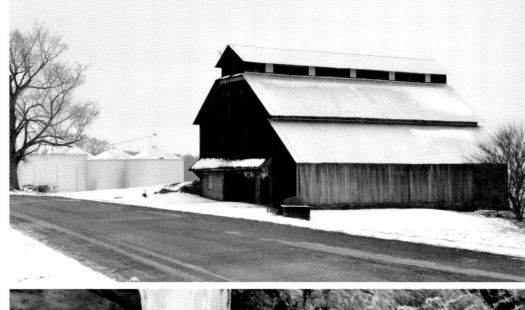

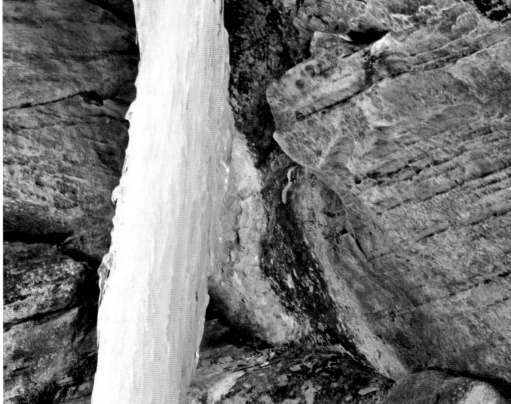

DEVIL'S PUNCH BOWL, SHADES
STATE PARK *(facing)*

BARN NEAR BRIDGETON *(top right)*

TURKEY RUN STATE PARK, TRAIL 2
(bottom right)

A new friend recently told me that the old-timers used to say that spring isn't truly here until you've heard the peepers' call twice. We've heard them more than that around my place.

—A Place Near Home

SILVER CASCADES, SHADES STATE PARK

JACKSON BRIDGE *(facing)*

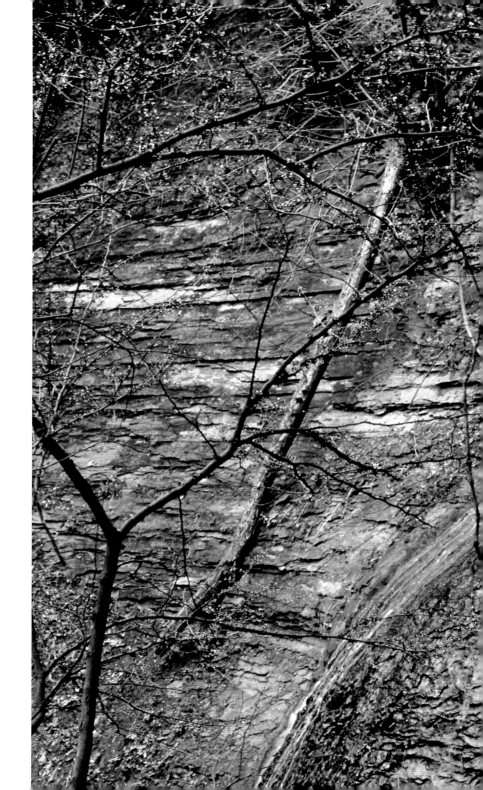

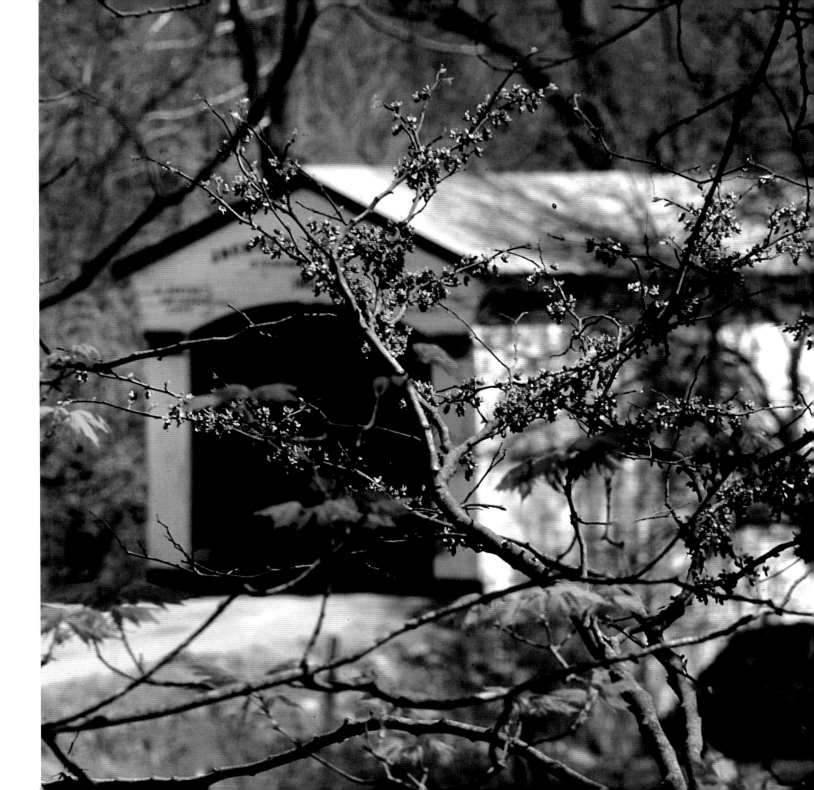

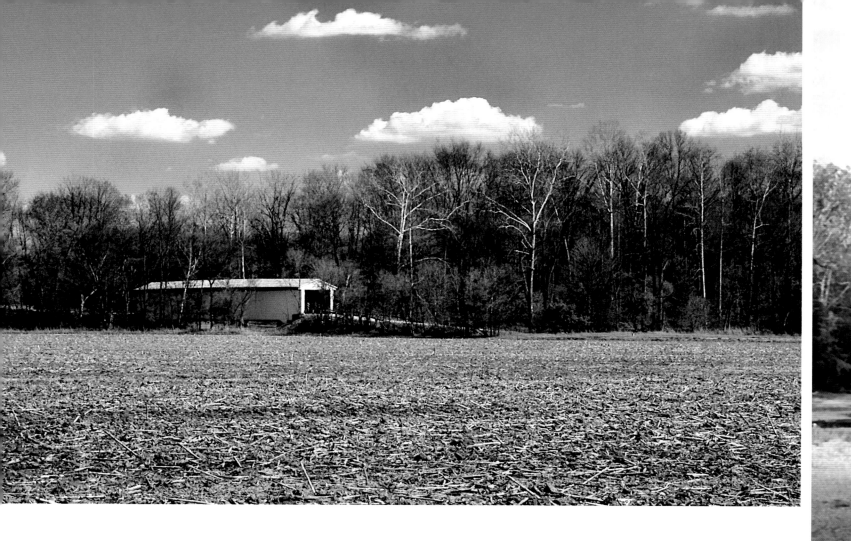

PORTLAND MILLS BRIDGE

SUGAR CREEK AND NARROWS BRIDGE *(facing)*

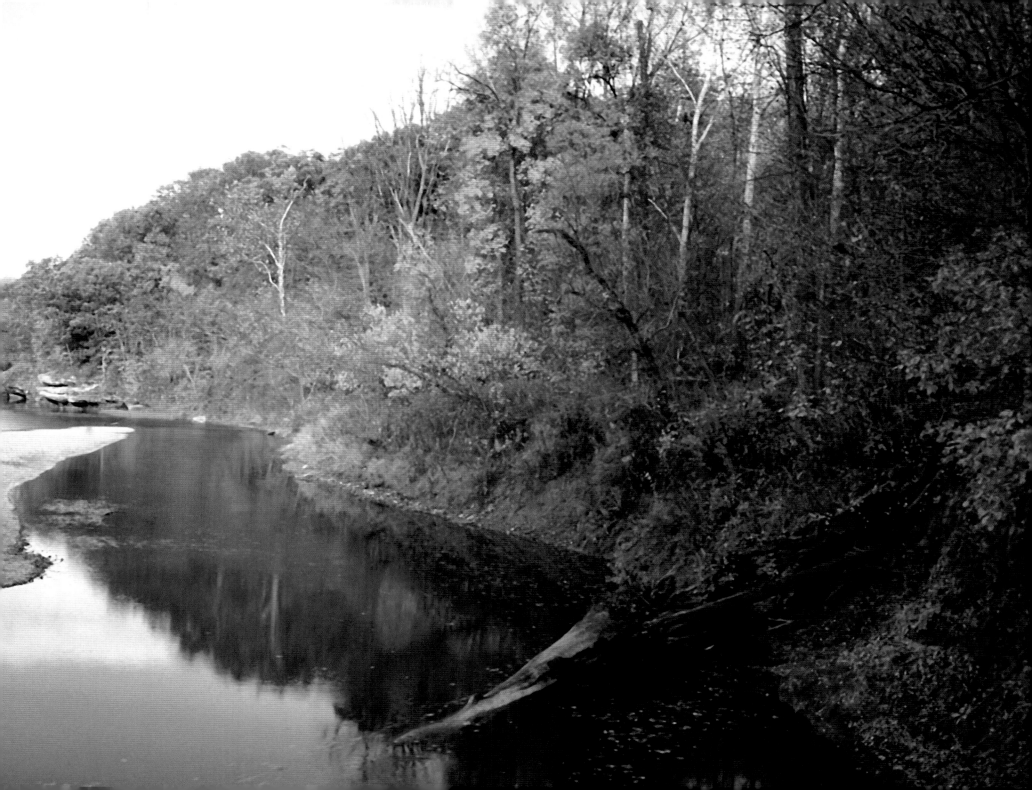

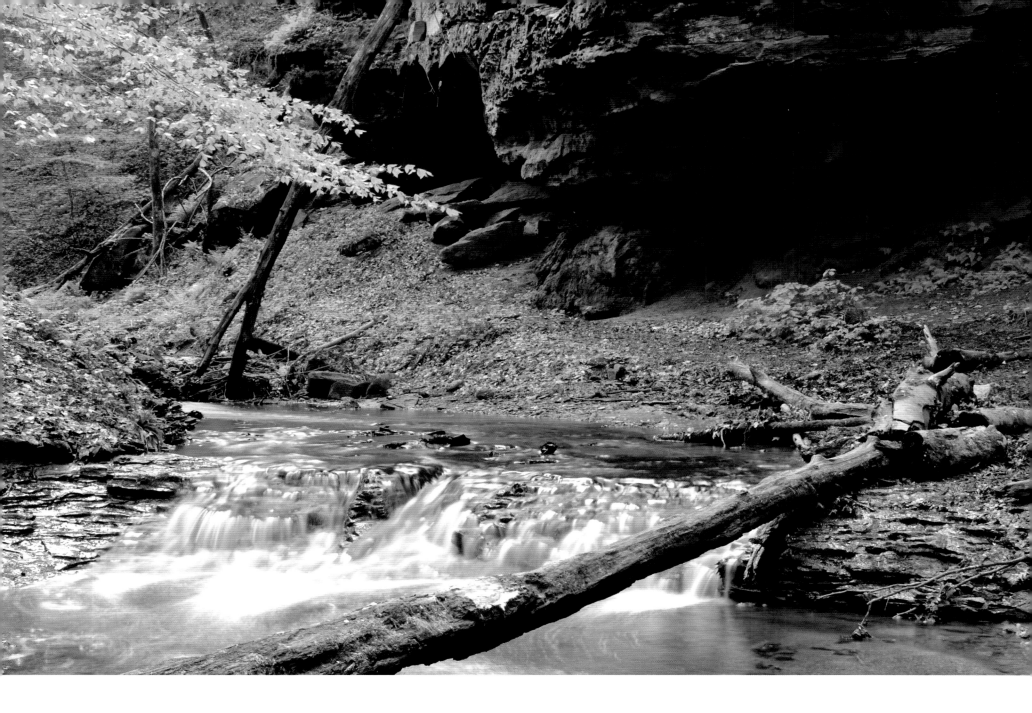

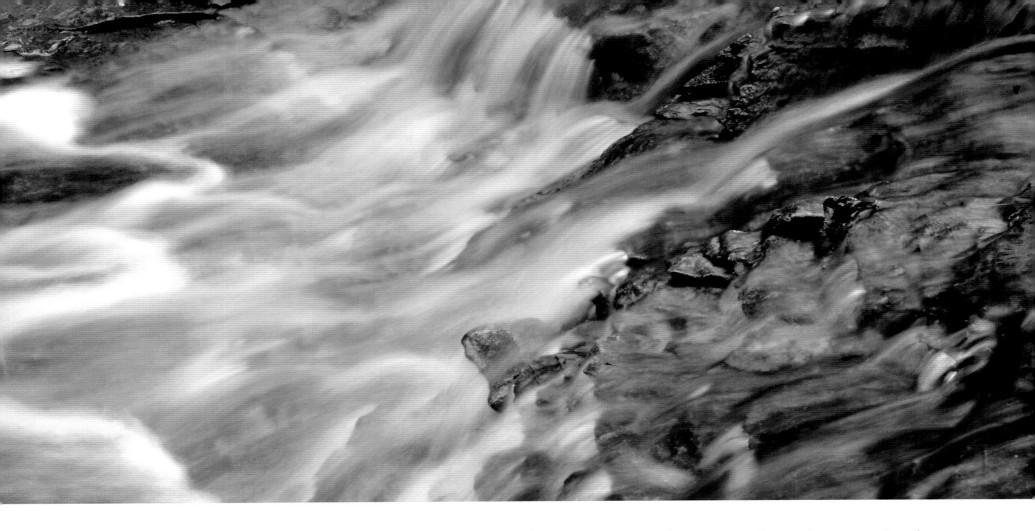

The great naturalist John Burroughs once said, "Nature teaches more than she preaches."

I can't recall a summer where that rings true more than this one.

—A Windy Hill Almanac

SHADES STATE PARK, TRAIL 1 *(above and facing)*

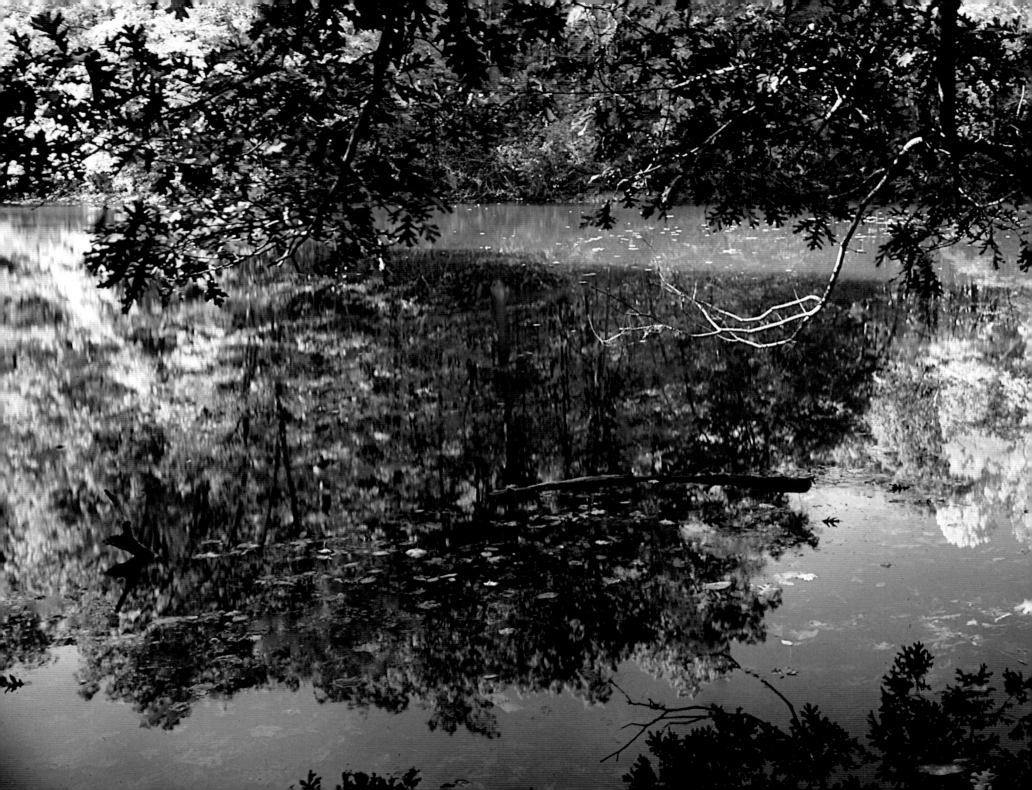

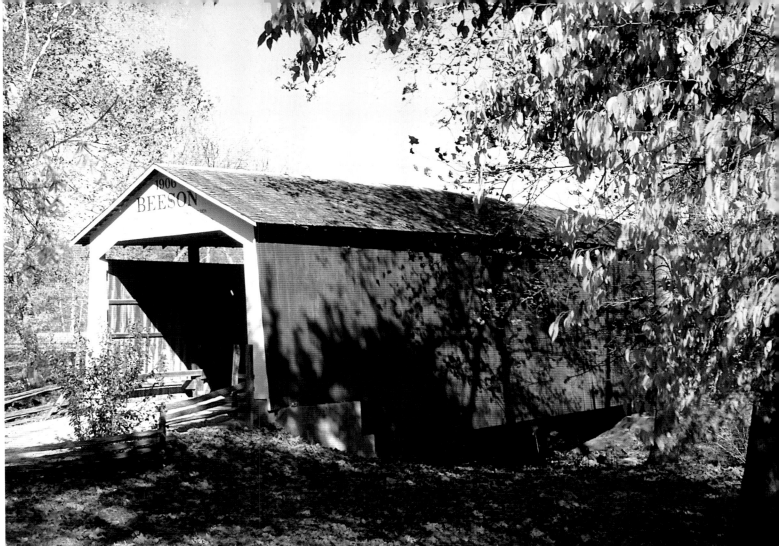

BEESON BRIDGE

POND AT SHADES STATE PARK *(facing)*

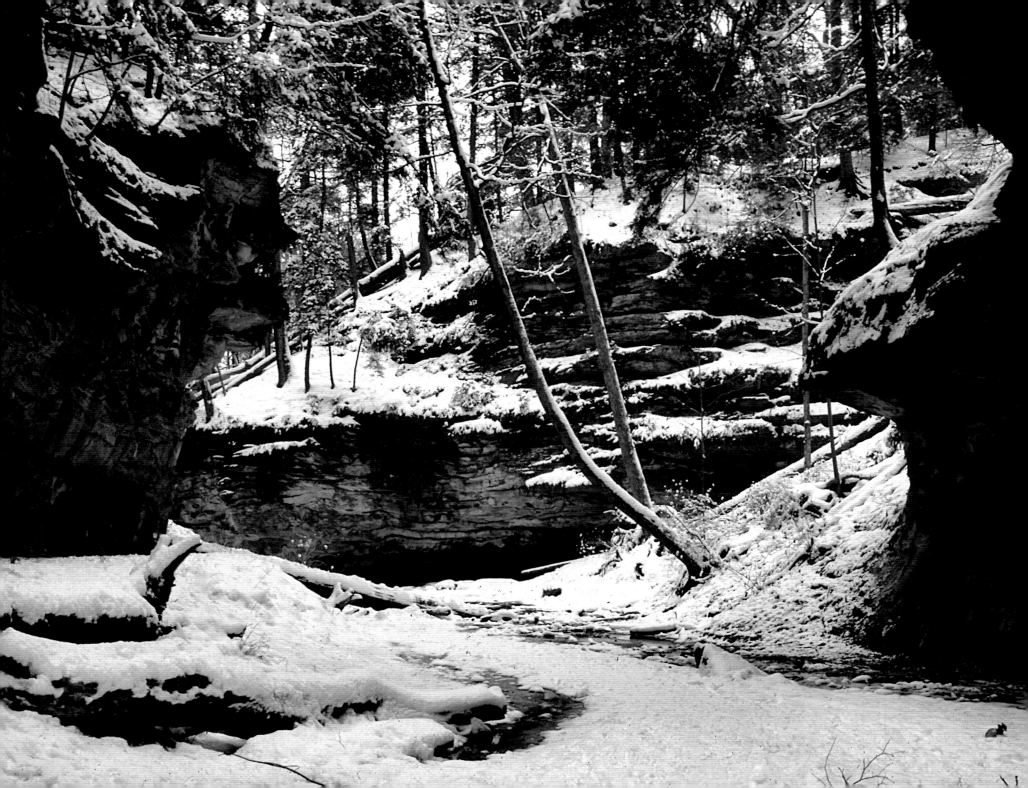

If I am to catch steam on creek water,

Test ice on white-frosted ponds,

If I am to become inspector of last year's cattails

and paper-thin leaves,

It must be now.

—Before March Comes

TURKEY RUN STATE PARK *(facing)*

TURKEY RUN STATE PARK, TRAIL 2 *(top right)*

TURKEY RUN STATE PARK, TRAIL 3 *(bottom right)*

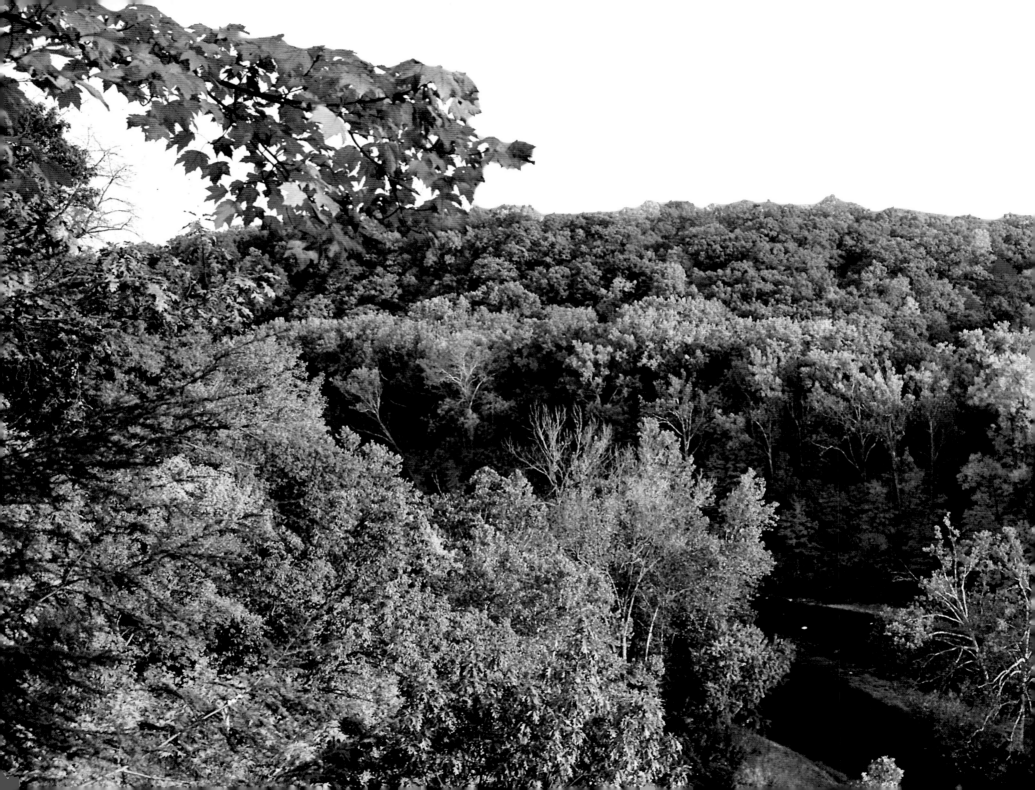

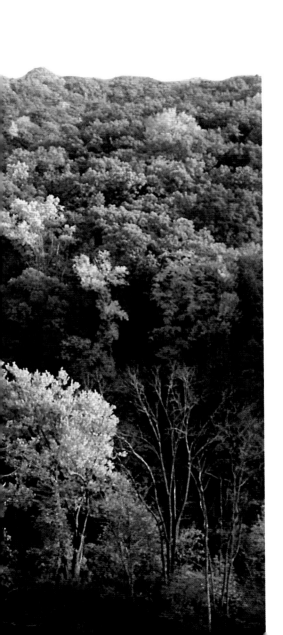

PROSPECT POINT,
SHADES STATE PARK
(facing)

TURKEY RUN
STATE PARK AND
SUGAR CREEK

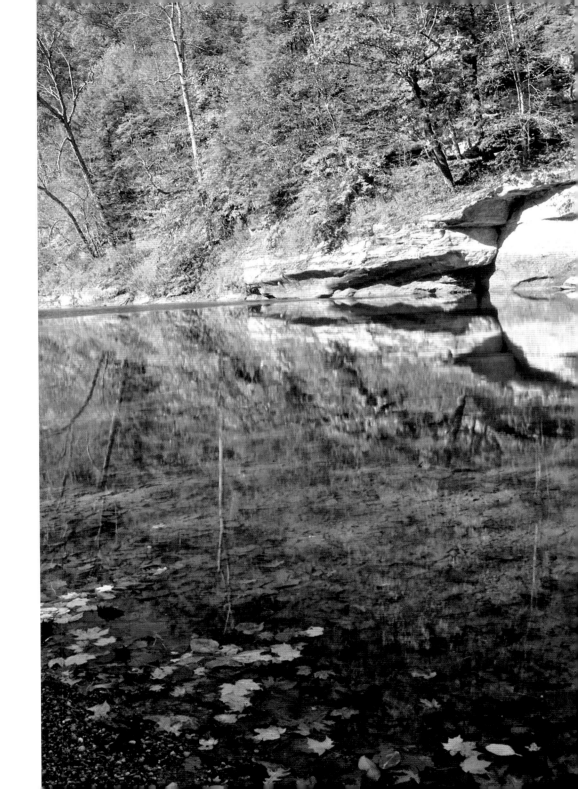

*I think I've always been a homebody, happy that
I have a sanctuary to return to, where it is quiet
and comfortable, where blue jeans and home-grown
tomatoes and home-cooked meals always have been
and still are the order of the day.*

—The Off Season

NEAR TANGIER

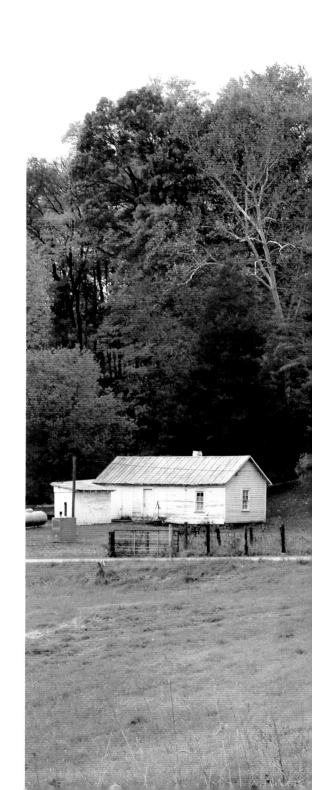

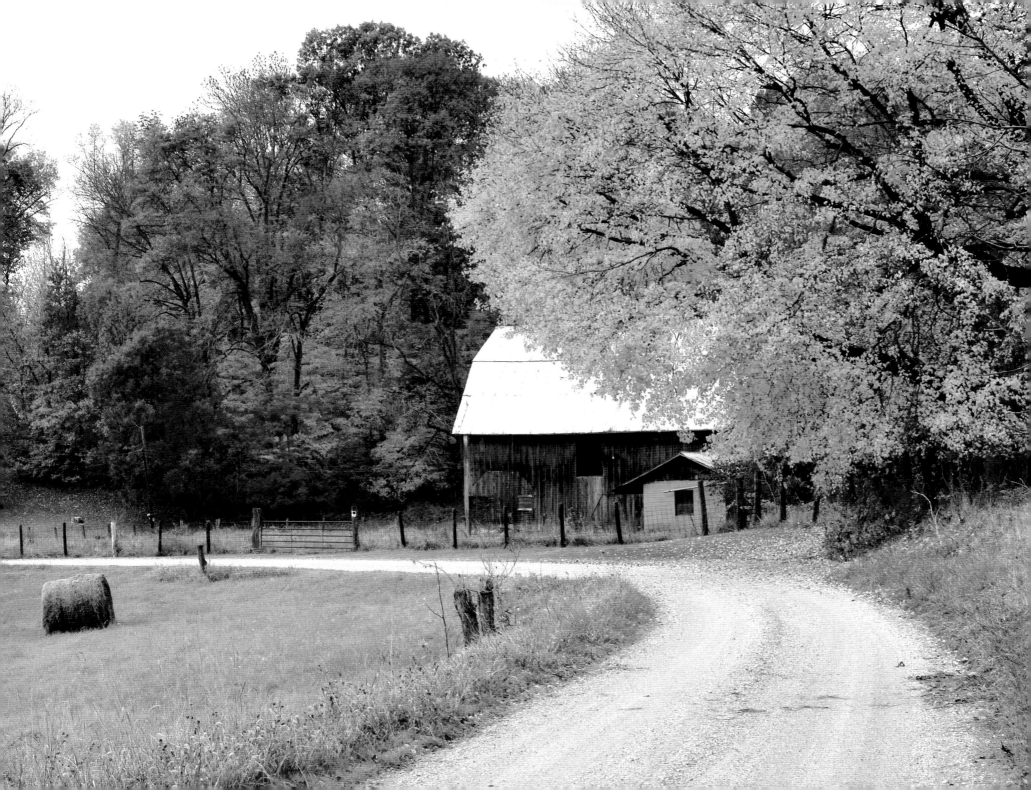

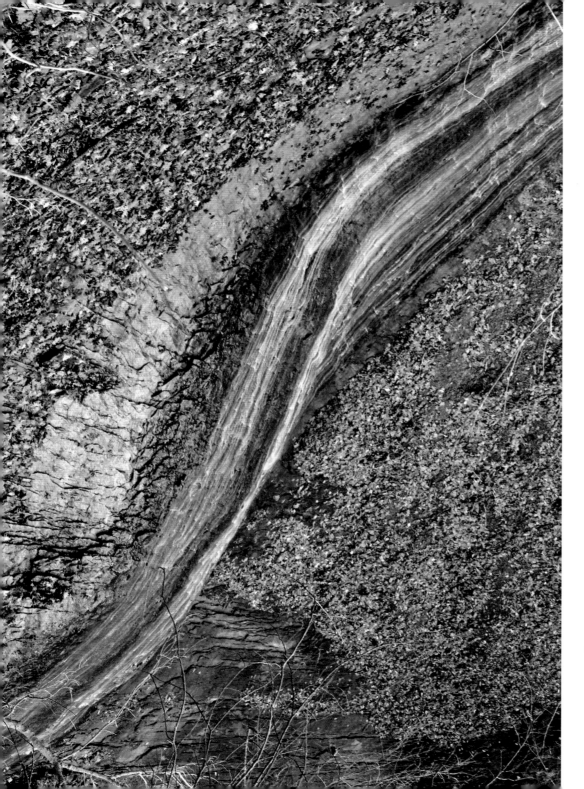

SILVER CASCADES,
SHADES STATE PARK

TURKEY RUN STATE PARK
(facing)

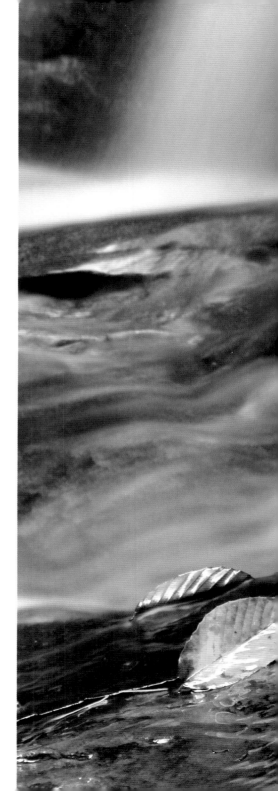

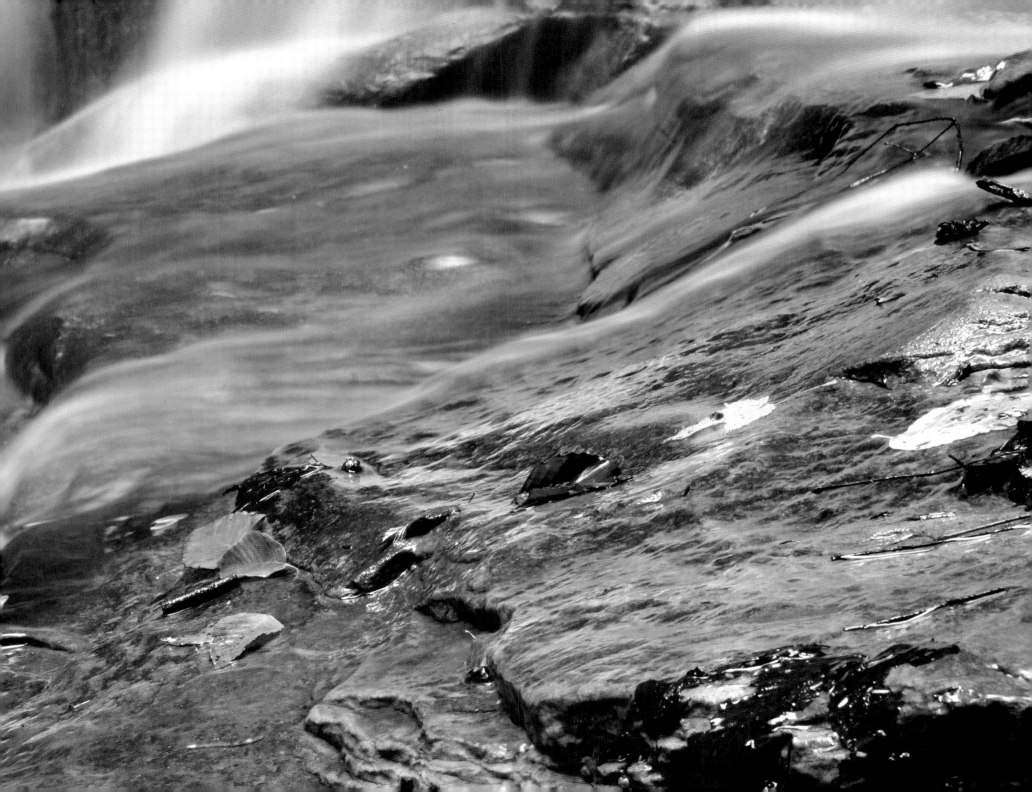

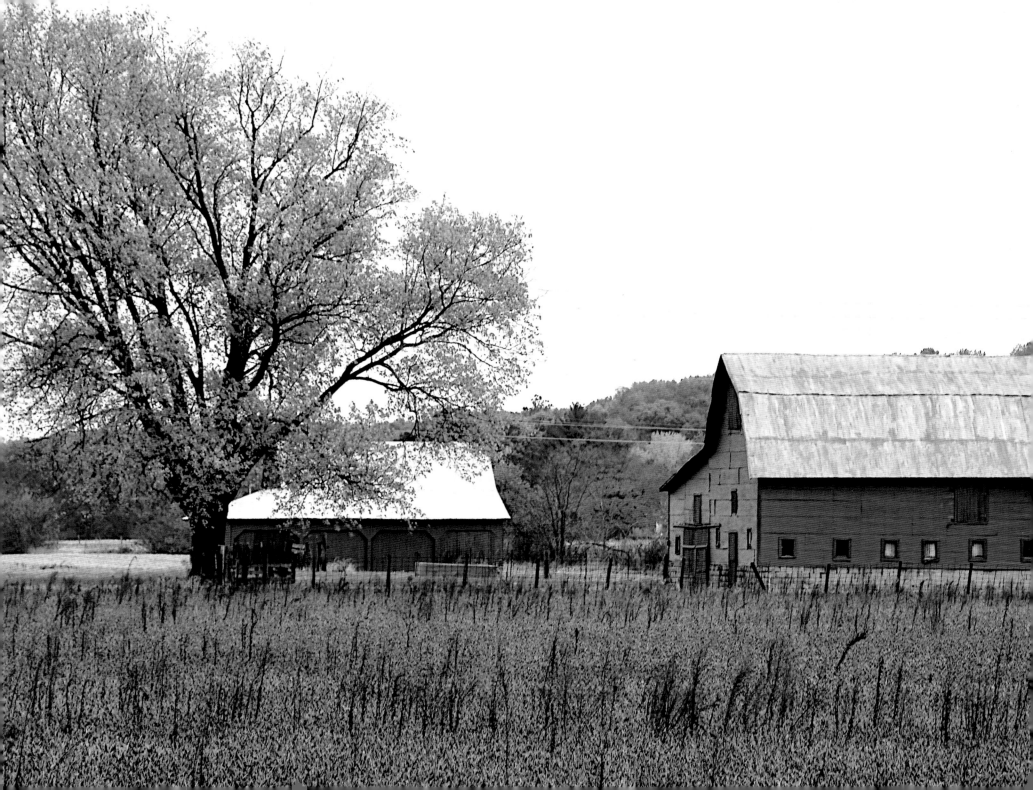

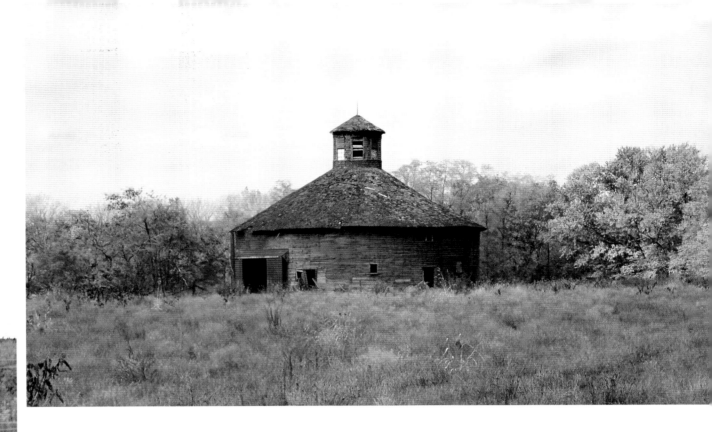

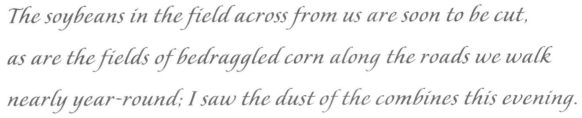

The soybeans in the field across from us are soon to be cut,

as are the fields of bedraggled corn along the roads we walk

nearly year-round; I saw the dust of the combines this evening.

—A Windy Hill Almanac

NEAR LODI *(above and facing)*

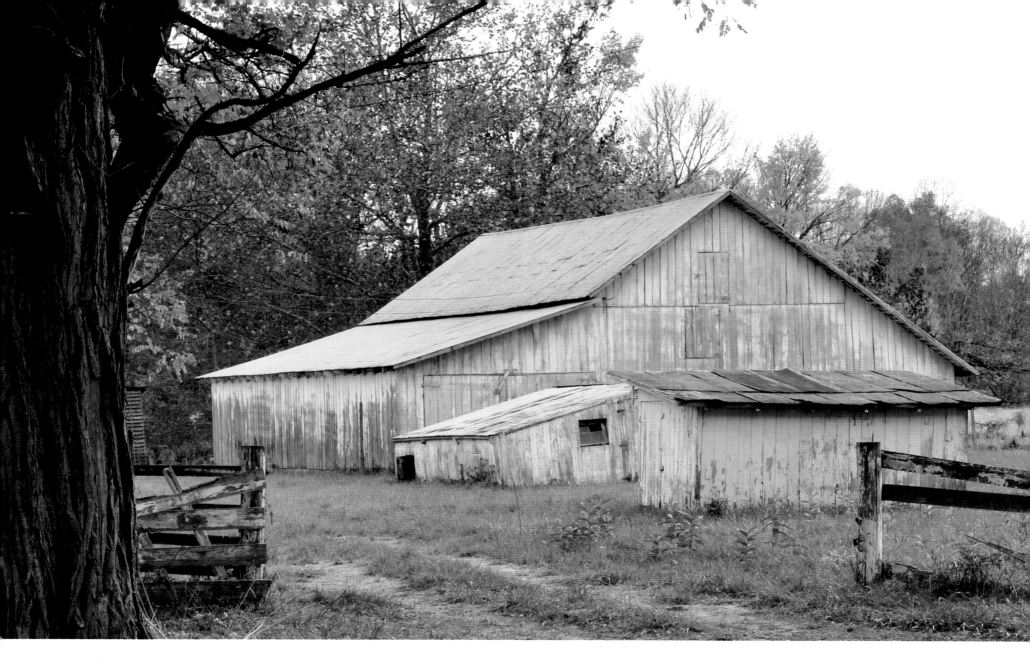

BARN NEAR BELLMORE

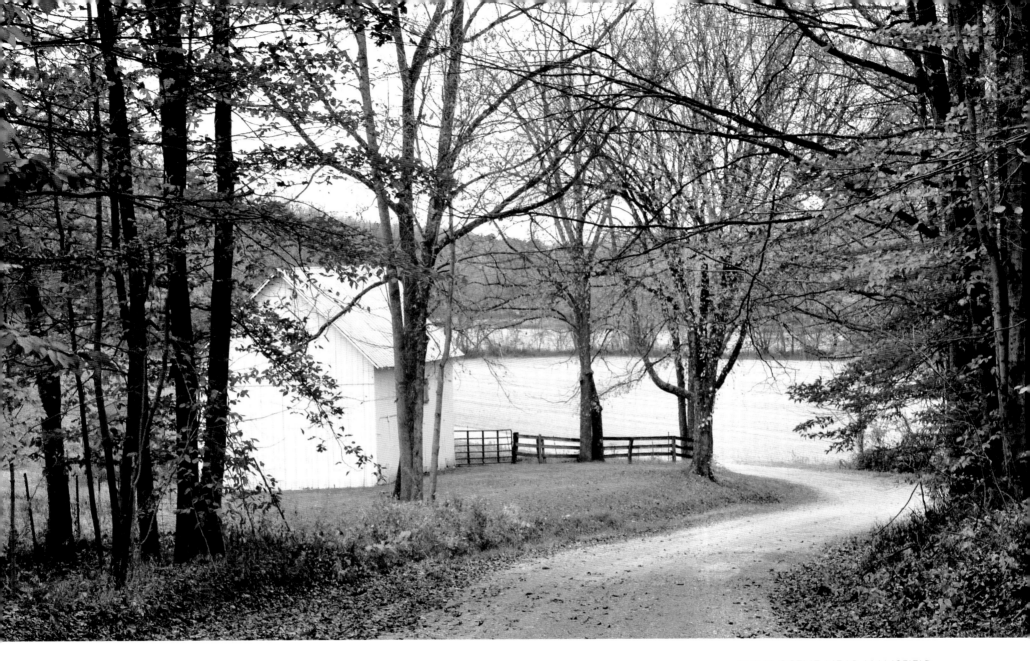

RURAL SCENE NEAR MANSFIELD

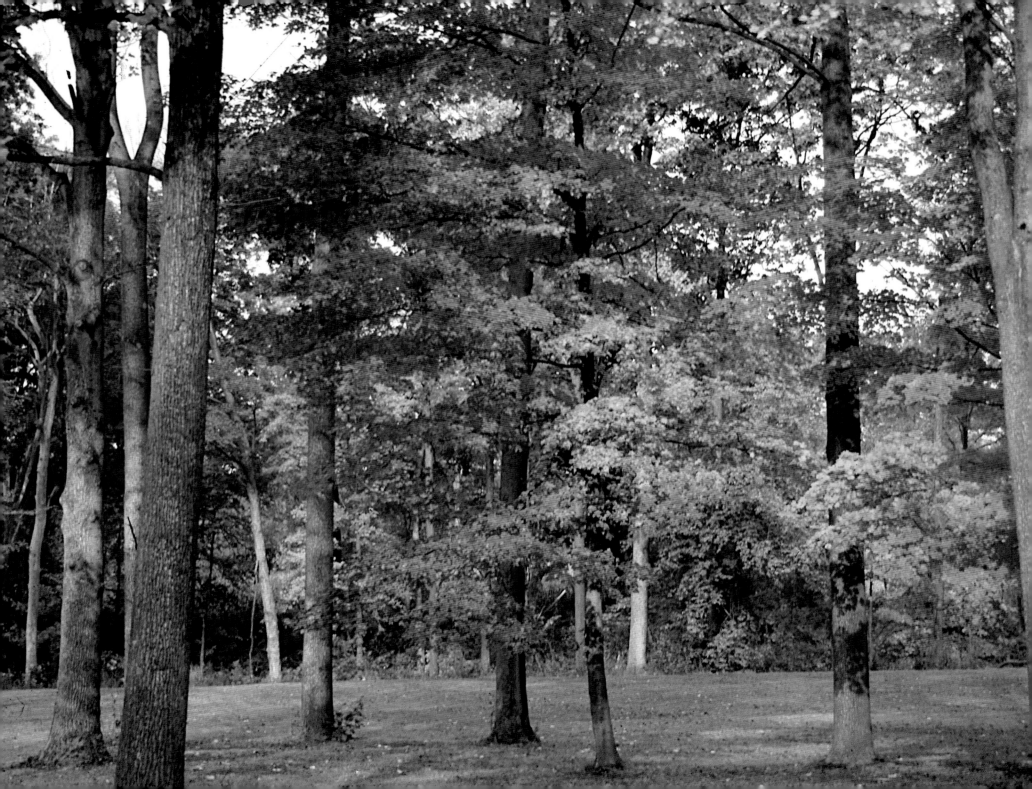

AT MANSFIELD

NORTHERN PARKE COUNTY *(facing)*

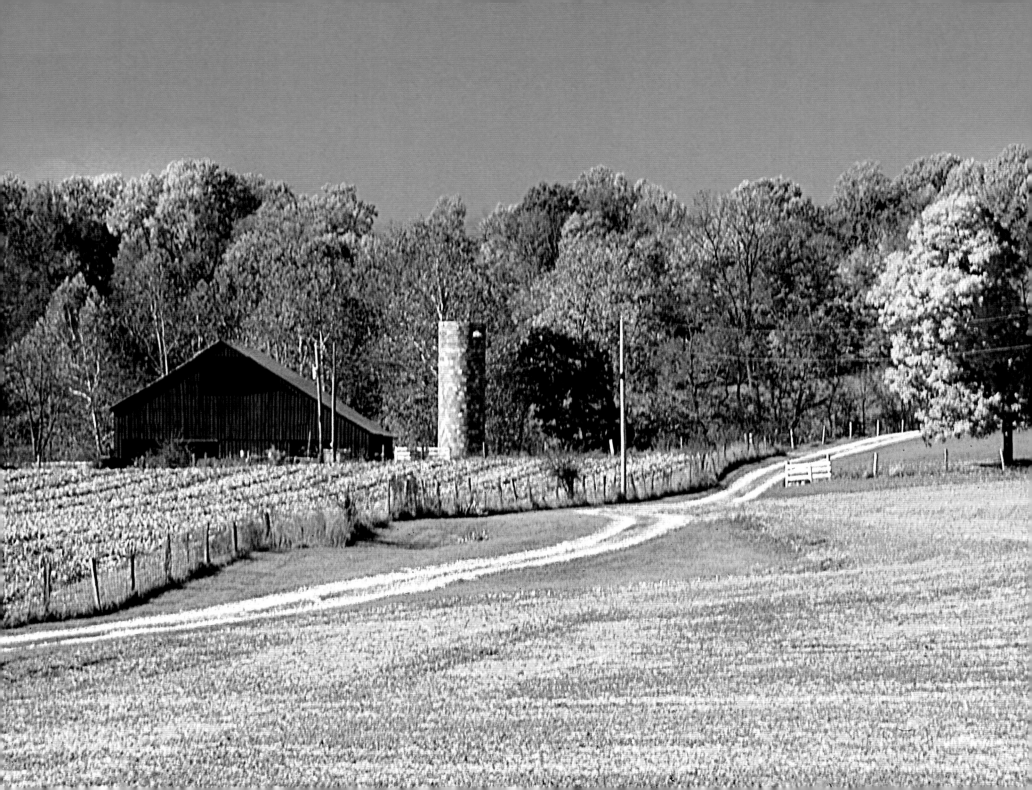

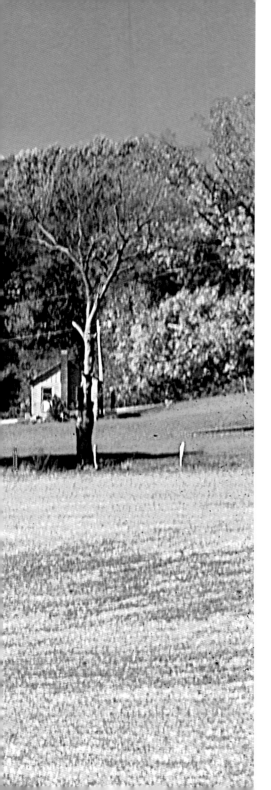

Now is the time of year for putting things in their places;

my wife is itching to buy pumpkins, wants to know if

I have a few bales of straw in the barn to sit under our

yellowing tulip poplar.

—A Place Near Home

NEAR ROCKVILLE

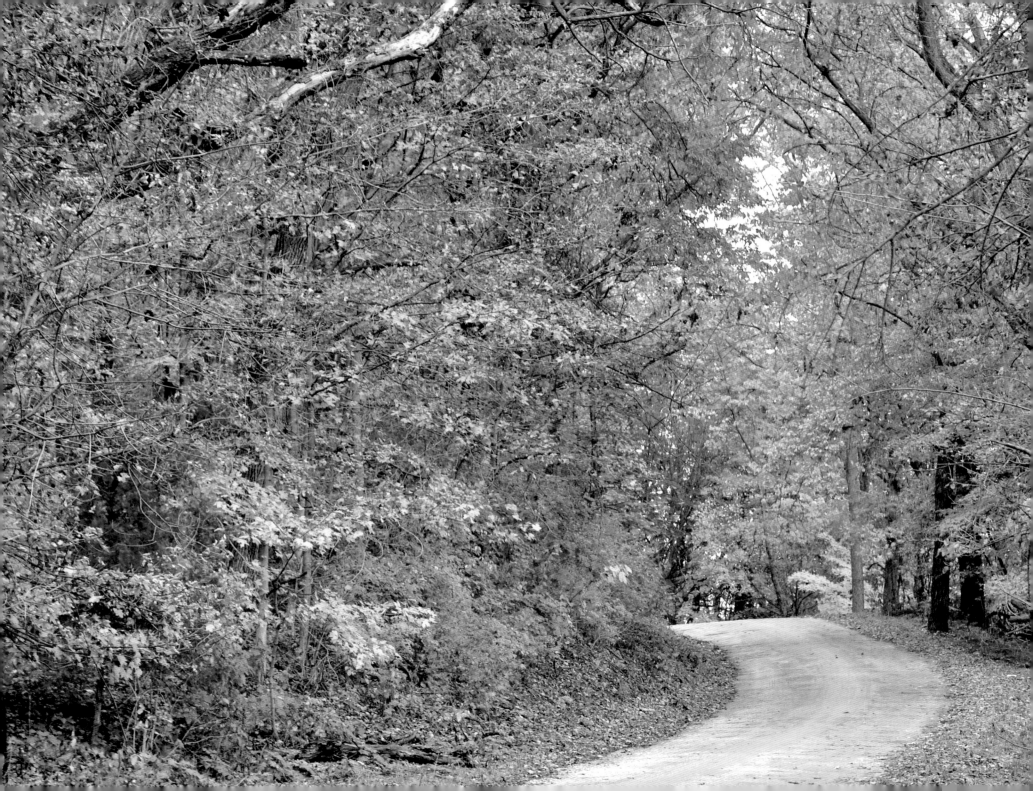

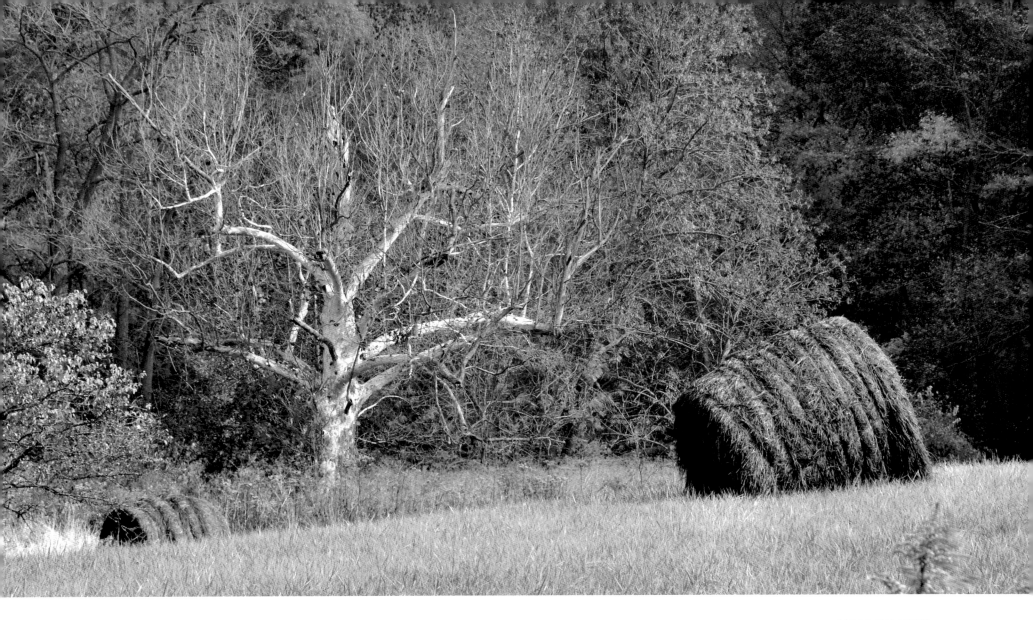

NEAR TANGIER

NEAR HOWARD *(facing)*

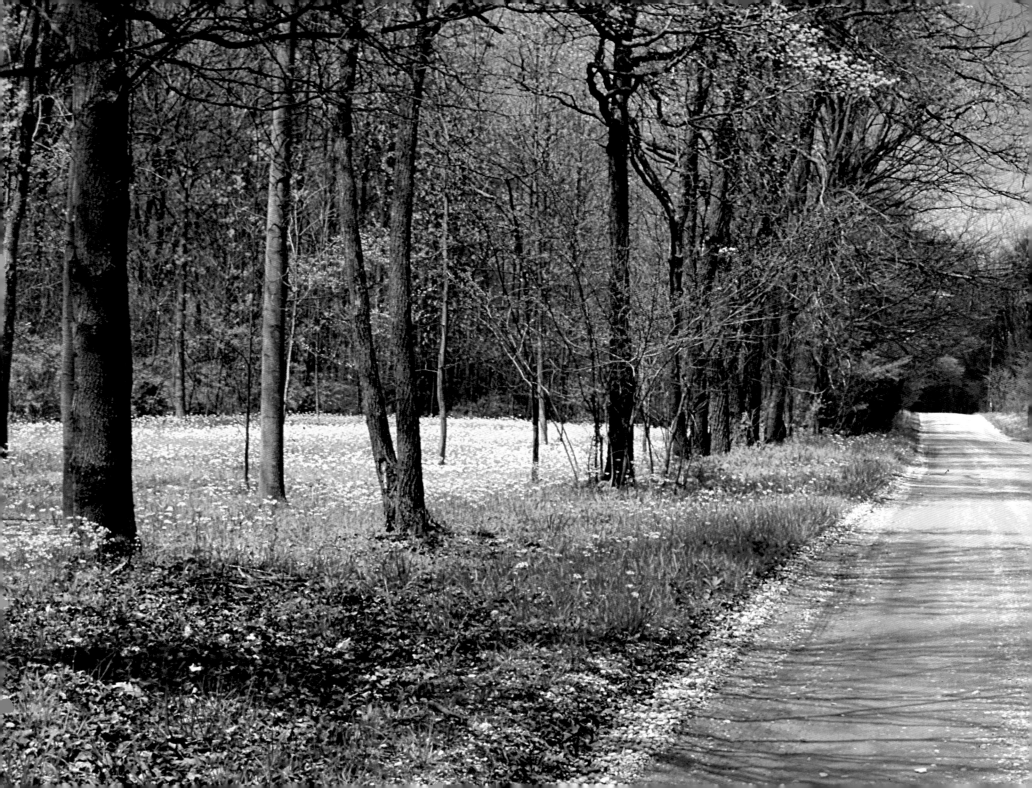

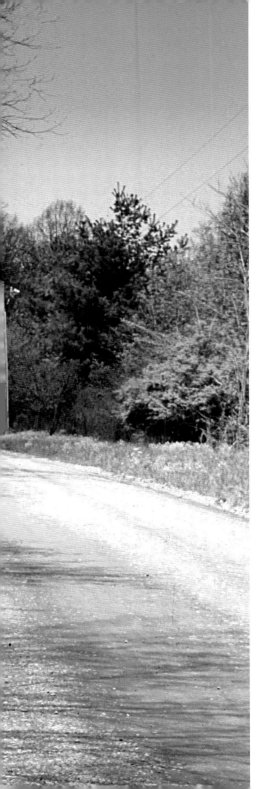

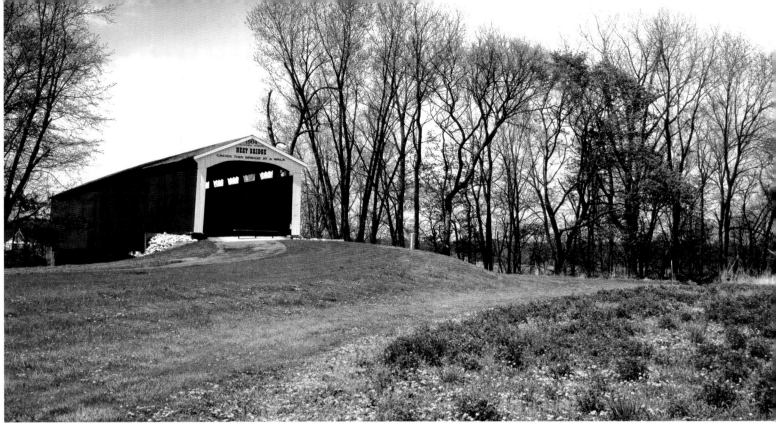

In this report from the country, I am glad to say that the sassafras

is green and the raspberry briars and the honeysuckle have small

ruby-colored leaves of new growth on them; I can smell the flowers

of the latter in imagined summer breezes already.

—A Place Near Home

NEET BRIDGE

NEAR MARSHALL *(facing)*

PORTLAND MILLS BRIDGE

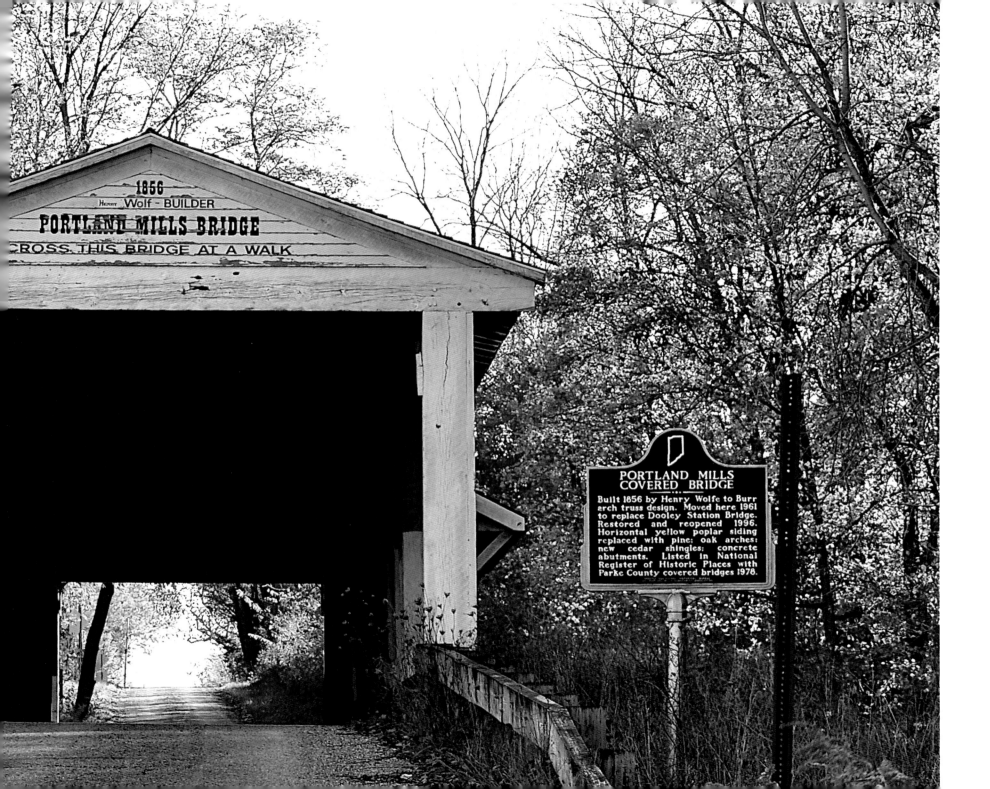

129

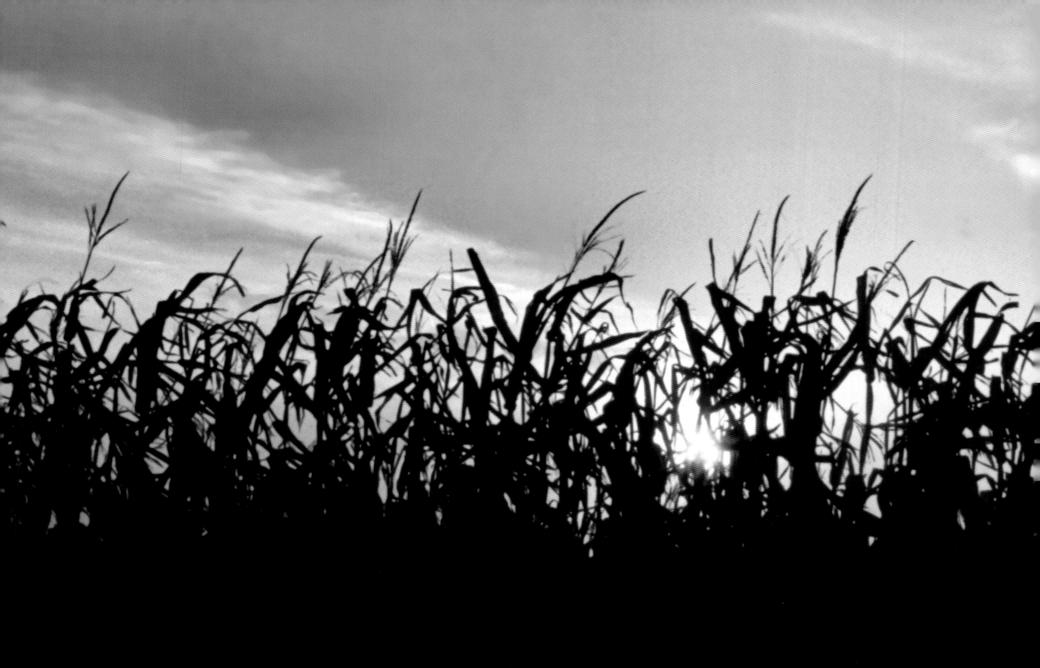
SUNSET, SOUTHERN PARKE COUNTY

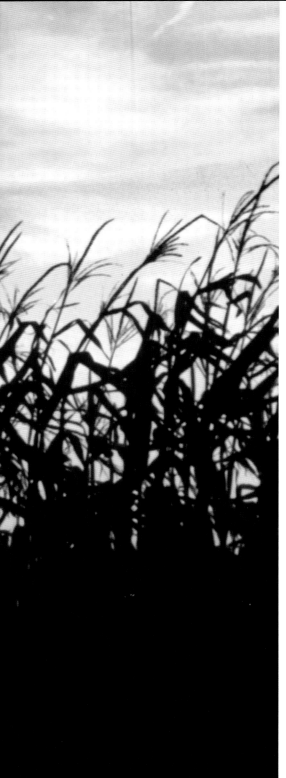

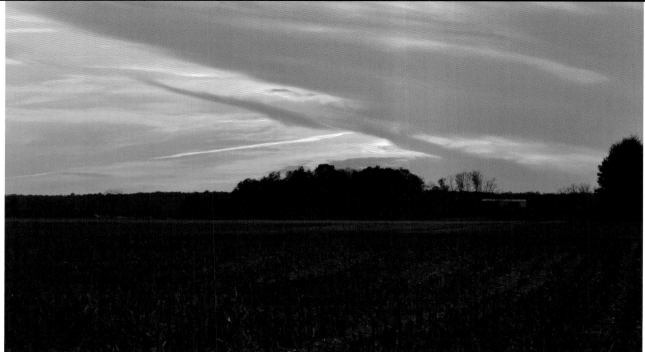

I'd like to think that I thought of it, but my poetic mate

says she thinks the rattle of the brittle, sandpaper-like

leaves of the drying corn sounds as if the plants are

clapping in a skinny standing ovation for the bountiful

harvest and the coming fall. I think its rustling in the

breeze is a sad sound, as if the corn knows its time has come.

—The Off Season

SUNSET NEAR MANSFIELD

AFTERWORD

Jon Kay

FROM COVERED BRIDGES AND OLD BARNS TO WOODED landscapes and waterfalls, the images of Marsha Williamson Mohr capture in colorful detail the picturesque landscape of Parke County. Her images bring into view the rich natural and cultural heritage of this distinct pocket of the state. However, just beyond the focus of her camera are the people who make this place their home.

I write this afterword not as an expert on Parke County. I am not a historian or local scholar, but rather an outsider, a wondering folklorist who was lucky enough to spend time in the county interviewing a few of the creative locals and learning about their lives and their artistic pursuits that are inspired by the natural resources and cultural heritage of this community. As the director of Traditional Arts Indiana, I had the opportunity this past fall to explore the communities and traditions of the "Covered Bridge" region of our state, working to identify some of the traditional artists who live near Turkey Run State Park. From woodcarvers and taxidermists to quilters and blacksmiths, I documented the work of a variety of artisans in the region, and quickly discovered that many of their expressive forms related to the county's strong hunting, timbering, and farming traditions. The relation between people and place struck me as a defining aspect of life in this rural region. Below, I introduce a few of the people who shared their talents and stories with me while I crisscrossed the county that Mohr has so strikingly captured in photographs. My aim is to encourage readers to appreciate this county, not just because of the artistry of Mohr's images, but also because of the aesthetics of everyday life found there.

When I began my research project, several locals told me I had to meet John Bennett, an artisan blacksmith whose ironwork is both imaginative and functional. Having grown up on a farm in Parke County, he learned to do welding and metal fabrication, but he became enamored with blacksmithing after seeing a hammer-in at the Feast of the Hunters Moon festival in West Lafayette. On his way home from the event, he bought an anvil, and soon he began teaching himself traditional blacksmithing techniques. Today, the flora and fauna of Parke County inspire his work. From hummingbirds in flight to dogwood blossoms, John incorporates natural forms and motifs into his architectural ironwork and decorative pieces. In iron, his art halts the momentary splendor of nature for others to appreciate. Describing a recent project, he says, "I designed a staircase that has roots at the bottom . . . and the whole staircase itself as it goes up is a tree and every picket that comes up is a smaller tree—and there is oak, maple, sassafras, and tulip poplar in the whole spiral staircase and I stopped counting at 173 leaves." Recently he began making antlers that he shapes from iron and textures to resemble those that bucks shed in winter. An avid teacher and demonstrator, John is working with Parke County 4-H to lead workshops and mentor the next generation of young smiths. He also demonstrates his talents at various local festivals and events, including the Covered Bridge Festival activities in Bridgeton.

For some of the artists in Parke County, nature serves as an inspiration for their creative work; others gather raw materials from the environment. Occasionally, material and muse unite, and an artist may carve a bird from a found piece of wood or shave a scene into the hair of a deer hide. These creative impulses are more than an expression of personal artistic vision; they are also a reflection of the region's strong sense of place. Just a few miles north of Rockville, Dave Blake operates his tannery and hosts demonstrations by other area artisans. In a room off the back of his shop, he tans and shaves animal skins to produce pictorial

scenes that he calls "spirit hides." From an eagle soaring in the sky to hounds treeing a coon, he sculpts images by cutting the hide's fur to different lengths, which produces the various shades in his wall hangings. Though originally from Montana, his family relocated to Parke County in 1969, when he was a teen. Over the years, he moved back and forth between the two states, but finally settled permanently in Rockville in 2005. Though Dave learned to trap, skin, and tan hides at a young age, it was not until years later that he started making fur hats, coats, and moccasins to sell. In 1995, while snowed in in Montana, he tanned an elk hide. Looking at the skin, he envisioned an image of an eagle carved in the fur and the idea for his spirit hides was born. Today his art hangs in parks, resorts, and lodges throughout the United States, but it is shaped by his love of nature, hunting, and life in Parke County.

Similarly, Josh Schmeltz transforms wild game into works of art. He grew up in his family's taxidermy business and did his first mount, a squirrel, when he was twelve. By the time he was eighteen, he was working alongside his father, learning the trade. Since then, he has done thousands of mounts, mostly deer heads and wild turkeys for local hunters throughout the tri-county area. He works in a rustic shop that his father and grandfather built, and that Josh helped expand a few years back. The father-and-son team worked in tandem for several years, until Josh's father passed away; now the young artisan does most of the work by himself, mounting the prize trophies of local hunters and preparing special exhibition pieces for park nature centers and museums. Josh strives to make his art as realistic as possible: by hand-shaping styrofoam forms and taking special care in the placement of the eyes, he tries to make each of his mounts appear alive. An avid outdoorsman, Josh has also invented a lifelike decoy made from a wild turkey mount that pivots and fans its tail feathers, which imitates the appearance and movements of wild turkeys. The decoys have garnered the attention of turkeys and hunters alike. In addition, he makes fur hats and bags throughout the year, which he sells at the Covered Bridge Festival.

Glen Summers grew up in Michigan, but always loved visiting his family's property in Parke County and knew that when he grew up he would make it his home. The land that lured him to Indiana continues to inspire him as both an environmental advocate and an artist. Glen makes wooden bowls. In fact, he continues a tradition that has deep roots in the region. While visiting the Indiana State Fair in 1982, Glen Summers met veteran bowl-maker Bill Day, and spent the afternoon talking with the senior and watching him work. After that chance meeting, Glen was lucky to find a bowl adze at a flea market and soon taught himself to hew bowls based on Day's instructions. After years of making bowls, he reconnected with Day, and visited with him from time to time until Day's death. It might seem improbable that a random meeting could fuel decades of bowl-making, but perhaps Glen was predestined for this kind of handwork. A fourth-generation woodworker, he reflects, "My great-grandfather was a barn builder in Illinois and my grandfather and dad were carpenters and I have been a carpenter as well, but there was some tug for me to more traditional woodworking." This pull toward the traditional has led Glen to make ladder-back chairs with woven hickory-bottom seats from timber harvested from his family's land, using tools he inherited from his great-grandfather.

Traditional knowledge meanders through the generations, sometimes in the most uncertain of ways. An elder may wait years to identify a receptive apprentice, and may never find one at all. Greg Bryant weaves intricate patterns into the seats and backs of old chairs in his antique shop near the small community of Annapolis. In his early teens, he bought an old chair at a sale, and wanted to re-cane it. Luckily, Hubert Saylor, an elderly neighbor, was willing to teach him. While the old farmer thought his student "wouldn't stick with it," decades later Greg continues the craft. He canes both for his community and to repair the chairs he sells in his shop—doing most of the tedious work in the wintertime when business is slow in Parke County. Alone in his shop, Greg pokes and pulls strands of wet cane into attractive honeycomb and bow-

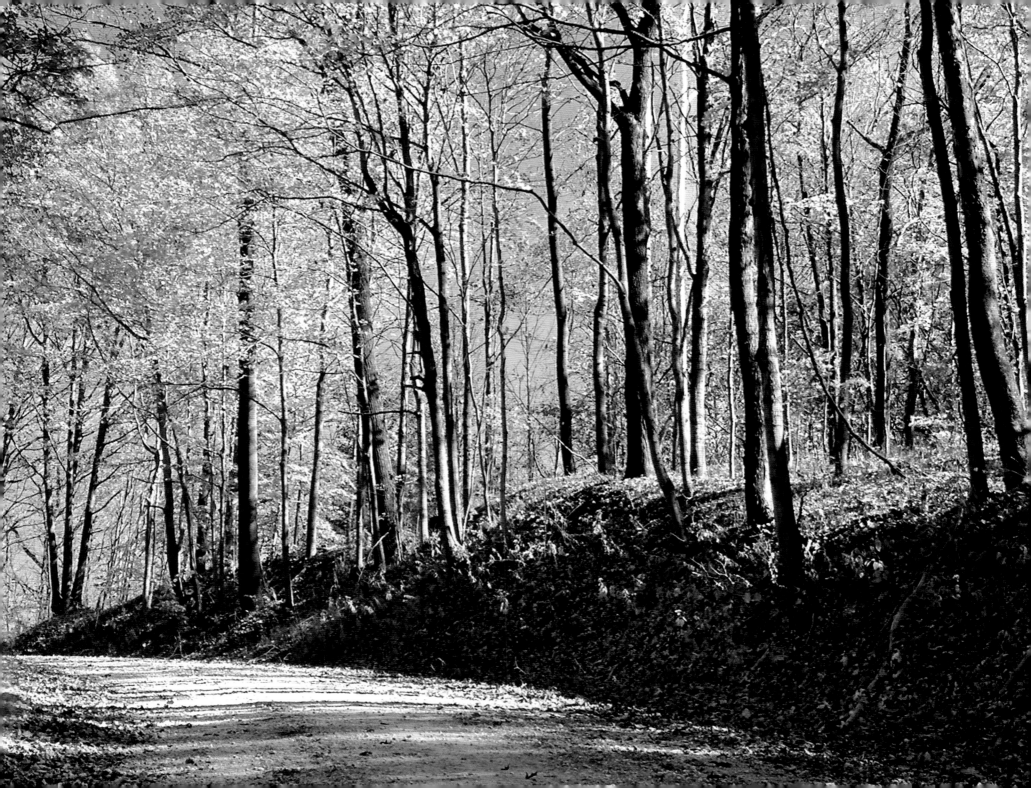

tie patterns—breathing years of life back into old chairs and continuing an old Parke County tradition.

The making of maple syrup remains an important winter practice in some Parke County families. Each year several sugar camps open their doors to visitors wishing to observe the process and sample the sweet success of their labor. While some camps such as Foxworthy's hold to traditional methods, others like the Williams & Teague camp have embraced new techniques to keep the tradition going. Florence Williams grew up helping her family make maple syrup. At ninety-one, Florence has seen great changes in the way her family makes syrup—where once they tapped trees and hung buckets to collect sap, today they use tubing to accomplish this task. In addition, they now use a reverse-osmosis system to remove the excess water from the sap, which shortens the amount of time and energy it takes to boil down the syrup. Nevertheless, syrup-making continues as a family operation, with both her sons-in-law and her grandsons helping each year. Despite her age, Florence remains an avid spokesperson and promoter for syrup-making in the county, which hosts an annual maple syrup festival on the last weekend in February and the first weekend in March.

The Covered Bridge Festival is arguably one of the most defining facets of life in Parke County. Generations of families and community groups have made and sold festival foods and popular crafts to the roughly one and a half million visitors who flood into the county each fall. One artisan, Sue Engle, makes homemade candies that she sells under the "big tent" in Rockville during the ten-day festival. Between Labor Day and the beginning of the event, she and her family make at least ten thousand bags of rock candy. While the event is large and a major economic driver for the county, many come to the festival year after year to see old friends and family. For some, buying a bag of candy from Sue is an important annual ritual, and more than a few bags of her sweets are sent overseas to boost the spirits of homesick soldiers. It is this sense of community and family engendered by the festival that inspires locals such as Sue to continue to participate in this event.

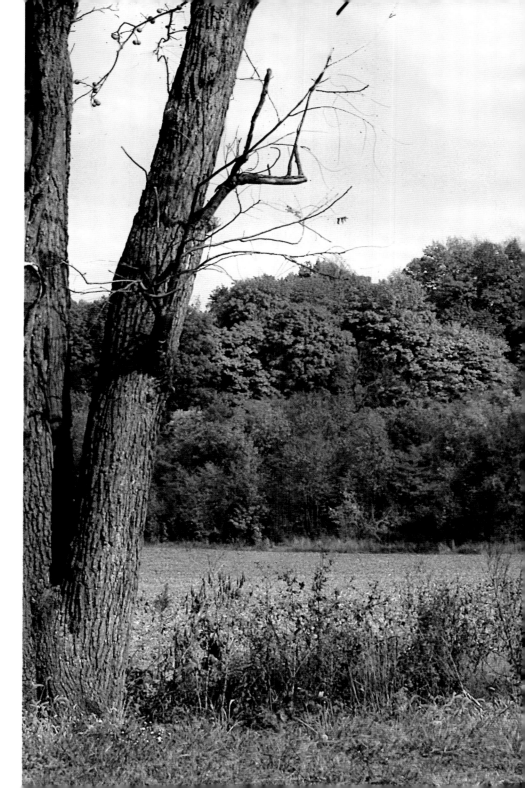

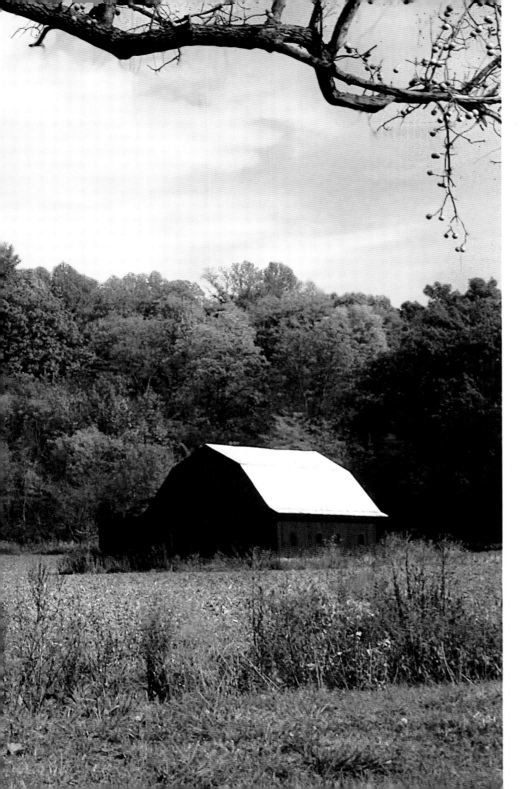

I wish I could tell you about the woodturners, gourd-growers, and other locals I met on my Parke County pilgrimage, but space does not allow; however, I want to introduce you to one more person. Archie Krout does not live in the county, but his art connects him to this special place. The ninety-year-old Crawfordsville man plays a variety of old Parke County fiddle tunes. Archie's father fiddled for square dances held in people's homes throughout the county and even played at the Turkey Run Inn during the early days of the park. When young Archie expressed an interest in playing music, his father made him a cigar-box fiddle and fashioned a cornstalk bow. It was on this simple instrument that he learned to scratch out local variations on old tunes such as "Arkansas Traveler" and "Red Wing." Today, Archie continues to play fiddle with friends at local nursing homes and senior centers, where others enjoy hearing the old tunes they remember from their youth. Through music, Archie holds a piece of Parke County within him—old melodies with a long history in this place. I mention him, however, because all of us who have been to Parke County keep a piece of it in our hearts and memories. The beauty of Mohr's images is that they remind us of the county's breathtaking landscapes and lasting heritage. Just as melodies carry Archie's thoughts back to long-ago days, I hope the photographs in this book bring to mind your own memories of that special place known as Parke County.

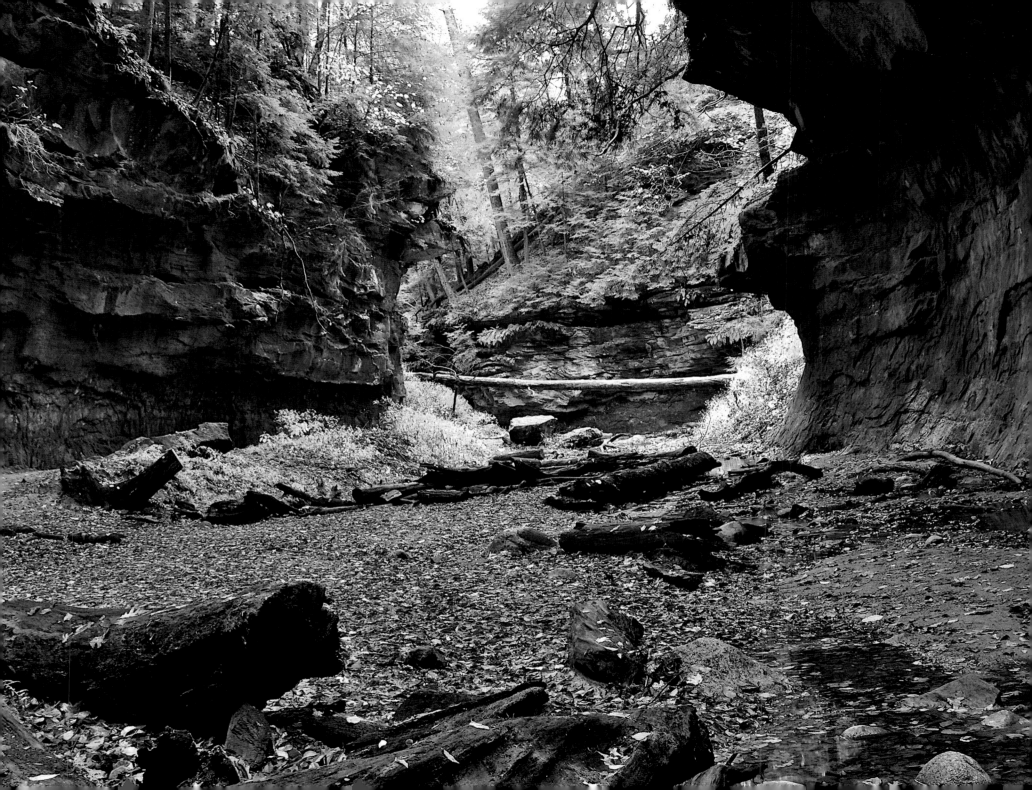

SOURCES

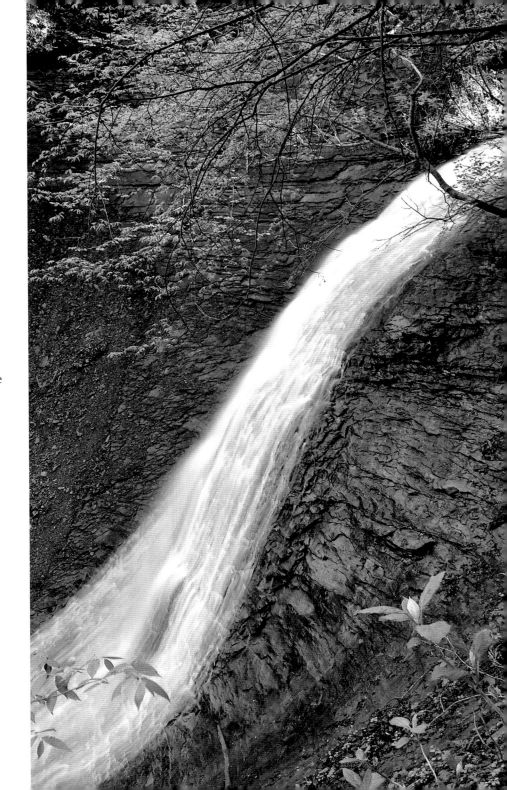

ALL TEXT ACCOMPANYING FIGURES
COURTESY OF MIKE LUNSFORD

"The Long Goodbye to Winter." *Terre Haute Tribune-Star,* March 2, 2014. http://www.tribstar.com/mike_lunsford/x1783699122/MIKE-LUNSFORD -The-long-goodbye-to-winter

"Memories Now Water under the Bridge. *Terre Haute Tribune-Star,* June 27, 2005.

The Off Season: The Newspaper Stories of Mike Lunsford. Rosedale, IN: Shade Tree Press, 2008.

A Place Near Home: More Stories from the Off Season. Rosedale, IN: Shade Tree Press, 2011.

A Windy Hill Almanac. Rosedale, IN: Shade Tree Press, 2013.

UNPUBLISHED POEMS

"Crossing the River"

"Before March Comes"

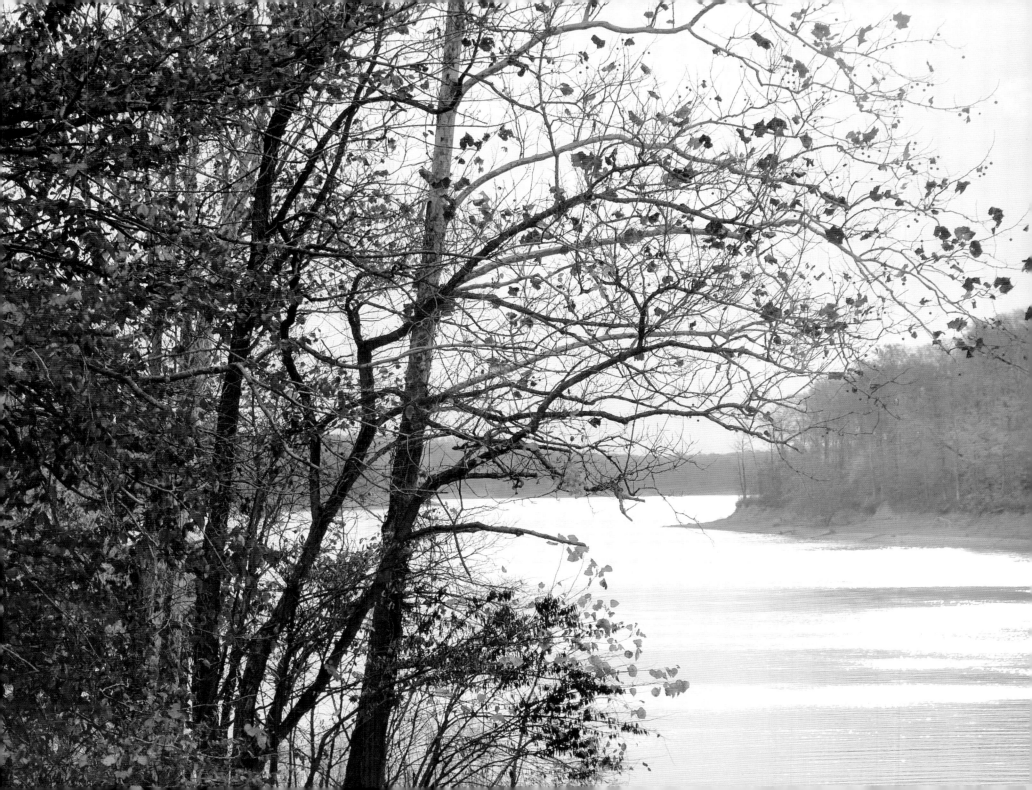

Jon Kay

Jon Kay is Director of Traditional Arts Indiana,
the official state folk arts program at Indiana University.

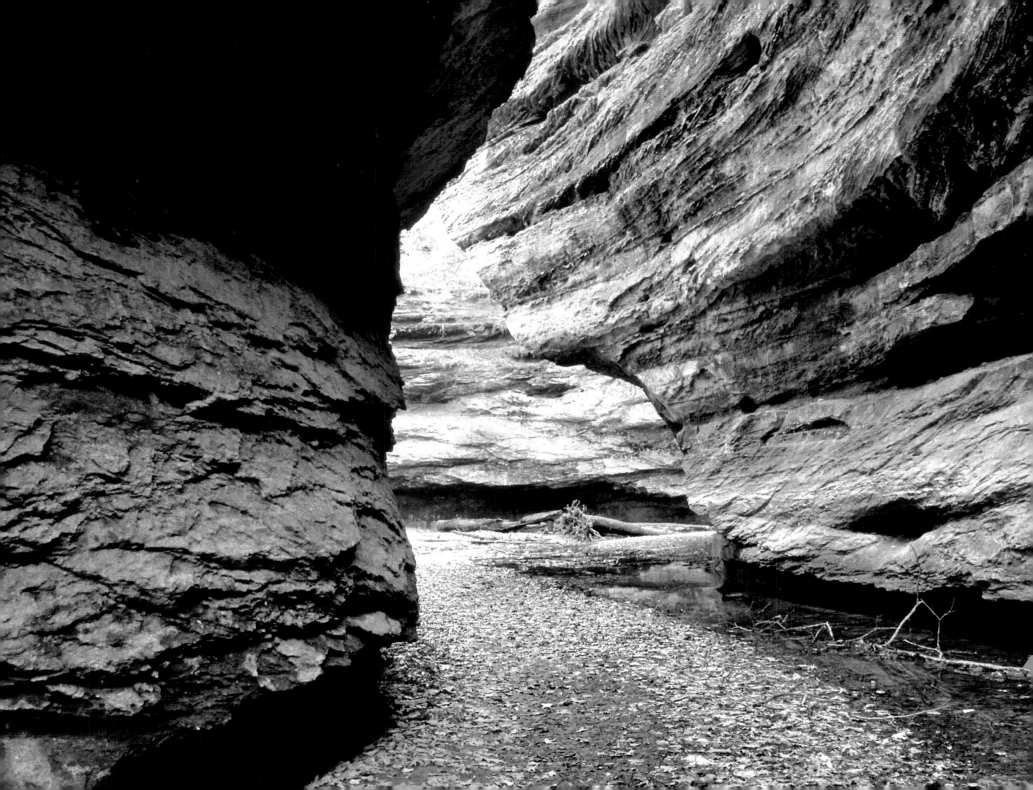

Mike Lunsford

Mike Lunsford writes *The Off Season*, a human interest column for the *Terre Haute Tribune-Star;* he is currently working on his fifth book. His website is http://www.mikelunsford.com.

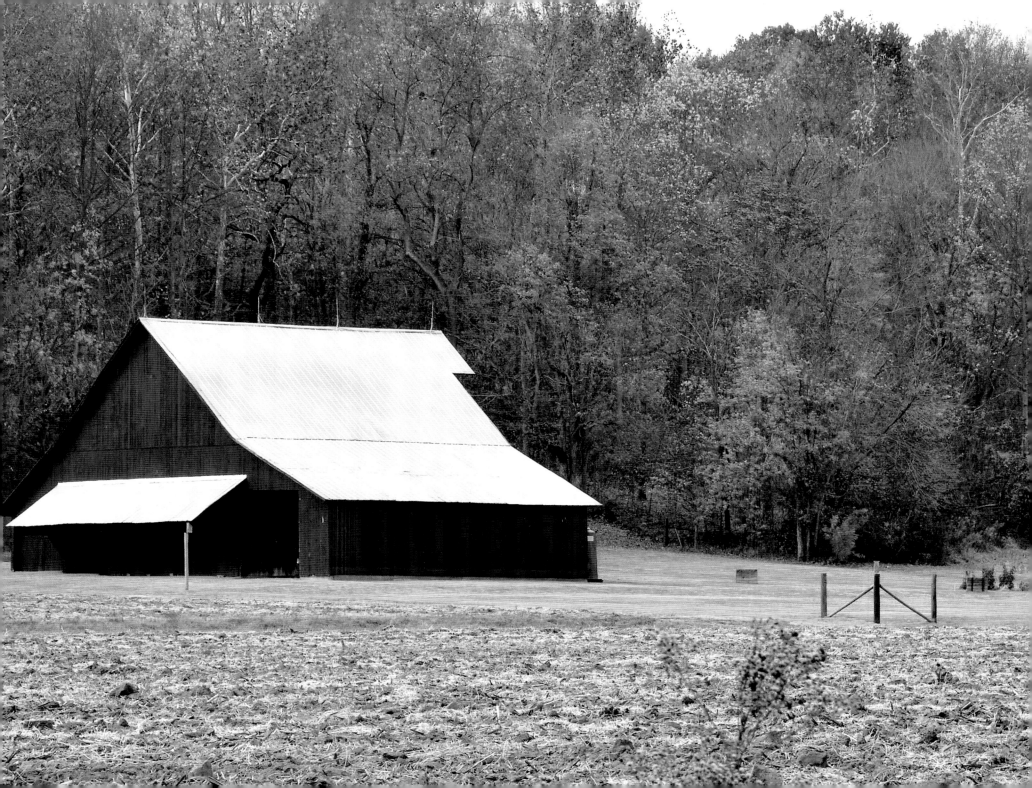

Marsha Williamson Mohr

Marsha Williamson Mohr, a freelance photographer, is author
of *Indiana Barns* (IUP, 2010) and *Indiana Covered Bridges* (IUP, 2012).

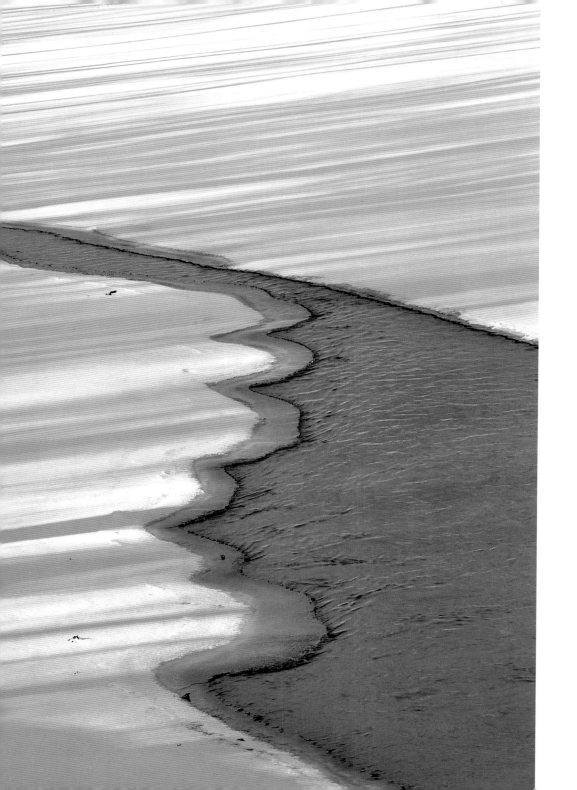

EDITOR: Linda Oblack

ASSISTANT EDITOR: Sarah Jacobi

PROJECT MANAGER/EDITOR: Nancy Lightfoot

MARKETING AND SALES DIRECTOR: Dave Hulsey

EDITORIAL AND PRODUCTION DIRECTOR: Bernadette Zoss

BOOK AND COVER DESIGNER: Jennifer L. Witzke

PRINTER: Four Colour Imports